WHISPER WRITING

Joseph L. DeVitis & Linda Irwin-DeVitis
GENERAL EDITORS

Vol. 36

PETER LANG
New York • Washington, D.C./Baltimore • Bern
Frankfurt am Main • Berlin • Brussels • Vienna • Oxford

MELISSA M. JONES

WHISPER WRITING

Teenage Girls Talk about Ableism and Sexism in School

PETER LANG
New York • Washington, D.C./Baltimore • Bern
Frankfurt am Main • Berlin • Brussels • Vienna • Oxford

Library of Congress Cataloging-in-Publication Data

Jones, Melissa M.
Whisper writing: teenage girls talk about
ableism and sexism in school / Melissa M. Jones.
p. cm. — (Adolescent cultures, school and society; vol. 36)
Includes bibliographical references and index.
1. Mentally ill children—Education (Secondary)—United States—Case studies.
2. Teenage girls—United States—Social conditions—Case studies.
3. Feminism and education—United States—Case studies.
I. Title. II. Series: Adolescent cultures, school & society; v. 36.
LC4181.J67 371.92—dc22 2003025889
ISBN 0-8204-7089-9
ISSN 1091-1464

Bibliographic information published by **Die Deutsche Bibliothek**.
Die Deutsche Bibliothek lists this publication in the "Deutsche
Nationalbibliografie"; detailed bibliographic data is available
on the Internet at http://dnb.ddb.de/.

Cover design by Lisa Barfield
Cover art by Jesse M. Combs and Randi Sue Kuhn

The paper in this book meets the guidelines for permanence and durability
of the Committee on Production Guidelines for Book Longevity
of the Council of Library Resources.

Printed in the United States of America

To Bill, Cari, and Jesse
You are my strength

For Girls Everywhere

❧ Table of Contents

✤ Acknowledgements

This book, while written by one person, was influenced by many. Every idea presented herein is the result of a seed planted at another place during another time. I am grateful to the individuals who came before me that opened up the dialogue about sexism in schools, and for those who have struggled to get ableism recognized as a bonafide *ism*. Their names are too numerous to mention, but their contributions are not forgotten.

More specifically, I would like to recognize Joseph L. DeVitis for his helpful suggestions while editing this book, as well Chris Myers, Bernadette Shade, and all of the other wonderful people at Peter Lang Publishing for their guidance and support during the publication process.

The original research that is the foundation for this book would not have been completed without the encouragement of my mentor, colleague, and friend, Kate Rousmaniere. I remain indebted to her for her support during this challenging and sometimes gut-wrenching process.

I would like to thank Lisa Pfalzgraf for taking a risk and welcoming me into her school program. Her openness and camaraderie, was always appreciated. The teachers of the school program I explored all deserve thanks, not only for permitting me to enter into their classrooms, but also for the work they continue to do every day. Theirs is often a thankless job with only intrinsic rewards related to watching students succeed.

Most importantly, I would like to thank the three young women who willingly engaged in this research project with me. Without their honesty and willingness to share their stories, there would be no book. I promised I would help their voices be heard. This book is my way of keeping that promise.

On a more personal level, this project could not have been undertaken without the support of my husband, Bill Jones. The late nights, the constant questioning, the barrage of stories shared in the dark. You are there for me always.

My daughters, Cari Carlier and Jesse Combs are two of the strongest women I know. They have endured years of my feminist rantings and are my partners in trying to change the world. They have always been my source of inspiration.

And finally, thanks, Mom, just for being you.

Ah, cruel Three! In such an hour,
 Beneath such dreamy weather,
To beg a tale of breath too weak
 To stir the tiniest feather!
Yet what can one poor voice avail
Against three tongues together?

Lewis Carroll
Alice's Adventures in Wonderland
1865

❧ INTRODUCTION

"But I don't want to go among mad people," Alice remarked. "Oh, you can'n't help that," said the Cat:"We're all mad here. I'm mad. You're mad." "How do you know I'm mad?" said Alice. "You must be," said the Cat," or you wouldn't have come here."

<div align="right">

Lewis Carroll
Alice's Adventures in Wonderland

</div>

Hidden Culture, Hidden Voices

Adolescence is a broad term used to define that period of life we all have experienced, filled with secrets and adventures, growth and change, success and shame. Yet, as we pass through this time of our lives entering adulthood, we are often left with a sense of unknowing about what had just happened to us. Somehow, as adulthood envelops us, we seem to forget—or refuse to acknowledge—our experiences and thoughts during this turbulent time of our lives, cloaking adolescence in mystery. As we work with adolescents, we often do so with only a casual acknowledgment of their life experiences as they mirror our own. We develop programs and instructional strategies from an adult perspective, frequently missing opportunities to relate to the ones in our lives who are currently engrossed in this rite of passage called adolescence.

As parents and professionals, in order to create environments that nurture adolescents, we not only need to recapture our own rites of passage, tapping our memories to determine what adolescence really was all about, but we also need to listen to the voices of others who are in the midst of this life-changing portion of their lives. By listening to the voices of students who are currently negotiating adolescence, we can better understand what others are going through, and what we went through ourselves. But adolescence is not simply defined as an experience. It can also be viewed as a culture, as groups of students around the same age negotiate their identities and newly found freedoms together in a dance of conflict, friendship, independence, and belonging. In order to learn about this culture then, one must listen to the voices of students in concert, recognizing the harmonies and discords that prevail.

To suggest that there is only one adolescent culture to study, however, would be misleading. In fact, there are multiple subcultures or even counter-

cultures that make up the larger, broader concept of adolescent culture. Some of these subcultures are formed naturally as students begin to discover who they are and who they want to be, joining groups of like-minded individuals in order to feel connected with others. Other adolescent subcultures, however, are artificially constructed by the adults in a school system through the structures they create to serve a variety of students. For example, tucked away in the recesses of many school buildings and districts are subcultures of students who have life experiences somewhat different from their peers. These are students we actually know little about, because they do not quite fit in to the conforming *nonconformity* of typical adolescence. These students are students with disabilities.

Each disability label carries with it its own baggage. Depending on the disability category under which a student receives special education services, that label affects how the student is perceived by others, and of course, how she or he perceives herself or himself. One disability category under which many adolescents receive special education services is that of emotional disturbance (ED), sometimes referred to as a behavioral disorder. ED is a school-related disability in which a student's behavioral difficulties, which must be intense in nature and severity and occur over an extended period of time, must also impede the student's academic performance (Individuals with Disabilities Education Act Amendment of 1997). There are a variety of specific behaviors a team must consider when determining whether or not a student is eligible for special education services under this category.

The term *emotional disturbance* has been chosen for this study because it is the term used in the federal definition for a school related disability characterized by significant behavioral issues. However, each state uses a variety of terms to describe ED. These terms include severe behavior handicap (SBH), behavior disorder (BD), emotional handicap (EH), and emotional impairment (EI). While the labels might be different, and may even imply differences in disability characteristics, the reality is that they all describe the same federal disability, and students in each state must meet the same federal requirements for eligibility of special education services under this category.

In addition to the general characteristics, which must be present in order to determine that a learner has a behavior disorder, learners with ED often have a medical or psychiatric diagnosis of some other condition as well, such as attention deficit hyperactivity disorder, oppositional defiant disorder, conduct disorder, or depression. However, it is not necessary for such a diagnosis to exist in order for a learner to be found eligible for special education services under ED. Most often, learners with ED have a history of offenses against school rules, experiencing difficulty with academics due to

the disruptive nature of their behaviors. They typically are the learners who do not conform to the traditional expectations of school culture, particularly in the area of compliance to school rules.

One fact of interest about the nature of ED school programs is that the majority of special education programs for students with ED are located in segregated environments. These environments range from seclusion in self-contained special education classrooms to a separate school located off the public school campus. Although there has been a push for more learners with disabilities in general to be served in the regular education setting or in their neighborhood schools supported by teachers serving learners cross-categorically, learners with ED continue to frequently spend a portion if not a majority of their school day in self-contained ED classrooms. This is due, in part, to the often disruptive nature of the disability. Between 1984 and 1995, the percentage of students receiving services in special classes, day treatment centers, and residential facilities ranged from 54 percent to 57 percent (U.S. Dept. of Education, 1996). These environments are all considerably more restrictive than the educational environments experienced by most students with disabilities and certainly more restrictive than the general education environment.

Furthermore, during the 1995-1996 school year, nearly five percent of students with ED were served in the most restrictive settings, such as residential facilities, hospitals, or at home. This is in contrast to only a little over one percent of all students with disabilities served in the same settings (U.S. Dept. of Education, 1996). By educating students in these environments, educators have essentially constructed an artificial culture dominated by students with behavioral and emotional difficulties. It was this culture, this hidden society of challenging students, I chose to study.

Although ED programs are theoretically designed to provide the intense level of supports and services these students need to benefit from their education, in actuality many of these programs are inadequate in this regard. Teachers, although quite caring and concerned about the welfare of these students, often do not have the training and expertise needed to support the learning of alternative behavior (U.S. Dept. of Education, 1996), unintentionally setting the stage for increased conflict from students through coercive practices (Gartin & Murdick, 2001; Shores, Gunter, & Jack, 1993). Due to this lack of training, ED staff may emphasize a curriculum of control, utilizing strategies that are not supported by research for addressing the needs of these challenging students. Even among teachers who are prepared for the challenge of working with students with ED, teachers and aides for students with ED are more likely to seek reassignment or leave their positions than teachers for students with other disabilities due to the high level of stress

involved in working with groups of students who have behavioral difficulties (U.S. Dept. of Education, 1996). Center and Kaufman (1993) reported attrition rates for teachers of learners with ED to be 30 to 50 percent over a three-year period.

While it may be the intention of educators to provide a supportive environment in which these students can thrive, the act of grouping these students together only compounds the issues students with ED present, creating a contained box of explosives just ready to ignite. Most often, this grouping of students has been for the convenience of school districts, providing resources and supports in one bounded location. While perhaps demonstrating fiscal responsibility through an efficient use of resources, this may not be the most effective way to meet these learners' needs. Since ED environments are manufactured by schools for schools, grouping students together who experience behavioral difficulties, schools have actually contributed to the creation of an artificial subculture of youth with behavioral problems. This subculture is in essence a petri dish in which power relations within adolescent cultures can be readily studied.

This is not to suggest that educators in charge of ED classrooms consciously contribute to student oppression, nor do I intend to condemn ED programs. In fact, there are many special education programs for students with ED that have been designed with the intent of providing a safe and nurturing environment for students, relying on extensive research and promising practices to support learners with ED. However, the reality exists that even in the most successful ED classrooms, the students bring with them heavy baggage as demonstrated through their noncompliant behavior, requiring extensive structure and support in order to access the school curriculum.

Personal experience with ED programs has shown me that it is possible for a student to achieve success as determined by self management of her or his behavior, and I have known a few students who have successfully transitioned back to the general education environment. When this occurred, it was often a result of some facet of the ED program in which the student had been involved in conjunction with therapeutic services and an aspect of trauma recovery when necessary, such as prosecuting a perpetrator of abuse. While success stories do exist, the fact remains that the majority of students with ED continue to be grouped together for most of their school careers, and these students present the most challenges to teachers and the structures that have been created to support them.

Aside from the segregation to which many students with ED are subjected, another interesting characteristic of programs for students with ED is that the majority of students served in ED programs are male, with females

an underrepresented group in this special education population. In two national studies, it was found that females averaged a mere 25 percent of the total ED population (Cullinan, Epstein, & Sabornie, 1992; Valdes, Williamson, & Wagner, 1990). So, within this group of what some might call *social misfits,* girls experience a double dose of oppression, being marginalized within an already marginalized group.

Girls in ED programs are not considered marginalized simply by their low numbers and minority status, but also by the historical and material context through which gender marginalization has taken place. As a historical construct, then, one of the aspects of gender in need of consideration is how gender is traditionally characterized since it plays such a significant role in how we relate to one another (Kurz, 1998). For example, the hegemonic (or commonly accepted) definition of masculinity is often narrowly defined through aggressive acts. Hence, aggression in boys is actually somewhat promoted and socially accepted, both in schools and in the larger society (Connell, 1996; Eder, Evans, & Parker, 1995; Jackson & Salisbury, 1996; Jordan, 1995; Kenway & Fitzclarence, 1997). In addition to aggression, masculinity is also often defined in opposition to femininity. As a result, as boys begin the process of defining themselves as masculine, they do so at the expense of girls by degrading anything that resembles traditional ideas of femininity (Chodorow, 1978; Jackson & Sallsbury, 1996; Jordan, 1995). Name-calling such as "sissy" or derogatory comments such as "You throw like a girl," although intended to injure the identity of another male, actually results in demeaning girls who are within earshot.

As Jordan (1995) explains, "Many of the disadvantages suffered by girls and women are the result of being caught in the crossfire in a long-standing battle between groups of men over the definition of masculinity..."(p.78). Jordan believes that the harassment girls encounter by boys is not arbitrary, but in reality a result of this gender anxiety exhibited by boys as they attempt to position themselves within a masculine camp. Given the minority status of girls in ED classrooms, where adolescent boys who may be acting out as a means for establishing their masculinity or maintaining a masculine status (Connell, 1996) are concentrated, the focus of such abuse on these girls may be compounded.

As boys negotiate their identities, girls are continually confronted with contradictions and conflicts, which they too must negotiate. These internal conflicts often result in girls demonstrating some sort of resistance or accommodation as a means of coping with the contradictions they experience. As Anyon (1984) describes, the resistance that girls demonstrate in school through discipline problems can not be qualified simply as acts of defiance against school rules, but also as resistance to typical conceptions

about gender, such as submissiveness, passivity, and acquiescence. Verbal and physical aggression, talking out, tardiness, and absenteeism, are all behaviors in contradiction to what is deemed acceptable behavior for a girl. Anyon refers to these demonstrations of resistance as *organized nonconformity*. As a structured response to resistance, they may not be conscious acts, but they are also not a result of an inability to follow rules. They are, in essence, a choice.

It was the phenomenon of accommodation and resistance by adolescent girls in ED classrooms in which I was most interested. If the physical and psychological abuse of women by men (or of girls by boys) is perhaps part of the male identity formation process, then the identity formation process of adolescent females must be inextricably intertwined with the male identity formation process. How might girls who are already resisting societal norms of gender through their dress and behavior deal with this overt exploitation initiated by boys?

Given the reality of an ED classroom, such a segregated environment can be a lonely place for a girl. The minority status experienced by girls in these classrooms could lead to further abuse, harassment, and oppression beyond what they had experienced prior to being identified as having an emotional disturbance (American Association of University Women Educational Foundation Survey, 1993; Stein, 1998). It is difficult to even refer to these girls as a group because rarely does one find more than one girl in an ED class, if any at all. As the only girl to 11 boys, a frequent phenomenon in ED classrooms that even have female representation, there is little with which that lone female student can identify, having to choose to either become a member of a group fraught with friction and domination, or to become a social isolate, attempting to ignore the advances and abuse of her male peers.

The infrequency of girls in ED programs is a phenomenon worthy of study in itself. Perhaps it is due to the fact that girls often tend to deal with life's stressors differently than boys, displaying more inwardly than outwardly their responses to conflict and oppression (Anyon, 1984; McRobbie, 1978). Anorexia, depression, and promiscuity are often not disruptive to the school environment, so the internal conflicts many girls face may go unnoticed by teachers, their voices remaining unheard, their active resistance unnoticed.

Many boys, on the other hand, respond to stress through overt acts of aggression and violence, blatantly striking out against authority and oppression. Such behaviors, manifested in the form of noncompliance, disrespect, and violence, invariably get the attention of teachers and administrators. This overt resistance may be a contributing factor in the

higher incidence of boys over girls receiving disciplinary actions in schools, as well as being identified as having an emotional disturbance. Whatever the cause, however, the end result is the same. Boys have jurisdiction over the ED domain, and girls in ED classrooms are a marginalized entity.

With so few girls represented in ED classrooms, their existence has been virtually ignored in the literature. Although much has been written about girls, gender, and schools in general, girls with behavioral issues are conspicuously absent from the research, particularly girls or young women with ED. As Roman (1992) explains, feminist research needs to draw on the differences among groups of women in order to theorize what is common or different about their experiences, including commonalities and differences in various forms of oppression and privilege they may have experienced. As we persevere to unveil the multitude of perspectives representative of women, the need remains to identify groups of females that have not yet been heard, in order to continue to add to the color and dimension of the landscape of current feminist literature. The young women in ED classrooms are a unique group of women who have not often been studied. Given the circumstances in which they find themselves, these young women can provide additional information about how adolescent girls in general react to the cultural constraints and power hierarchies in a school and in society.

Identity Formation and Rewriting History

The problems posed by this research project were twofold. The first was to determine how these female adolescent students, given their gender and the political structures encroaching upon them, reacted to the ED culture in which they are submersed. Secondly, this research project explored how these girls' senses of identity were then shaped by those reactions.

However, the purpose of this research project went beyond the interpretive investigation described in the problem statements above. Aside from exploring how these young women gave meaning to their ED environment, the intent of this project was to hopefully have emancipatory ends (or beginnings, as it may be for these participants). By engaging in this inquiry, not only would the researcher gain insight into how these students were responding to their environment and how those responses influenced their sense of identity, but the students participating would gain insight as well. It was the hope that as these young women became more cognizant of the power forces that contributed to their subjugation and their choice of actions of accommodation and resistance, perhaps a sense of solidarity and agency would be fostered among them, supporting them as both individuals

and as social group members to find more productive ways of responding to these power forces. Together, it was hoped that they might be able to rewrite their histories that in turn would have an impact on their futures. The teenage girls in this study were considered to be a marginalized subgroup within the larger oppressed community of adolescent students with ED.

The concepts of marginalization and subsequent acts of resistance are quite complex within the ED culture. While marginalized groups are often defined as those who are silenced, with voices muted or muffled by oppressive practices, many students with ED could be considered militants, refusing to be silent, actively opposing the structures and politics that they feel continuously attempt to squelch their independence. In response to emotional traumas, learning difficulties, physiological and psychological disorders, and varied life experiences, students with ED often find it difficult to flourish in the traditional classroom setting and may act out as a way to communicate their need for something different, challenging the authority of the class structure. As a result, these students often do not succumb to the traditional disciplinary practices and structures in schools.

These students' responses to authority may not be organized. However, their small acts of agency or resistance may be all that is available to them in a system where there is overwhelming oppression. They may initially feel exhilarated and empowered by their acts of defiance, reinforcing their continued use of such strategies as an attempt at agency. Except, since conflict is both disallowed and illegitimated as a model of social interaction in schools (Pinar, 1994), the communicative acts of resistance demonstrated by many learners with ED frequently lead to punishment. In schools, punishment can include detention, suspension, expulsion, time-out or restriction of privileges, and segregation into special education classrooms and programs for learners with behavioral issues or an emotional disturbance. In essence, these students may actually perpetuate their marginalized status as their defiance toward authority results in further oppression (Willis, 1977).

Not only may the students with ED be contributing to their oppression, but a student's individual sense of agency may actually be working to defeat her or his awareness of subordination, resulting in both a personal and societal denial of the existence of oppression. Mahoney (1994) believed that the opposition expressed through these challenging acts simultaneously creates a duality of both a *true* and a *false* consciousness among students such as these. Their self-knowledge and confidence resulting from the actual experience of opposing authority possibly blinds their recognition of personal and social oppression and suffering.

In an effort to unveil the intricacies of power and oppression existing in ED programs, I participated in an ethnographic study occurring over the

course of one school year. Through this study, I carefully listened to the voices of three adolescent girls with ED as well as their classmates, and together we attempted to capture the essence of their lives in ED programs. Through numerous observations of ED classrooms, and ongoing interactions with students with ED and their teachers, I have tried to create a set of visual images for the reader representing the realities of one particular ED school program and the female students who participate in it.

Making Sense of Wonderland

I was immensely humbled by my experience with the young women who agreed to participate in this study with me, as I was once again reminded how limited my view of education and students has been. The secret world of ED school programs reminded me of the mixed up world Lewis Carroll created in his book entitled *Alice's Adventures in Wonderland* (1865/1992). Wonderland was an underground world, hidden from the view of most people, being only accessible by a seemingly endless rabbit hole. Just as Alice ventured down that rabbit hole, unsuspecting of what she might find, so had I as I entered the ED school culture.

As Alice explored Wonderland, she found herself trying to make sense of it, using her current understanding of life, of the things she had been taught in her world, attempting to apply it to the seeming nonsense of this fantasy environment. I admit that I had to do the same as I explored the Wonderland of an ED program, because my world as an educator, as a middle-class woman, as someone who followed the rules and achieved success in the world of academics, was the only framework I currently knew from which to view the scenes played out before me. However, just as Alice had, I found I had to adjust my sight, attempting to perceive the world through the eyes of the inhabitants of that culture. Since no one can truly achieve this without being an actual member of that culture, I developed a strategy called *Personal Life Presentations*, through which the students themselves share their view of their experiences, allowing the reader to hear, if you will, directly from the Griffin, Cheshire Cat, and Rabbit themselves about their understanding of their world. In three chapters of this book, the young women involved in this study personally share their insights about their experiences in ED classrooms.

Personal Life Presentations

One of the challenges offered by qualitative research is in the presentation of the narratives. As an ethnographer, it was important for me to present the stories and interpretations of the stories gleaned during research in such a way to be meaningful to the reader of the research. Clandinin and Connelly (1991) explained that once a story is told, it no longer belongs to the storyteller alone. Instead, it becomes part of a shared experience as the person listening to the story experiences the tale through their own personal lives and understanding. An important facet of this research was the acknowledgment that the reader would have her or his own experiences and stories that she or he will use to make meaning for her or himself from the stories shared by the research participants. As a writer of narrative research, it was imperative for me to attempt to capture something to which a reader of this research could relate in order to create a shared experience between the participants in the research, myself as a researcher, and the reader of the research (Clandinin & Connelly, 1991). However, in acknowledgment of the volatile nature of some ED classrooms, I needed to be cautious to avoid sensationalizing the experiences of these students.

Initially, I began this study using a traditional form of ethnography, observing in classrooms, interviewing students, and taking copious notes. I would then write up my field notes to share with the individual students. The purpose for using this member-check process had been twofold. While I had wanted the girls to check for accuracy of what was recorded, I had also hoped that the reading of field notes would be a therapeutic tool for these girls as well. Having them reflect on their earlier responses, perhaps they would discover how they possibly contributed to their own oppression. However, I am afraid that instead of being liberating, the use of this strategy only contributed to their sense of subjugation. While recognizing that one is oppressed is a beginning step to becoming liberated, I feared that being reminded of how they were oppressed only made these students angry, further paralyzing them from being able to proactively address the situation. Part of the reason these girls attended this segregated school was because they did not currently have the skills to address such oppression effectively, choosing to act out aggressively toward their oppressors because that was the only response in their repertoire at that time. Expecting more of them without providing the instruction and support was possibly unethical, given their current situation. In addition, even with their input, I was concerned that what I was capturing on paper was only a monocular view of these students' lives in schools.

Finding Alternatives Within Liberatory Research. To address these problems, I employed an additional strategy in an effort to provide these learners an opportunity to be heard. To empower these students as true participants of this study, I decided to have the learners generate their own autobiographies, sharing a historical perspective from the students' viewpoint. Inspired by the work of Sara Shandler (1999), I wanted to find a way for these girls to actually be able to tell their own stories. The stories told for the purpose of this study needed to span the scope of several dimensions in the girls' lives, involving both their school experiences and the histories of their oppression outside of the school environment. Doing so in a traditional fashion of autobiography had proven to be a challenge for these girls for several reasons, necessitating a more supportive format of autobiography.

As I attempted to engage these students in writing their autobiographies, I encountered several roadblocks. One such roadblock was the time constraints within which we were operating. Another roadblock turned out to be the poor writing skills of the student participants. Of the two issues, time was perhaps the most difficult factor to overcome. Although I was able to spend an adequate amount of time in the classrooms observing these girls in the school culture, the time allotted for them to actually work with me alone was limited, contingent upon the completion of their other schoolwork which often did not get done until the end of the school day (if at all). In addition, although the girls were interested in participating for the most part, their writing skills varied, making gathering written information difficult. Although I acknowledge one student's proclivity for journaling, the others were not as proficient. For one student in particular, any form of expressive language, whether verbal or written, was limited.

In order to add dimension to the stories told while maintaining the integrity of the young women's voices, I had to create yet another alternative means through which the student voices could be hear. Consequently, I engaged these girls in a coauthorship of their stories, what I call Personal Life Presentations, working collaboratively to put in writing their tales of rules, relationships, families, and schools. The addition of these students' Personal Life Presentations afforded me an opportunity to present a double description of the experiences shared. As LeCompte (1993) describes it, this double description affords the reader the opportunity to view the world presented using binocular vision. Through binocular vision, the reader actually acquires depth perception as one is presented with two versions of the same universe. The Personal Life Presentations offer one version from the student perspective, while the inclusion of interpretive anecdotes provide a researcher perspective. And yet, the two are not mutually exclusive of one

another. We were bound by the coauthorship relationship that was needed in order for the writing of the student stories to become a reality.

Coauthorship in Research. Applying the principles of coauthorship during research is not a new concept. LeCompte (1993) reminds us of the rich history of storytelling as a part of research through the use of oral history, narrative biography, life-history ethnography, and emancipatory life-history narratives as a means for uncovering and analyzing social-cultural realities. To facilitate coauthorship, I combined the information gathered in my field notes, of observations and conversations the students and I had engaged in, to generate a draft of the students' Personal Life Presentations. The draft was composed as a nonfictional piece, consisting entirely of events and quotes shared or observed during the field experience. The drafts were then shared with each of the girls in order to get their input and to make any changes needed to better reflect their perspectives. The three students were asked to read through the Personal Life Presentations and edit as needed, changing any words or language they deemed necessary, sharing the responsibility with me for the final story told.

Substituting Assignments. In order to address the issue of time constraints limiting the girls' opportunities to work on their Personal Life Presentations, an agreement was made with their teachers. The students participating in this study were permitted to substitute some of their English assignments, which usually consisted of completing several worksheets or journal entries, with tasks associated with their Personal Life Presentations. Such tasks included editing the stories we were creating, writing additional autobiographical accounts to make their stories more complete, and reviewing previous journal entries they had already written as part of their daily work assignments to decide if there were any they would like included in their individual Personal Life Presentations. Once additions and changes to their Personal Life Presentations were made by the students, a second draft of their stories was completed and shared, followed up by conversations with each of the students to clarify any additional points and make further edits.

Having students edit their stories gave them authority over the text. For example, on one occasion a student participant felt uncomfortable with the *self* that was presented in an earlier draft of her Personal Life Presentation. Even though direct quotes had been used from a conversation we had previously had, this student expressed discomfort because the way she had been quoted made her appear selfish. Not wanting to be perceived in this manner by a reader of this work, she crossed a passage out. Together we rewrote the passage to create the image she wanted to present of herself.

While no student participant ever requested that I completely remove a story from my field notes, had she requested me to do so, I would have been compelled to honor her request.

Even though the young women participating in this project rarely asked that information shared be removed from the field notes, they did, however, ask to change the subject if the conversation came too close to revealing something they did not wish to confront. Several times, opportunities to unveil some aspect of their experiences and perspectives were lost because of a student's reluctance to discuss a difficult matter further. Yet, the fact that certain subjects were not permitted during our conversations was an intersubjectivity to be analyzed in itself.

This process, whereby the research participant becomes intimately involved in the text produced, is referred to as *isomorphism*. Lincoln (1993) explains that if isomorphism exists as part of a research inquiry, then it is the silenced who determine the authenticity of what is presented, and not some outside source. Additionally, through coauthorship, the students and I began to formulate a double consciousness as we struggled together on an equal basis to determine what would be shared and how we would reciprocate with one another, as LeCompte (1993) suggests. We became inextricably linked to each other as a consequence of this research format.

From a critical researcher's perspective I felt that this approach constituted the best way to facilitate having these young women share their stories in a comprehensive manner. Through the coauthorship of their Personal Life Presentations, we were better able to capture the depth of their life experiences, providing a more complete picture over time of their perspectives of themselves as adolescents and of their school culture. If I had not facilitated the writing of their Personal Life Presentations, these stories may never have been written and the voices of these students would have been either lost or limited. While their writing may only be a whisper alluding to what they have experienced, it still can be considered a representation of their voice. Captured in this way, the picture provided is a cinematic view rather than a single snapshot of one particular moment in time. Perhaps it could be said that I was the videographer and producer of the autobiographical film created. While the students told their tales in a variety of ways, I cut and pasted them into the scenes shared in this book. In this way, these students could be recognized as people with real lives and feelings, not subjects of a research project, allowing me to write with them instead of about them, better presenting their authentic selves.

As an ethnographer, I admit that by collaboratively creating the autobiographies of these young women I have perhaps unwittingly infused my perspectives with theirs. One might then suggest that I am falsely

representing these stories as their own. Since this is a real possibility, I attempted to nullify the effects of my perspective by encouraging the girls to edit my original drafts and make additions and deletions. In the end, they would have ultimate control over what was shared and how they were represented. Given the constraints of the school culture and their individual abilities, it seemed the best alternative for helping these young women share the selves they wished to present. While the stories depicted may be organized by me for presentation's sake, nothing presented is fictional. All characters are real, although their names have been changed (the girls made up their own names), and all incidents shared were either observed and discussed, or related to me by one of the girls involved in this research project. Most of the statements recorded are direct quotes lifted from the field notes and incorporated into their Personal Life Presentations.

Insider or Outsider? As a method of self-check to guard against the oppressive potential any research has with the participants, I found it necessary to continuously reflect on both my insider knowledge as an educator and my position as an outsider throughout this research project, as Pinar (1994) and Wright (1995) suggest. It was important for me to recognize my own complicity in the maintenance of oppressive practices experienced by these students. This reflexivity needed to include the recognition of the various and often contradictory positions I hold as a woman, an educator, a researcher, and as someone from a position of privilege.

Even though I attempted to establish a rapport with these young women that would allow the co-performance proposed for this research, I could not dare to claim any sense of equality with these students because doing so would ignore the power structures inherent to my position as a researcher and as an adult. As argued by Ellsworth (1989), Freire and Shor (1987), and Roman (1992), I needed to continually engage in a reflexive practice, acknowledging that any efforts at establishing a cooperative relationship with these students would automatically take place within the hierarchal structure between researcher and student, particularly the middle-class researcher and the working-class student (Carlson, 1987). That is why it was imperative for me to follow the guidelines of liberatory inquiry in order to prevent the potential subject-object dualism inherent to research.

Acknowledging the View

Before we push forward over the terrain of the ED school environment, it would be beneficial for the reader of this text to understand the lens through

which this information is being presented. I am fortunate to be involved in academia at a time when the talk is of border crossing, with multiple perspectives being recognized as not only an ethical issue but also a necessity in order to better understand the world in which we are a part. My fortune lies in the hope that this research, having been conducted during such times, will be accepted as an example of border crossing of various theoretical foundations. Resisting the expected practice to situate myself into only one area of educational study within one theoretical framework, I am attempting through this research to cross the borders between special education and general education, between classroom management and schoolwide renewal, and between psychology, critical theory, and feminist theory. I resist positioning my theoretical framework within one camp because doing so would detract from the plethora of resources from which I continually gain knowledge and information. Instead, a more integrative approach to research was embarked upon, demonstrating my willingness to move beyond the boundaries of perceived theoretical wisdom, combining ideas from seemingly unconnected sources.

Perhaps more in line with a reconceptualist position (Grumet, 1980; Pinar, 1994), I submit that my theoretical foundation is and will continue to be a work in progress as I persist in pairing divergent perspectives with my own personal experiences. In essence, I continually redefine my theories and reformulate my practices through a hermeneutic of critical reflection on educational experiences as I commit to my perpetual evolution as an educator and a researcher. Following the paths of Diane Brunner (1994), Mary Pipher (1994), Michelle Fine (1992), and Maxine Greene (Ayers & Miller, 1998), I prefer to embrace an eclectic approach to teaching, learning, and research, perhaps demonstrating my own counterhegemonic resistance toward categories and labels. My experiences with special education, both personal and professional, have taught me the detrimental limitations imposed by labels of any kind, having a direct impact on my choice of research design.

Through my experiences as a sibling of someone with a disability, a special education teacher, a supervisor of ED programs, an educational consultant, and now a professor of special education, I have come to recognize that disability may actually be a phenomenon that is constructed by social and cultural influences, resulting in oppressive practices of legendary magnitude both in schools and in the general community. As Oliver (1996) explains, people with disabilities continually suffer from both social and economic exclusion, as well as exclusion in critical research and in literature. *Ableism* is traditionally disregarded in the dialogue around other *isms* such as racism or sexism. In fact, there has been little written about disability oppression and even less written on resistance to it (Charlton, 1998). Even

when writers have specifically examined disability oppression, they have failed to conceptualize it as a social phenomenon, caught up in the common belief that the disability experience is an individual experience (Oliver, 1996). This void in critical research and literature is a virtual abyss, demonstrating once again the exclusion of people with disabilities, even among those who claim to vigilantly expose the plight of the *Other*.

The exclusion of individuals with disabilities is perpetuated by a historical focus on disability as an individual problem requiring medical treatment, attending to an individual pathology rather than a social model of disability. The implication is that to have a disability is to have something wrong with you, something that needs to be fixed. As Morris (1993) explains, one of the most oppressive beliefs held by society is that people who have a disability want to be *normal* or something other than they are. Even the term *dis*ability implies an aberration as it is presented as a binary situated in opposition to ability. By creating disability categories, society has created an *Other*, differentiating between the *abled* and the *disabled*. For adolescents, whose life is already fraught with contradictions and turmoil as they try to define themselves, adding disability as a signifier has direct implications on who they actually strive to become. Hence, the focus for this research inquiry was on the social-cultural influences of disability on adolescent development and sense of self, specifically for teenage girls with the disability label of *emotional disturbance*.

Communities of Resistance

As stated previously, students who have been identified as having ED are typically those students who have continually resisted school structures and school rules. One area in particular in which students with ED typically express resistance to school rules is in their use of profanity. Oftentimes, students with ED have received many discipline referrals in the course of their school careers because of their language in school. As is often the case with oppressed groups, their speech is considered back talk or defiance instead of something that might actually be considered a condition for survival (Ellsworth, 1989). Students who use profanity may do so in part as an attempt to gain power by oppressing those they feel have dominated them. Yet, Freire (1971) explains that in order for the struggle of the oppressed to have meaning, those suffering from oppression must not in turn become the oppressors. Therefore, initially I had assumed that I needed to engage with student voice and share their voice in a way that would not be considered offensive to the reader.

As I began to spend time with the adolescents in this special education environment, however, I realized that many of their acts of rebellion were in fact how they defined themselves. Therefore, if I were to redirect or cover up their defiance, derogatory comments, and use of profanity then I would be, in fact, perpetuating the same silencing of their voices that had been going on for years. How they currently responded to oppressive practices was limited to what actions were in their personal repertoire. What I discovered was that if I, and in turn you, the reader, were to gain a better understanding of how these students understood the ED environment, then I would need to listen to the words that exemplified their resistance of traditional efforts by schools to control their behavior. Profanity played a big part in how these students resisted conformity to rules. It was imperative for me to preserve the students' word choices to demonstrate their acts of resistance. This is not written as a warning, but rather as a note to the reader to remain mindful of the intent of the students' word choices. Instead of being offended by the students' use of profanity, look beyond the words to better understand what these students are actually saying to us.

In addition, as we delve into the lives of the three young women who contributed most to this project, be prepared to be confronted with some disturbing scenarios. As a reminder, the purpose of sharing these stories is not to sensationalize the traumatic events each of these girls has experienced, but rather to learn from them as we unveil lifestyles and reactions with which the reader may or may not be familiar. Similar to Alice going down the rabbit hole in Lewis Carroll's tale of *Alice in Wonderland* (1865/1992), what is presented hereafter may seem unreal to those who visit. The Personal Life Presentations or narratives written by students and field note excerpts are meant to provide the reader with a visual of this adolescent subculture, inviting would-be travelers and future researchers to join these women in segregated school environments such as this one. So welcome to Wonderland, a place of contradictions, where things may make sense only to the inhabitants, remaining a mystery to those who have never before ventured down the rabbit hole.

Welcome to Wonderland

The rabbit-hole went straight on like a tunnel for some way, and then dipped suddenly down, so suddenly that Alice had not a moment to think about stopping herself before she found herself falling down what seemed to be a very deep well.

Lewis Carroll
Alice's Adventures in Wonderland

Envision the Setting

Before we embark upon this journey into this underground culture of adolescents, learning from the inhabitants of this socially created subculture, let me create a picture of the setting for you, to help you to become familiar with the bounded space of this ED environment. The particular school program in which this study was conducted served students from nine different local school districts in one rural county. The participating school districts had formed a consortium through which finances were pooled in order to generate the resources and services necessary to meet the intense educational needs of their students with severe emotional disturbances. A county service center coordinated the expenditure of the district funds and oversaw the implementation of the ED program.

The building in which this school program was housed was a vacated public school building built in 1939. The public high school that previously occupied this building had been relocated in a newly built facility located a few miles away. The building in which the special education program was housed was currently under the control of the local county commissioners who inhabited the first floor, with most of the first floor reconfigured into office space, with the exception of the school gymnasium.

The special education ED program took up the second floor and part of the third floor of this building. The other half of the third floor was occupied by an alternative school program for students at risk of expulsion due to their behavior. This at-risk program was also run in cooperation with each of the nine school districts in the county, but predominately served students who were considered general education students, not students identified as having a disability. Students in the alternative program stayed anywhere from 10 to

80 days, depending on the offense for which they were being disciplined. The principal who ran the special education ED program in this building also oversaw the at-risk program.

This special education school program had only been in operation for three years. At its inception, the staff had come together and participated in the writing of the school program's vision and mission, which follows.

> Our Vision: We believe that all students should be given educational experiences that maximize their potential in meeting the challenges of a constantly changing world. We are committed to instilling a sense of belonging by providing an environment of mutual respect for self and community through the development of life skills for success now and in the future.

> Our Mission: Our mission is to fulfill this vision by encouraging individuality, acceptance, tolerance, and friendships that will reinforce the students' needs for belonging, power, freedom, and fun. We will strive to create an atmosphere of belonging through tolerance and acceptance of others, their views and beliefs. Students will develop work ethics and community awareness to become a positive member of society.

The principal of this school program had been highly influenced by the work of Brendtro, Brokenleg, and Van Bockern (1992) who promote a philosophy of classroom management based on the *Circle of Courage.* The Circle of Courage was developed to model the child rearing strategies of Native Americans, focusing on four arenas of empowerment, which should be in place to support youth. The four arenas include Belonging, Competency, Altruism, and Independence. It was also evident by the mission statement above, that some of the staff had been influenced by the work of William Glasser (1986), recognizing a person's need for belonging, power, freedom, and fun.

Although the program was designed with a foundation in positive and proactive philosophies to behavior management, actually realizing these ideals in everyday practice proved challenging for this staff. Even with the best intentions, they continued to perpetuate a school society organized by strategies focusing on punishment and the restriction of privileges as a means for gaining control over their students. In the description of the organizational culture of this school program, the staff's attempts to demonstrate a belief in student autonomy were apparent. Students in this school program were encouraged to be a part of a classroom culture (belonging), make choices (power), earn free time (freedom), and engage in desirable activities (fun).

The nine school districts from which these students were transported served primarily a white Appalachian population, but the districts had quite a

varied tax base. Of these nine districts, three of them were labeled by the state as *Equity Schools*, meaning they were eligible to receive additional state funds for technology because they were considered to be among the poorest school districts in the state. Equity funding was a means for providing equitable opportunities to students living in poor school districts as compared to their peers in more wealthy school districts. The other six districts ran in the low, low-average, to average range of per pupil expenditures throughout the state.

This particular special education program had the capacity to serve 56 junior high and high school students. The students assigned to this facility by an Individualized Education Program (IEP) team were those identified as needing an intense level of services in order to access the school curriculum. In partnership with the local Department of Mental Health, Juvenile Court, Police Department, and county service center, this school program provided students and their families with a high level of assistance and support.

Other students in the county who also were identified as having an emotional disturbance were served in less restrictive public school settings along a continuum of services ranging from self-contained special education classrooms to consultation with an itinerant teacher. The level of assistance that a student received was determined by the individual student's IEP team, depending on the severity of the student's disability. At the start of this research project, 45 students were attending this ED program, with 41 of those students being boys and four being girls. The student attendance continued to grow throughout the course of this study, with the addition of six boys to the ED program by early spring. Numbers of students were difficult to measure due to the students' high mobility rate, with students signing themselves out of school at age 18; being incarcerated or sent to residential treatment programs; going to foster care or changing foster care placements to homes outside of the county; returning to their home schools; or being expelled and put on home instruction.

The office for both the ED Program and the Alternative School program was on the second floor of the building. In order to access the school, one had to ascend a set of concrete steps that had the appearance of a fire escape at the side of the building. Upon entering, visitors were confronted with another flight of steps that took them into the main corridor of the upstairs hallway. The floors were dark brown, the lockers were gray, and the classroom doors were framed in solid wood, stained dark to match the doors and the other woodwork in the building. While there were inspirational posters hung throughout the hallways, the overall impression of the setting was a mix of history and poverty, indicative of many old public school buildings.

The classrooms were large, with expansive wood-framed windows that only stayed open with support. There was no air conditioning and the heating system was ancient, making the rooms either viciously cold or oppressively hot. Much of the equipment and materials in the school were cast-aways from the contributing school districts, with desks and chairs unmatched, creating a patchwork effect in each of the classrooms. There were large chalkboards and bookcases or closets, and several of the rooms had stationary chemistry tables with sinks, although chemistry was not part of this school's curriculum.

The teachers were provided with a budget comparable to those of other teachers in the public schools of the surrounding districts, and they had autonomy in deciding how they could use those funds. As in any school, some teachers worked harder on their classroom environment than others, so the structure and appearance of each of the rooms was as different as the personalities of the teachers who taught in them. Since there were three different students participating in this study, much of the research was conducted in three classrooms. For the most part, students did not change classes and remained with one teacher throughout the course of their school day, with the exception of electives and Friday Clubs, a tool used for schoolwide behavior reinforcement, which will be described later. Every class had two teacher desks, one for the classroom teacher, and one for the teaching assistant whose primary role was to keep track of student point sheets.

A redeeming factor to this otherwise humble environment was the state-of-the-art computer lab recently opened at this school. Supported through district and state funds, this computer lab provided students with an opportunity to improve their computer skills for word processing and research, accessing resources not otherwise afforded to them given many of the students' socioeconomic status. There were 13 high quality computers in all. Teachers could sign up for computer lab tim,e and they utilized the lab in varying degrees.

Since the building was rather old, there was no working intercom system in the school. Therefore, every staff member carried a walkie-talkie. Staff members used the system to communicate with each other for the purpose of monitoring the whereabouts of students throughout the school building. Comments such as *"Carl's returning to class," "Gail, I'm sending Jonathan down to the office. He has a headache," "Ms. Johnson, will you please report to Ms. Elgian's room?" "Ms. Oneida, I need you to come to my class as soon as possible please,"* could be heard repeatedly during the course of a school day. Often the walkie-talkies created a constant buzz, interrupting class instruction.

The calls to staff over the walkie-talkies were made on a frequency that all staff were tuned in to, so the entire school could hear the calls. If staff members needed to talk confidentially about a particular student, they would call over the walkie-talkie and ask for a person to go to Channel 2, which was a private channel between the two speaking. However, anyone could turn to Channel 2 and overhear the conversation. Students in the sending and receiving classrooms could also often hear the discussion being shared over the receivers.

The primary method of classroom management used by the teachers of this program was a point system. Each student had the potential of earning 100 points throughout the course of a school day. The point system was broken up into 10 categories of desirable behavior, which were also broken down into hourly time frames. Each time a student had an infraction of one of the school rules, such as not staying on task, talking inappropriately (for instance, using profanity), or not completing work, a tally mark was made on the point sheet and the student ultimately lost points for that period of the day. The point sheets were required to be taken home and signed by a parent and returned the next day in order for the student to earn additional points. Depending on the teacher, each student had to earn a particular number of points within a week in order to participate in Friday Clubs.

Friday Clubs was created to help motivate students to control their behavior. Each week the clubs changed, but the students were informed of what they were working toward at the beginning of the week and then signed a contract for the club they chose to participate in if they earned it. Club choices varied from week to week, but had included activities such as making pancakes, watching a movie, playing chess, or doing an art activity. If a student did not earn the privilege of going to clubs, then the student was required to go to an *ineligible* room. While in that room, students had to sit quietly and complete work for the entire 50 minute period. Right before clubs were to begin, announcements were made throughout the school, declaring who had earned which club and who needed to report to an ineligible room. The teachers rotated between facilitating a club activity and monitoring an ineligible room.

Every teacher had her or his own expectations for acceptable student behavior, but those expectations were loosely organized around the criteria established on the schoolwide point sheets. If a student refused to work or was considered noncompliant, there were several levels of options from which the teachers could choose as a means for helping the students get their behavior under control. Initially, students received verbal warnings as well as a reminder that they were losing points. Next, an in-class time-out could be given, however, this was only observed on a few occasions. On such

occasions, students were required to stand quietly by their desks until the teacher gave them permission to sit down and return to their work. Most often used was a Level II intervention, meaning that the student was sent to another classroom for a time-out. While in that class, students were expected to complete work assigned or write an apology before they were permitted to return to their own classroom. Each classroom was equipped with one or two Level II desks to be used for this purpose. Several teachers had their own rules posted for what learners were expected to do while they were in that class. If a student continued to have difficulty while in Level II, then a Level III intervention was implemented.

In Level III, a student was escorted to a room designated specifically for this purpose. It was monitored by a teaching assistant who had extensive experience with learners with emotional disturbances. If the student was considered to be out of control, she or he was put in an isolated room that had no windows or adornments. This room was approximately six feet by eight feet and was a room within a room. Someone monitored the doorway at all times until the student was calm enough to change environments. On occasion, students had to be restrained in this room because of a fear that they would either hurt themselves or hurt others.

If the student calmed down, or was not so out of control to need an intrusive intervention, then she or he could sit at a desk in the other part of the Level III room. There, students were expected to complete work assigned by their teacher. If they did not complete any work, they could not return to their classroom. One student once told me that he was in Level III for three consecutive school days because he had refused to work. Eventually he got bored in that environment and decided that he would get some of his work done just so he could return to his regular classroom.

While in Level II or III, students did not earn points toward Friday Clubs, so if a teacher had to resort to either of these interventions for a student, then that student lost Friday club privileges, even if she or he had good days the rest of the week. Absenteeism also took its toll on student points since a student could not earn points if she or he was not in school. Again, even though a student may have had good days on the days she or he attended, if the student missed a school day, the student became ineligible for Friday Clubs.

Few students were ever suspended from this school unless a serious offense had been committed, such as an assault or bringing a drug or weapon on to the premises. Otherwise, the behavior issues were dealt with by the school staff. The staff included an administrator, teachers, teaching assistants, mental health workers, a school nurse, and a police officer. While most of the behavioral problems that occurred were solved within the segregated school

environment, many students had also been subjected to a change of placement, meaning that they were sent to either a juvenile detention facility or a mental health facility, either of which were usually court ordered.

Behind Door Number One. One of the classrooms in which this study was conducted was a desolate place, with little signs of any educational focus. While there were a few posters on the wall, they were the same ones seen in other parts of the building, a product of donations given to the school with no connection to the curriculum. Although there was a computer and electric typewriter in the classroom, materials in general were meager, and clutter was everywhere. Each student occupied a small table that was approximately three feet wide and the student tables were organized in rows. At the beginning of the school year there were four boys and one girl on this teacher's class list, although oftentimes there were only two or three students in attendance. Later, the class composition changed as the female in the class was moved to the classroom next door and a new male student was enrolled in her place.

Overall, the structure in this room was quite loose. The teacher primarily taught using worksheet packets, providing little formal class instruction. Periodically, however, students were required to copy notes from an overhead as a means for creating study guides in preparation of an upcoming test, and class discussions were encouraged. The teacher in this class was exceptionally adept at using humor to diffuse potentially difficult situations, oftentimes effectively de-escalating student behavioral problems. In addition, many students felt comfortable confiding in this teacher. She was often distracted from her academic instructional plan because she was frequently drawn into a personal discussion with students. In addition to being a special education classroom, this room was also where the Yearbook committee met.

Behind Door Number Two. Another classroom in which this study was conducted was next door to the first one described. Six boys and one girl were initially in this class. However, for the first quarter one student was out with a serious medical condition. The rest of the male students attended fairly regularly, but the female student did not. While this room was often in disarray, there existed a structure to the daily schedule that seemed to benefit the students. Student tables were situated around the perimeter of the room, with several long rectangular tables positioned in the center. The long tables were primarily used for Art class, which was also conducted in this room. On many days, the teacher wrote an inspirational quote on the chalkboard, as well as a writing prompt for journaling. Student artwork was displayed

throughout, as well as several examples drawn by the teacher's daughter. The school vision and mission were posted by the door.

As in the first classroom described, instruction in this class was also done predominately through packets of worksheets, however, some variety did occur. In the afternoons, the students listened and followed along as the teacher read to them from a novel she had chosen. While this study was being conducted, the novels chosen reflected the themes of the Holocaust and racism. Many of the students in this class were prejudiced against people of color and other minority groups, so this teacher was attempting to address their bigotry through the sharing and discussion of stories about societal oppression. The teacher tried to create a nurturing environment by using terms of endearment such as *babe* and *hon* when addressing the students and seemed to have a good relationship with several male learners in the class.

Behind Door Number Three. The third class in which this study was conducted was filled with educational materials including bulletin boards and learning centers. Instruction was given in a concise manner and redirection and reinforcement were evident consistently. Although there was an obvious structure to the daily activities, the teacher provided a lot of variety as well, creating thematic units across the curriculum. Every day as students entered the room in the morning, they began their assignments by checking a bulletin board, upon which their assignments were posted. Journal prompts, math word problems, vocabulary words, and other assignments were all centered around a particular theme for the week. Even though worksheets were utilized daily in this room, they were interspersed with projects and hands-on activities as well.

The classroom was managed by three rules: *Be good to yourself; Be good to others;* and *Be good to the environment.* At the beginning of the school year, the students discussed the meaning of those rules and came up with examples and non-examples of each. The teacher used these rules to redirect students by asking if what they were doing was an example of being good to others, and so on. This teacher had high expectations for each student to respect these rules and little tolerance was shown when a student chose not to comply.

Students sat at tables arranged in a "U" shape facing one of the chalkboards. With two students to a table, masking tape marked the boundaries of each student's personal space. Initially there were five boys in this class and one girl. While these numbers remained consistent throughout the majority of this research project, the names and faces changed as students came and went. Five computers were set up around the room to be used for free time as well as an aquarium, art supplies, and books.

As one can envision from the above descriptions, the classroom environments of this school program are similar to those seen in many school districts across the country, particular poorer districts. While the vision and mission of the school had been student centered, the actual structure of the school had a different focus. The underlying message implied by the current school structure and practices was that in order to change student behavior, the teachers must control it. Now that you understand, from a researcher's perspective, the philosophy and conditions under which these students were instructed, let us enter into this world and hear what the students have to say about this environment.

Complexity in the Air

She [Alice] generally gave herself very good advice (though
she very seldom followed it), and sometimes she scolded
herself so severely as to bring tears into her eyes; and once
she remembered trying to box her own ears for having
cheated herself in a game of croquet she was playing against
herself...

Lewis Carroll
Alice's Adventures in Wonderland

Who I Am and Where I've Been

My Personal Thoughts. Hi, I'm Air. I picked the name Air 'cause that's my
nickname and it really says who I am, just a real airhead. You know, kind of
out there. I'm 15, but soon I'll be 16. I think I express myself best through
my writing and I've kept journals since I was nine. I have a ton of them and I
keep different journals for different subjects, like *Woman to Woman*, *Love*,
etc., and they are all very important to me. I almost lost all of my journals last
November, though, when my apartment burned down, but for some reason I
had decided to take them with me in a bag to stay at a neighbor's house. To
this day I don't really know why I did that, but I'm glad I did. The fire was
probably my fault because they say it started in my bedroom where I had left
a candle burning. But to tell you the truth, I think that my ex-boyfriend may
have actually started the fire.

See, we had recently broken up, but we were hanging out with each
other that night, swinging from vines at a place called Graffiti Wall. I went
home to check my messages and my parents had called. They had been
arrested for having drugs in their car and my mom wanted me to take my
little brother, who was nine at the time, to a neighbor's house for the night. I
sent my brother on over there, but I was in the apartment for a while with my
ex-boyfriend. I had gone into my room, but I didn't notice the candle burning
anymore. I know I had lit one earlier, but I swear it was out when I went in
there. Then, I went to go do something in another part of the house, and I
remember that my ex-boyfriend had gone into my room, my bathroom, and
my parent's bedroom. When I asked him why, he said for no particular
reason, "Just looking around."

Later that night, I smelled smoke from my neighbor's apartment. My neighbor wouldn't let me out of the apartment to see where the smoke was coming from 'cause he had a bunch of warrants out for his arrest and he didn't want to be seen outside. Four hours later my apartment had burned down with all of my family's things in it. My dog died in that fire, but somehow my cat survived. To this day I wonder what would have happened if I hadn't sent my little brother on over to our neighbor's house. Man, I just can't even imagine that!

I don't really know why my ex-boyfriend would have started that fire, but we really hadn't been getting along that good. For some reason we were fine that night, but for the most part we weren't really friends anymore. His sister was angry with me for breaking up with him and I had to beat her up three times to get her to leave me alone. I remember hitting this girl's head into the concrete, but man, she just kept coming back for more. I guess he probably did it to get revenge.

It doesn't really matter anymore, anyway. Some of my journals have been stolen and I think I know who did it. A while back I had brought my journals in to school to share with some people, but I accidentally left them in a duffel bag here at school for awhile. When I finally got my duffel bag back, three journals were missing out of it. The teachers acted like they were looking for them, but I told them I wasn't going to keep telling them what they fucking looked like. I called my mom, but she couldn't do nothing to help. I even called my probation officer, but she's never at her desk. They never did find them, and it still makes me sick to think about it. Those were my personal thoughts I'd been writing down for years... but I've started a new journal now.

I Can Relate to... Pain. Aside from my journal writing, I also write a lot of poetry and song lyrics. I know the words to just about every song and I love music, both old and new stuff. I guess I would have to say that Pantera is probably my favorite group, though. Most adults probably wouldn't like that kind of music, but it really speaks to me because I can relate to the type of pain the group sings about. When I first started cutting myself, I thought I was the only one feeling the way that I felt. I would rather be the one inflicting pain on me instead of my mom or anyone else doing it. A friend of mine told me about Pantera and when I started listening to their music I realized that I wasn't a freak and that I wasn't alone. I think the song which best reflects me and who I am is "Five Minutes Alone." There are also two

slow songs on the CD *The Great Southern Trendkill* that I really like. One is "Suicide Note Pt. 1." [1]

Early in the school year it was hard for me to write because I had this stupid patch of poison ivy on my arm and it was right near my cut. In August, before school started, I got in a big fight with my mom and I got so mad that I ended up cutting myself pretty badly. I had to get staples in my arm to keep the skin together it was so deep. It's just a bad scar now, but I remember how that damn poison ivy drove me crazy! I'm not sure where I got it from, but I'm guessing that I got it from my boyfriend's bed since that's the only place I was that week.

Sometimes, when things get really bad, I catch myself looking at objects differently, seeing things in another light. Like the Town Tower for instance. You can see it from some of the windows here at school. Sometimes I look out the window and just see a tall bell tower sitting in the middle of a small town. At other times, though, I look at that same tower standing there and I wonder what it would be like to be up there and just jump off. Instead of a tower, it becomes a tool I can use to end my life. I don't know what's wrong with me. Sometimes it just feels really bad. I have this problem a lot. I feel like killing myself. I can't help the way I feel.

All Over the Country. One of the things that really depresses me is my home life. Because it sucks, I've run away more than six times. I've been in several foster care placements because of running away so much. The last foster home I was sent to was several counties away because my caseworker decided that if I was far enough away from anything familiar, I might not run away — and she was right, I didn't. That particular home had 14 girls in it, with bunk beds stacked all in one room. I never really had any trouble with any of my foster parents, but I know other girls who did. In this one foster home, the girl in the bunk below me woke up once with bruises inside her thighs and on the back of her legs. She said she dreamed that the foster dad had sexually abused her, but she said she couldn't remember whether or not it had happened for sure. The man never messed with me, though. Another foster father I had was really weird, but the only trouble I had with him was because he was crazy. He never touched me or nothing.

Actually, I've been all over the country and have gone more places by myself than with my family. I've been to Tennessee, Florida, and South Carolina as well as lots of places in Ohio. One time I walked probably 30

[1] The lyrics to this song suggest a life with cocaine helps to kill the pain. Suicide is a part of the refrain, pointing out the scars on the wrist to prove that the individual will try to kill himself again.

miles to see my big brother. Now, that was a very strange trip, but I don't really want to talk about it. One time, though, when I was 12, I went on a trip with my brother to Florida. Well, at least that was the plan. At first it was fun because he actually let me drive part of the way. When we got to Georgia, however, things didn't end up going so good. We had gotten out of the car to switch drivers, and as I was stepping into the passenger seat, my brother said something stupid to me (I don't remember what) and I told him to shut up. He got so angry that he stepped on the gas and left me stranded in Georgia.

Fortunately, two girls took me in and took care of me for awhile. They were really nice, but pretty messed up. One had a child and did not know who the father was, and the other had two boy friends that would beat her up, and both girls were prostitutes. Eventually, I told one of the girls that I needed to go home so she bought me a ticket so that I could leave. I haven't seen or heard from her since, but I think about her sometimes. I know what you're thinking, but no, I never prostituted myself. But that doesn't mean that I haven't had sex with someone so I would have a place to sleep, or so I could change my clothes. But I've never been paid for sex.

My parents don't talk to me anymore. In fact, I hardly ever see them because I'm usually in bed by the time they get home from doing drugs downtown. When they are home, I try to stay away from them by going to my boyfriend's house or sitting in the bathroom. My favorite place in the house is in the bathroom because it's the only place I can find any peace and quiet. My house is filthy, with stuff piled everywhere and three loads of dishes in the sink. My daily schedule usually consists of coming home from school (that is, when I go to school), doing my homework, and cleaning up the house. Then when my little brother comes home I feed him and give him his insulin shot because he's diabetic. After that I usually talk on the phone and then go to bed.

My mom always yells at me for not cleaning up, so the other day I spent two hours working on the house, trying to clean it. I did it just so my mom wouldn't complain when she came home, but it didn't matter. That night, when my mom got home she said, "So, you don't clean up anymore?" That made me really angry and frustrated. She didn't appreciate what I had done at all! She's more worried about her drugs than she is about me.

Getting Stoned. Drugs are a big part of my life. I know I shouldn't do drugs, but getting stoned makes me happy and I can't seem to find happiness anywhere else. I know I need to find a way to achieve happiness naturally, but for right now until I get emancipated or turn 18, drugs will be what gets me through. I'm not like other druggies like my parents. I don't buy drugs, I

don't sell drugs, and I don't go out looking for drugs. But if I'm offered drugs, I'll take them.

Although most of my family does drugs, I don't really worry about my little brother taking them. He walked in on me in my bedroom once while I was doing drugs, so I offered him some just to see what he would say and he turned them down. He said he already has enough problems with his diabetes, going to the hospital for blood tests, etc., that he doesn't want to mess his body up any more than it already is. Besides stuff I get from my friends, I take prescribed medications too for my depression, but it doesn't really help.

Missing School. It's hard to believe, but if you add up the total amount of time that I've been in drug rehab and juvenile detention, with six months here and three months there, it amounts to a total of five years! I've had to go to juvenile detention for stuff like drugs, running away, and domestic violence for hitting my mom. But you know, whenever I've hit my mom, it's been because she hit me first. The sorry part of it is that I've had to take domestic violence classes, but my mom never has. She's never even been charged for hitting me.

Of course, this also means that I've missed that much school each time I go to one of these places, but I miss school for a lot of other reasons too. For example, I had a court hearing the other day for a car theft charge, but it ended up not being a big deal. See, me and a friend were walking down a street in downtown when we saw a car door left open. Just joking, we pushed it closed and a man started yelling at us to get away from his car. He ran to his car and started ransacking it, looking for something. He began shouting that we stole his checkbook and so we got arrested. Later, the man said he found his checkbook, but I still had to go to court.

Another time I didn't come to school for four days because I went to Chicago to be on *The Jenny Jones Show.* They were giving makeovers to girls who have big boobs. I flew there with my mom and my boyfriend, but the whole thing was a joke. They dressed me up to look slutty with a tiny mini skirt and a low-cut halter top. I had a really hard time memorizing my lines. They told me to shake my boobs in front of the camera and tell everyone they were just jealous of what I had because mine were real. They made me look stupid. Then they dressed us up in clothes that no one would want to wear and asked us how we liked our new looks, which of course, no one did. I think I would rather go on the *Maury Povich* show, something more serious. If I had the opportunity to give some advice while I was on T.V., the one thing I would say is to stop worrying, because worrying doesn't change anything.

Can't Really Help Me. I try to live by my own advice. Instead of worrying about my life, I try to spend my breaks from school having fun and getting stoned, like over the Thanksgiving break. Me and my mom fought and had shitty attitudes that whole weekend, but I got to see my little sister. She stayed with us all weekend long. Man, I had a great time! We danced and colored and did each other's makeup. I dyed my hair a deep purple and it looked pretty cool. I drank two pints of tequila. I fell asleep, threw it up, and then drank some more. It may not sound like fun to you, but it got me through. I need to do stuff like that since things at home are so terrible, and there are no signs of it getting any better. It all started so long ago that I don't think there is anything anyone can do now to make it right.

I started to go to counseling when I was seven years old because of some major shit I had gone through. It was about that time when I found out that the woman who was raising me was not my mother, but actually my aunt. My mom had been incompetent to raise me so my aunt had assumed the role and title as my mother, but nobody told me she was my aunt. They wanted me to get to know my mom, so regular visitations were set up. After the visitations with my mom began, I started having flashbacks of when I was a tiny kid, remembering what my dad had done to me. He sexually abused me when I was just a toddler.

I saw my dad for the first time in a long time when he came over Christmas Eve this year. It was great seeing him, but we don't get along. He is really sick. You can tell by looking in his face that he ain't right. He's really messed up. I got a picture taken with him though, and I have it on my desk. My mom had also been a victim of sexual abuse herself. That's why I think she probably does drugs—to escape. I can kind of understand it, but since she's so caught up in her own problems, she can't really help me, and neither can anyone else.

I know that I'm going to have to rely on myself to get out of this mess and turn my life around. I think it will all start getting better when I'm finally able to get a job, but 15 is a hard age to be because no one will hire you. If I had a job, then when I turn 16 I could become emancipated from my parents, get out of the house and marry my boyfriend. Once, I had planned to go to Columbus to try out for a modeling agency. All my friends have told me I should. I've been told I look like Madonna, Drew Barrymore, and Angelina Jolie. I made plans to do that, but I didn't get to go because my stepdad had the car. I probably should just get the camera and take some pictures outside to send to them, but I have to admit that I haven't tried very hard to make this happen. I guess I should try harder.

Of course, coming from this school doesn't help when you're trying to find a job. The other day, we had an assignment to call an employment

service and ask how we could go about looking for a job. While I was on the phone, Jake, a student in my class, was brought into the room I was in because he was having a hard day. He started screaming and cussing at our teacher. Although I tried to keep my cool while I was on the phone, when I hung up I was so mad at Jake that I threw my pen at him and told him to shut up because I was trying to get a fucking job! Jake exploded and came over to me shouting, "You want to cut me, go ahead and cut me. Use your pen and cut me with it!" A police officer and my teacher had to grab a hold of him and Jake was taken to the office. It's stuff like that which makes getting a job difficult. After the phone call I made from school, I actually had an interview with the employment agency. They got me an interview with Burger King, but they told me they don't hire until 16. I guess I'll have to wait.

The Importance of Relationships

Most of My Friends Are Boys. My teachers complain that I say inappropriate things and flirt too much with boys, and I guess I do flirt some. Take Mark, for example. We hated each other last year. If you had asked Mark at the time he probably would have said that I was a real bitch. But now we joke and laugh together, and we sometimes punch around on each other. We joke around a lot and Mark makes me laugh. When I get a little out of hand in class, Mark will say stuff like, "I'm just going to have to come back there and whip your butt myself." He makes me laugh. Don't get me wrong, Mark's great, but it's not like I'm gonna cheat on my old man or anything. I'm not gonna do nothing—it's just Mark.

Sometimes the joking and flirting can get to be too much, though, and some boys will cross the line. Well, not in my class but sometimes in other classes. It can get pretty bad out there. Especially at lunch. But you gotta expect it—it happens everywhere, even at my old school. I just tell them to get their hands off me. If they act like they want something from me, I tell them stuff like "I don't want nothing you got up in there," or "All I want to give you is a split lip."

Most of my friends are boys and I guess I would consider most of the people in my class as friends, or at least they were. There are only four girls at this school and something like 50 guys, so the chance of me making friends with girls here is slim, but that's fine with me anyway. I don't see Mandy much because she is upstairs and is so much younger than me. Isis is probably the only cool girl here. She's a little more immature than some other girls because she doesn't seem to get into boys and the whole dating thing, but I like Isis because she tells it like it is. Man, you know where you

stand with her. We don't fight, and I've never had any problem with her. She does bug me sometimes because she thinks she has to tell everyone when she thinks they're wrong, but overall, she's okay.

There was this one girl I really couldn't stand here and that's Amber. Amber and I were in jail together and when we got out, Amber told people that I tried to sleep with her. Of course, it's not true. She and I were in different cells and had different recreation times, so it was impossible for us to have even ever been together, but whenever I see Amber she harasses me about it. For example, we saw each other at the mall last year and Amber started going on and on about the whole thing. My mom told me to just walk away, but I ended up punching Amber in the jaw. I left the mall right after that because I didn't want to get thrown out. I like to go there and I wanted to be able to go back. You don't have to talk to Amber to not like her because her actions show her feelings. If you ever had a chance to meet her you would see for yourself.

Aside from my friends here at school, my favorite person to hang out with is my boyfriend. He's the only thing that really makes any sense to me. His name is Joshua and he's 24 years old. He has 10 body piercings and three tattoos. His hair is long and usually colored a bright color, just like mine. Dying our hair is something we like to do together. I've had purple hair before, and now it's a bright pink. I think I will try blue next. My boyfriend has a deep turquoise color right now. I have to be honest that there have been times when I've wondered why a 24-year-old guy would date a 15-year-old girl, but I just push those thoughts out of my mind because they lead to thoughts of breaking up. Whenever I want to talk to him about it, Joshua usually cuts me off because he wants to avoid talking about breaking up. But I don't like to get cut off. I want to have my say.

Overall though, we have a great time together and I really love Joshua. He is the best thing that ever happened to me. We hang out at Josh's house a lot because I can't stand to be home. Joshua's mom, Angel, is with this guy we call Woody. He's a drunk. He goes through three bottles of vodka every day, and he is dying. He only breathes out of 13 percent of his lungs. He is really mean to Angel. I hate drunk people, I swear!!!

My best friend is Tom who is 34 and is a very nice man who is a very plain and mellow kind of guy. Tom has had a tough life too, and when he was my age he went through a lot of the same things I'm going through now. We talk about everything and Tom is a great listener. My boyfriend, Joshua, doesn't like the fact that I hang out with another guy, but I told him that if he doesn't like it he knows where the door is.

Bragging to all the Fans. Tom takes me to concerts and stuff and we have a lot of fun together. In the fall, he took me for the second time to see Peter Criss, Gene Simmons, Paul Stanley and Ace Frehley, better known as the band Kiss. They were formally known as one of the big hair bands from the 70s. My friend Tom and I were walking to the Nutter Center to watch Ted Nugent's great performance when I saw a huge bus pull up along side of us. All of a sudden Paul and Ace Frehley jumped out and threw out a pair of drumsticks into the screaming crowd. There was so much emotion shown to the band. I ended up in the fourth row, where I was so close that I could touch Gene. Paul started flying around the crowd touching people. He stopped to land on a separate stage, where I happened to be standing close to. I jumped up on the stairs where Paul stood two feet in front of me. I reached out my hand and started to cry. I turned around to get my friend's attention and before I could turn back around I was arm locked with Paul. I was so shocked that I began to cry again!

At the end of the night I was still bragging to all the fans how I got to touch Paul Stanley, not that they didn't see it but I was happy! Well, Tom and I were on our way out when some guy who worked there said, "Someone wants to see you." So we followed him and ended up with backstage passes. We had 10 minutes before they were going to leave so Tom and I took off running in total shock. We made it backstage where we seen Paul, Ace, Peter, and Gene. They all told me I was a cool chick and that if it wasn't for girls like me their show would suck. They hugged me and left with huge smiles on their faces. That night was something else. It went by so fast it all felt like one big dream, but I do know one thing, that it is a night I'll never forget!

The Same No Matter Where I Went. I really try to savor nights like that because most of the time my life is a fucking nightmare. Like last week, for example. My teacher found a joint I had hidden in my necklace. The school called my probation officer and I'm not quite sure what's going to happen as a result. I don't come to school very often because of this same fucking shit that happens every time I come here. I wouldn't even come here at all if it weren't for Mark. He's the only reason I come, because he listens and will counsel me when I need it. He's a true friend, not like Jimmy and Jake. I thought they were my friends, but then all this terrible shit started to happen. I'm not sure how it all started, but this is the way I see it.

In class one day, Jimmy, being his obnoxious self, went behind our teacher's desk and teasingly messed Ms. Casper's hair up by rubbing her head. When I saw him do that, it really bugged me because girls don't like their hair messed up, so I told Jimmy that. Jimmy yelled back, saying "And

some women need to keep their damn noses in their own business." Jimmy lost a point for swearing, but it wasn't over yet.

After Yearbook, Jimmy returned to the room. I was talking to Ms. Hinkle, the teaching assistant, and Jimmy made some comment to me that I couldn't really hear, but it bugged me that he was listening in on my conversation with Ms. Hinkle. I told him, "Didn't you just tell me to keep my nose out of other people's business? Well, you need to do the same!" Jimmy became very upset and started threatening me. "I'm gonna fucking hit you! If you keep it up, I'm gonna fucking hit you! I'll knock your head off!" I have to admit that I was really scared and began to cry. Ms. Casper put Jimmy in a Level II. Right after that, Jake came in and sensed what was going on and simply said that he wasn't going to take this shit and said that he was going to put himself in a Level II also and left the room. Later in the day, another student asked Jake why he had been taken out of class this morning and Jake said, "Air's a bitch. She was running her mouth off, and I didn't want to take it."

After the boys left, I just couldn't settle down because I couldn't believe what was happening. After all, these guys were supposed to be my friends! I couldn't understand why they hated me all of a sudden. What I ever do to them? I couldn't imagine what I had done to piss them off so badly. And if they fucking hated me so much, then why wouldn't they just leave me alone? I just didn't know what I had ever done to make Jimmy so mad to call me a bitch and a slut? I sure wasn't a slut when he came down to my house that one night.

See, a while back, Jimmy, Jake, and I made plans to go out together one Friday night. We thought we'd probably all go somewhere and drop some acid or something. We couldn't talk about it in class because there were teachers in the room, but we managed to make our plans anyway. Jimmy and I had always gotten along great, but I probably talked with Jake more because we both have a lot in common. Jake thinks a lot about suicide like me, and we talk about it. His is more bloody and gory, though. I know that's probably not that great for us to talk about, but we do.

Anyway, Jake and Jimmy ended up coming over to my house with booze and drugs like Vicadin, Xanax, and weed. I knew they wanted to get me trashed so I would sleep with them. I told Jimmy that I wouldn't do that because I had a boyfriend and he was sitting in the other room. Jimmy kept saying that he would beat up my boyfriend, but I told him I didn't want him to fight over me and to get over it. My boyfriend's not afraid of Jimmy! But Jimmy just didn't want to give it up. Another night he and five other boys drove up in a car and invited me to go with them for sex, but I told them no, that I wasn't no butt slut. But I couldn't imagine that was the sole reason for

them being so mad at me. If they really hated me that much, why wouldn't they just leave me alone instead of being so hateful?

I know that I flirt and have even crossed the line myself on some occasions, but to tell you the truth, I don't know how else to behave—that's just me. I have no clue what I could do differently to not lead guys on because I can't think of any other way to be. It's just how I am—I flirt with guys. Why should I have to change anyway? I just wished Jake and Jimmy would leave me alone. My home life is depressing enough and I didn't want to be subjected to that same shit here at school. What was I supposed to do? Where was I supposed to go? Where could I be happy? It seemed like everyone here hated me! I figured I could either commit suicide, fucking leave this school and die, or get out of the class that Jake and Jimmy were in. Honestly, though, I didn't know where I could go where it would be any different. There are all boys here and it would be the same no matter where I went. It was all getting so bad, I knew I would probably end up in a Level II that day.

The school mental health workers and teachers decided we all needed to talk this thing out. I thought that I would probably be better off talking with Jake and Jimmy separately because when they are together they tend to feed off each other. I asked if Mark could be there too, because I knew he would stick up for me and then I wouldn't feel so ganged up on. But Mark had a doctor's appointment and had to leave school early and the teachers and mental health workers decided that we should all just meet together and hash this out. They said because I'm absent so much, they were afraid that this whole thing would fester and just get worse if they didn't do something that day. I have to admit I was worried about confronting Jake and Jimmy, and knew that I was the one who was going to get hurt. Jimmy knows that I am smaller and weaker than him. He's a very big guy, but that wouldn't stop him from hitting me. All I wanted to do was to ask them two questions. First, what did I do to make them hate me so much, and second, if they hate me, could they just leave me alone?

When we got into the classroom, the rest of the class had been taken to another room. In the classroom was Jeremy [the police officer], Bobby and Sharon from mental health, our teacher Ms. Casper, Jake, Jimmy, Missy [the researcher], and me. Well, Jake and Jimmy immediately became upset. Jimmy said that he didn't want to talk to me and Jake was angry because he had told everybody not to make a big deal out of this. He went into a tirade about how he can't trust no one at this school anymore and that since they betrayed his trust he would not talk with them again about anything. He even said that he wasn't coming back. Jimmy cussed the entire time and argued with Ms. Casper about how she treats him like a child and that he wanted to

be treated like an adult. Ms. Casper told him that when he acts like an adult she'll treat him like one. Jimmy was also upset because the mental health workers were involved. He said that his mom didn't sign permission for him to receive mental health services and that they couldn't make him do this. Sharon told him this wasn't therapy, but Jimmy refused to listen.

Since Jimmy never shut up, Sharon never got the rules for the discussion out on the table, and I never really got a chance to speak. Finally, I couldn't sit there any longer so I told them that this wasn't going to work because these guys were too immature. They couldn't even talk with adults without cussing! They made me so mad that I just couldn't take it any more and ran out of the room. When school was over, I left feeling afraid that they were going to try to beat me up. It hasn't happened yet, but I still don't feel safe. I haven't been to school much since that whole incident with Jimmy and Jake. I tell you, it's no better here than it is at home.

Even though a lot of time has passed since that day, Jake and Jimmy are still being jerks. At lunch today, I was eating with Mark, and Jake and Jimmy were over at another table. I heard Jake say something funny and I tried to joke with him from across the room, but Jake didn't take the joke. Well, he can just go fuck himself, and I told him so. I can't stand those guys.

What saved lunch, however, was when Jon, an old friend, walked in. He used to go here. I hadn't talked to him in a long time and I told him I wanted his phone number. Ms. Smith kept trying to get me to go back to class, but I told her, "You don't understand. He's my friend. I miss him." Jon said that he would get his number to me before the end of the day. When I asked him what he was doing at school, he said he had gotten caught for possession at his high school, so he was expelled. Since he was out of school, he had decided to come visit his old friends at this school. Clyde, another kid in our class, said he lives near Jon and that Jon's dad is crazy. So what? Everyone here has crazy parents.

Comparing Scars. Eventually, they moved me to Ms. Smith's class because they said that no matter what they did, things were not going to get better for anyone in Ms. Casper's room unless we were all separated. Jake and Jimmy don't want me near them and to tell you the truth I don't trust them. I still think they're gonna try something. I really don't want to be in this class, and I told them that I wasn't coming back to school until I got switched back to Ms. Casper's room, but I know it isn't going to happen.

The kids in Ms. Smith's class are okay. Isis is in the class, and I get along with her fine. Sometimes she helps me with my work. And I like Isaiah, too. In fact, I think Isaiah is a lot like me. The first day we were in class together we compared scars on our arms. I think his life is probably as

bad as mine. The other guys in the class are pretty cool too, although we all tend to lose it every now and then.

Teachers and Relationships

More Communication Here. I go to this school because I've had a lot of problems in my life. I've been in ED classes since I was real little, so I know a lot of the guys here from way back then. Overall, I like this school better than the other schools I have been in because there is a lot more communication here—more chances to talk with my friends and teachers. The cussing is a release—it doesn't really mean anything and the teachers know that. If you have to get out of here, like if you couldn't take it for some reason, you can go to another room and get it all out. You just have to tell someone. There aren't as many girls here either, and I don't get along very well with girls, so that's better here too. Also, I get a lot of attention here. Attention is good. I like attention and need it. Positive attention that is... There is a lot more physical contact too with your friends.

So Many Rules. Although I like this school, it was better here last year because there weren't so many rules, and some of the rules are unfair. Like, there's a new rule that students can't wear tank tops, but Mark wears one everyday. God forbid if a chick were to wear one—she'd be expelled! Also, they have started to be more strict about the points and Level System they use. See, if you don't follow the rules, you lose points and then you can't go to clubs on Fridays, which is a time to have a little freedom and some fun. In clubs, you get to watch movies, or cook, or make something, or play a game. If you mouth off or refuse to work, you have to go to Level II, which is like time-out in another classroom. If you can calm down and do your work, you can eventually come back to class, but if you can't then you have to go to a Level III. Level III is a real mind breaker! They make you go to this little room and stare straight ahead. You can't turn your head to the left or to the right, or they yell at you. You have to stay there as long as they want you to.

Last week I had to go to a Level II, and I had to go there again yesterday too. See, my friend, Mark had been put in jail yesterday and it was my fault. We had been smacking each other into the walls out in the hall before lunch, just messing around. Ms. Hinkle told us to stop, so we did, but Mark kept on walking down the hall. Ms. Hinkle told him to stop and to wait for the rest of the class, but he just kept walking. Ms. Hinkle then called down to the lunchroom over the walkie-talkie and asked the staff to have Mark sit at a table and wait until she got down there. When we got to the

lunchroom, Mark was sitting at a table quietly. His teacher kept ragging on him, making him get mad. They wanted to put him in a Level II, but he told them that if they would just let him sit there for two minutes, he would be all right. After Mark continued to refuse to get up, the policeman grabbed him by the arm. Trying to get the policeman off of him, Mark swung his arm back. The policeman claims that Mark hit him, and the teachers in the room verified it, but I was there and I swear he did not hit the policeman. They filed charges against him and he was put in jail. I feel real bad about that because it was my fault. If I hadn't been pushing on him in the hall this whole thing never would have happened.

I was really angry about what had happened with Mark, and I just couldn't handle staying at this school any longer that day. I told Ms. Casper that I was going to leave, that I couldn't take it in this school anymore, but she stood in the doorway and wouldn't let me leave. I tried to push past her but when I did she fell. She told me that she could file charges on me too and gave me two choices at that point. I could either go to Level II or go to jail. Some choice! I chose the Level II.

In class, the teachers give us such a hard time. We can't even talk at all or we lose points. The point sheets are supposed to motivate us, but like I told Ms. Fields, the teaching assistant in the classroom, the point sheets don't mean a thing to me. Once, I went over to talk with Isaiah, and I just knew Ms. Fields was going to say something. I gave her 10 seconds and sure enough, she said something and yes, I lost points. She is such a mean teacher she probably doesn't even like me. The point sheets are a way for her to show it. Since I am always losing points, I never earn clubs. Even when I do all my work, I still don't earn clubs because of my attendance. It's just shit! You have to go to the ineligible room when you don't earn clubs and do work, but if they think I'm going to do work in there, they're wrong!

Nothing Wrong With My Behavior. Sometimes I think the teachers make things worse with kids by riding them when they are already upset and having a bad day. They should just leave us alone when we are like that. The teachers here also always assume that we're up to something. They really don't trust us at all. For example, some teacher found a black pair of thong underwear in the girl's bathroom the other day. Ms. Smith assumed that they were mine because I had gone to the bathroom earlier that day, but I looked her straight in the eye and told her that I never wear underwear. As far as I know, no one has ever claimed them.

Sometimes the teachers give you dirty looks, like Ms. Smith. I asked her once why she gave me dirty looks all the time because I assumed she just didn't like me. Ms. Smith said that she is not giving dirty looks, but rather

"disapproving" looks. She said it's not that she doesn't like me, but that sometimes she disapproves of my behavior. Well, people shouldn't judge other people or be over other people because all people are equal as living, breathing beings. At the time Ms. Smith told me that, she was not my teacher and the only one I expect to disapprove of my behavior are my teachers. It isn't anyone else's business what I do. Anyway, there is nothing wrong with my behavior.

Now, you might find that a strange comment coming from me, since I go to a behavior school. I'll try to explain. No one's behavior is naturally bad—other people make it that way. Take me, for instance. I've been beaten up my entire life. Not just in the physical sense, but also with girls saying stuff—you know, that immature stuff that girls do. I guess when you're about 14, 13, 12, you begin to live a life. You realize that there's a whole lot more to life out there, and you've only lived a little piece of it. You begin to get a taste of it and decide that you are not going to let people put you down any more and keep you from living that life. Before, I just took it, being beaten down and all. But now I'm not.

He Could of Just Listened. Sometimes "not taking it" gets me into trouble, but I know it and I apologize when I go overboard. Like this one day I had a terrible morning, and I tried to apologize to Ms. Smith for the way I acted. I wrote in my journal that I was sorry I did not have a good morning, but this boy started calling me names and all I wanted to do was sit at my desk and do my work because I was getting behind again and I didn't want to get behind. I told her I was sorry that I couldn't sit there and tell her I was sorry 300 times, but I said it one more time anyway! I was doing this packet of papers and writing as fast as I possibly could so I could go to my new elective. In my journal, I asked Ms. Smith if maybe one day a week me and her could talk to try to have a better understanding, especially with each other. I think talking things out is really important. I just wish Ms. Smith would listen more than she talks.

I really hate schoolwork because I don't know how to do any of it. Lots of times, I can't even think straight when I'm trying to do my work. It's hard to stay focused all day long on these worksheets, so sometimes I just have to take a break, but when I do I usually get into trouble. Like one time when I was walking around for a few minutes to stretch, I was just kidding and grabbed a potato chip out of Arty's hand and ate it. Ms. Fields told me I couldn't do that because I had not "earned" it, but that Arty had. I don't care. I do a lot of things I'm not supposed to do.

The more I think about it, there really isn't anything calm about this school. The only thing calm is Ms. Hinkle and one other teacher. Ms. Fields

is cool, but Ms. Smith is mean, Bobby always tells on everyone and makes them lose their points, and this one teacher smiles way too much. Now our principal, Ms. Oneida, that's another story. I really hate her. Well, I take that back. I guess I can't really say that I hate her. For a woman she actually says some pretty bizarre things, and that's pretty funny. But she can also say some very hurtful things, things that get right into your stomach, twist it, and tear it out. It feels so bad that I'll do what she tells me to do in order to avoid having her say such hurtful things. For example, she makes comments about my hygiene. I shower three times a day—in the morning, when I get home in the afternoon, and at night. I'm a clean person and I hate that she thinks I'm dirty. She says things that really make you feel bad.

Also, you can't really tell anyone anything here, which is frustrating. The teachers and mental health workers want kids to talk to them but as soon as we open up they go and tell someone and it just makes it all worse. It messes everything up. It makes us not want to talk with anyone anymore. I know I have a bad home life! I don't need teachers to tell me about it! Let me give you an example.

Earlier in the school year, I asked Bobby Clinton, an activity therapist, if I could talk with him about something, and he agreed. I really didn't know him very well at all, but because he's a guy, and I seen him talk with other kids I thought he would be good to talk to. He has a really great laugh too, and ... he's a guy! I know I could have talked to Ms. Hinkle, she's cool. But she's a woman. I just can't talk with women. Anyway, I told him about my parents doing rock, and he turned around and reported it to Children's Services, and then they came out to the house. All I had wanted to do was to talk with someone about it, but I didn't want anyone to do anything! If teachers report everything that kids tell them, then students are going to stop sharing things with them. Normally, I wouldn't have bothered talking with someone because my parents have been doing rock or crack for years, but sometimes things just get extra bad. I guess I saw some stuff I shouldn't have seen, and I just needed to talk with someone about it. Instead of reporting it, he could of just listened. I mean, if I was talking suicide or something, I could understand it, but not something like that.

A Personality Conflict. Although I have my ups and downs in school, it seems like this year I have most of my problems on the school bus. I guess you could say that the bus driver and I have a personality conflict. She is always writing me up for stuff like smoking, cussing, or walking between the buses. After I got caught smoking the first time, though, I stopped smoking on the bus because I'm on probation and I don't want to get caught, but she won't believe me. She actually sent a videotape of one of our bus rides to my principal, trying to prove how bad I was. But after several people viewed the

tape, they really couldn't see me doing nothing either, at least not until the bus driver made me mad. I was quiet the whole time on the bus, sitting in my assigned seat near the front all by myself, not saying a word to nobody.

When we pulled up to the school, I wanted to fix my hair, so I asked the bus driver if I could use her mirror. The bus driver said, "Air, I don't want you near me." When I asked her why, she didn't answer. Man! What did I do? When we got the okay to get off the bus, the bus driver told me that she wanted me to stay on. I said, "Why? I didn't do nothing!" The bus driver told me that she has to be able to see my head at all times because I'm not trustworthy. I told her that I had done nothing to make her not trust me. I said to her "I've brought two cigarettes on this bus this entire school year. And they didn't get torn apart or shredded or nothing. I sit in my seat and I don't say anything. You yell at me for walking between the buses. You don't yell at someone for that! I didn't even know that was a rule! You could of just told me that was a rule, you didn't need to yell at me for it!" The bus driver told me that nobody can talk to me because I don't listen. She said her supervisor told her to give me one more chance before kicking me off the bus. I kept telling her that I hadn't done nothing, but she just kept saying that she couldn't trust me. Finally, I just told her this was all fucking bullshit and she could kiss my fucking ass. She treated another girl the same way last year. She makes me feel real bad.

They Don't Understand What We Need. As you can tell, being a student in school has not been easy for me. Aside from teachers, bus drivers, and other students giving me a hard time, I haven't been very successful in school. I've actually been retained four or five times. Let's see, I repeated first grade, failed fifth grade, but took summer school to pass. Then I failed sixth grade and ninth grade too, but I think they still promoted me one of those times. I was young when I started school, and I'm considered a freshman even though I am 15, turning 16 this school year.

Even though this school is better than the regular public schools I've gone to, I still hate this fucking school. Although the teachers try hard, they don't seem to understand what we need. Like when my journals were stolen, they just didn't understand how important they were to me. Those journals were more important to me than my own mom! I just knew they wouldn't keep my most prized possession safe. I should have known something like that would happen here.

I also hate the schoolwork they give us. I hate fricking math, and it seems like that's all we ever do! I really hate all the worksheets they give us. I don't even understand them half of the time and Ms. Smith won't let us use

a calculator on the math. But just when I'm about to give up, when I decide that I'm not doing this shit, something happens to make things a little better.

I remember when I missed the week of the state proficiency tests. The following week, they made me do both the reading and math portions of the test even though you are only supposed to do one section each day. I guess they figured to get me while they could since I'm not here that often. But I don't know what difference it made. I didn't even finish the math because I don't know my times tables, percents, division, or any math for that matter. How could I even try if I don't know any of that stuff! Thank God Ms. Smith exempted me from some of the classwork that day since I had been in proficiencies all morning. I didn't think I could of handled any more of it! Also, Ms. Smith has offered to help me learn how to do math. She said that she will teach me how to do division by the time I'm 16. She actually gave me a multiplication chart so that I could do my work on my own. I asked her if I could keep it taped to my desk and she said yes.

What's the Point? I've always missed a lot of school my whole life, but after all that shit with Jake and Jimmy, I've barely come to school at all. Well, I actually did start coming to school more in November because of a meeting I had with my probation officer. She told me that she was going to file truancy charges against me since I had 17 unexcused absences at that point. She also told me that I had jail time "on the shelf," which means that I have been sentenced to 30 days jail, but that it is temporarily shelved or suspended as long as I come to school. If I miss many more days, though, I'll have to serve that time. I'm not looking for trouble and I don't need any more trouble with my probation officer. I got kinda scared, but I only did it to myself. Ms. Smith was right. I was on probation and if I slipped and fell one more time it would be my ass. Life sucks! I didn't even want to come to school, but I did, giving it a shot for a week or two, but it didn't last long. All I wanted to do was go home!

In December, both of my parents got arrested for possession of drugs, theft, and other warrants and sentenced to jail for six months. Well, you could forget about me going home during that time. I stayed with Josh instead. They ended up not having to do all of their time, and they both got out the same day and now they are doing so much better. I don't know if they quit smoking rock or not but I know they are home more often and my stepdad works two jobs. I haven't been in school much since then, though. What's the point? Even though things can be okay here at times, I think I would rather stay home and get sent to jail for not coming to school instead of staying here. Most of the time, Ms. Smith can be a real bitch! You know, I come here by my own choice. But when I come, it's terrible, so why should I

come back? I've often wondered why it is that when girls drop out of school, everyone assumes that they are pregnant. Yet, if a boy drops out, it's no big deal and nobody thinks nothing about it.

Even with all this shit, my wonderful life is getting better. My birthday is coming up, and when I turn 16, me and Joshua are getting married either in March on my birthday or sometime in April. I'm just worried that we're gonna get married and Joshua's gonna go to jail because I'm only 16. My mom don't care, but Ms. Smith said that I'd have to go to court and everything and that made me really angry. It's none of her business anyway. She don't understand what I've been through. I mean, I've been through some stuff she just wouldn't believe! Joshua's been putting money away to save so we can have something decent, an apartment. I'll probably drop out of school, at least for the first couple of months. Besides, my mom did it, my aunt did it. It runs in the family! And they're still married! Well, my mom and dad aren't.

So anyway, I'm trying not to talk about it in school 'cause Ms. Smith is always saying stuff and trying to talk me out of it. But it's coming up in a couple of weeks. I already have a dress and a ring. But we're moving out first. We're getting out this weekend and moving into an apartment on the other side of town. I get more love and support from the man I'm going to marry than I'll ever get from mommy or daddy. You know, I find it sad when people around you can't see your true pain. Well, he did. Joshua seen how my parents talked to me and how my stepdad is a crack head, literally, and how my mom is mentally abusive and disturbing to my heart. Joshua widened my lifespan by being there for listening. I can't wait til we're married. Finally, I will be happy.

There's Substance in the Air

"... for it might end, you know," said Alice to herself, "in my going out altogether, like a candle. I wonder what I should be like then?"

Lewis Carroll
Alice's Adventures in Wonderland

The Victim Syndrome

As I reread Air's stories, I am struck by the way that Air defined herself primarily as a victim. Without inhibition, Air shared with her teachers, her mental health workers, her probation officer, her peers and with me, countless experiences of abuse. While it is indisputable that Air certainly had been a victim of abuse, what is of concern is that she continued to see herself as a victim, not a survivor. In actuality, the possibility existed that some of the horrific tales Air relayed may have been embellished or even untrue.

Whether the stories were true or not, however, is not important in understanding her personal sense of identity. What is of significance is that Air wanted those surrounding her to see her as a victim. Perhaps by continually playing the role of victim, Air was able to remain blameless for her life choices. As a victim, Air could fault others for the injustices she had experienced, accepting little responsibility for her actions. *"No one's behavior is naturally bad—other people make it that way."* Yet, many of the life choices Air made because of her experiences contributed to her further victimization, concretizing her prophesy that being a victim was her designated lot in life, with little or no chance for redemption.

One exception to this theory of Air as *victim* was in the guilt Air harbored for some of the events in her life, both at home and at school. Although she only spoke about feeling guilty on a few occasions, the subject came up enough times to warrant consideration as we try to better understand who Air is wanting to portray herself to be. In the following section, the interaction between guilt, perpetrator versus victim, avoidance, school competence, sexuality, and secrets will be explored as a means for defining Air.

Living with Guilt

While Air may have relinquished responsibility for some of her behavior because she had been victimized by others, she did take on responsibility for events that may not actually have been her fault. She shared with us how she blamed herself for the fire that destroyed her home and her family's belongings because she may have left a candle burning. Yet, she did not seem to blame her parents for being in jail in the first place, her neighbor for not allowing her to see from where the smell of smoke was coming, nor even her ex-boyfriend, who she suspected actually set the fire.

Another episode in which Air took the blame for what occurred is when her good friend Mark was arrested for assaulting a police officer. "*I feel real badly about that because it was my fault. If I hadn't been pushing on him in the hall this whole thing never would have happened.*" Even though I reminded Air that if Mark had stopped when Ms. Hinkle had told him to, the whole event might have been avoided, she continued to feel badly about the part she played in the incident.

Contradictions: Perpetrator Versus Victim

While some of Air's victimization had been thoroughly documented, there appeared to be some contradictions within many of her stories of continued abuse. Take for example, her interpersonal relationships with peers. Most of the interpersonal conflicts Air had with peers in the ED environment stemmed from the fact that the peers claimed to have been the victims, accusing Air of making unwanted sexual advances toward them. By Air's own account, Amber complained that Air had tried to have sex with her while they were in jail. When Air denied it, however, she did so based on the fact that it would have been logistically impossible since the two girls were not ever in the same cell. Never during our conversations did Air mention to me the improbability of her wanting to have sex with Amber.

While as a single incident this may seem insignificant, in fact a similar scenario occurred with Jake and Jimmy as well. Various times throughout the study, I recorded their disgust for Air and her sexual harassment. In this instance, they addressed their dislike for Air directly to me when Air was not present.

> Jimmy: *Hey, will you make Air leave us alone? She's bugging us.*
> MJ: *How is she bugging you?*
> Jimmy: *She won't leave us alone.*
> Jake: *We think she's doing it because she wants Jimmy as a boyfriend.*

MJ:	*Air has a boyfriend.*
Jimmy:	*Yeah, that don't mean anything.*
MJ:	*It does to her.*
Jimmy/Jake:	*Yeah, right! (laughter)*

That same day, Jimmy said to me "Keep her over there. I'll pay you if you keep her over there." On another day, I recorded a conversation between Air and Jake that also hinted that possibly Air had been the one making sexual advances. Initially, the students were talking with Bobby Clinton, the activity therapist. As part of a conversation about wrestling, Bobby said to Jake, "I'd love to get my arms around you." The following dialogue ensued.

Air:	*Don't say that to Jake. He's a fag.*
Ms. Hinkle:	*Hey, that's not appropriate talk.*
Air:	*Okay. Don't say that to Jake. He's gay.*
Ms. Hinkle:	*Air, that's not appropriate.*
Air:	*Okay, let's just say he likes boys.*
Jake:	*You're just mad because I won't give you some.*

This conversation suggests that Air may have been the one lashing out at Jake because he had turned her down for sex, instead of the other way around as I had originally suspected. Another example exemplifies this point further still. During a period of Air's absence, I became worried about her because the last time I had seen her she had been very depressed. At lunch, I went up to Mark, Jimmy, and Jake, who at the time were all still her friends, and asked them if they had heard anything from Air. They immediately began to chime in chorus, *"She's a crack head." "She just wants to get into all of our pants." "She's fine. She just wants to screw everyone."* I reminded them to be kind because Air liked them all as friends and they responded with more laughter and comments about Air's *slutty* behavior. As you may recall from Air's Personal Life Presentation, she considered Mark to be one of her closest friends.

During the time when Jimmy and Jake had become extremely angry with Air, I found out that they had each confided in a mental health worker on two separate occasions that Air had been sexually harassing them. They both relayed stories of how Air had flashed her breasts at them, and had also grabbed their crotches. Jimmy had said, *"How do you think that makes me feel, a little girl grabbing a man's crotch?"* At the time, Jimmy was 18 years old and considered himself a man.

Mark had admitted to Air that Jimmy and Jake had often invented stories about her in an attempt to get her in trouble so she would be removed from class. While the stories of sexual harassment by Air may have also been a fabrication by these students, one must ask why the boys would want to get

her out of their class in the first place. Early in the school year, I had observed Air, Jake, and Jimmy talking together, making plans to spend time with each other over the weekend, but something had definitely changed in their relationship through the course of the fall, and it did not appear to be anything that had happened during school.

The fact that there were so many documented incidents across students that Air had sexually harassed others makes it difficult to discredit their stories. During the peer mediation set up by the mental health staff between Air, Jake, and Jimmy, both boys kept saying that they wanted Air out of their classroom or wanted to be moved to another class themselves. After Air had run out of the room, Jimmy reiterated that he was tired of Air touching him, stating that he wanted no part of her, and that he already had a girlfriend and wanted nothing to do with her. *"I just wish she would keep her hands to herself and leave me alone."* Jimmy also said that he would never talk with Air about it. He said that this was not a school matter and that he was going to *"get her"* sometime when they were not in school.

The boys' frustration with Air continued for quite some time. On another day during lunch, I overheard Jake say, *"I hate that bitch. I mean, I really hate her right now."* Jimmy responded, *"I'll leave her alone, but if she touches me I'll lose it."* As with any form of sexual harassment, the boys felt disempowered and even embarrassed by the incident. As one can see, Air's rendition of the story was very different from that of the boys.

In addition to the stories of victimization Air shared about her peers, she also frequently shared other abusive incidents as well. During one class discussion on racism, Air openly relayed this story to the class, explaining why she did not like African Americans.

> *"I have hung out with lots of black people! I was in jail in Jacksonville, Florida and they hit me and spit on me and treated me like dirt... My home life sucks and as a kid I ran away from home. Here I was, just a little kid, and a car full of black guys picked me up and raped me and then left me in this abandoned house. Because of that I don't like black people."* She began to cry.

In a matter of 30 seconds, Air threw out two different stories of abuse, one while in jail and one about being raped, openly sharing them with the entire class. Regardless of whether any of Air's stories were true or not, she certainly identified with being a victim and wanted others to perceive her in the same light.

Using Sexuality

Air conceded that she did flirt. *"I know that I flirt and have even crossed the line myself on some occasion,"* but she was left feeling hurt and confused because she claimed that being a flirt was the only way she knew how to act. It appeared that sex for Air seemed to be a way for her to get her needs met, both her emotional needs for happiness and her physical needs for shelter and clothes. As I witnessed Air's relationship with Mark, I saw evidence that this was possibly true. In school, Mark was Air's closest friend. When Air was in attendance, she and Mark often sat close to one another, sharing secrets about their lives. While Air was adamant that she was *"not gonna do nothing"* and cheat on her *"old man"* with Mark, I often observed Air with her legs laying over the top of Mark's during lunch, sitting very close and having a lot of physical contact. Whether she and Mark ever consummated their relationship, I do not know, but I am fairly certain that Mark believed there was a chance that could happen. While Air admitted that she did lead boys on, she also admitted that she did not know how to change. *"[T]o tell you the truth, I don't know how else to behave—that's just me... It's just how I am—I flirt with guys."* She cried out for attention and love, and her sexuality had proven to be an asset in her struggle to survive.

Making Justifications

Although Air admittedly took drugs for recreation and had sex with numerous partners, she recognized how people who partake in these activities are viewed. To lessen the impact such actions had on how she was perceived, Air justified her life choices, putting herself on a different plane than others who have sex and take drugs.

> *"I don't buy drugs, I don't sell drugs, and I don't go out looking for drugs. But if I'm offered drugs, I'll take them."*

> *"I've never prostituted myself. That doesn't mean that I haven't had sex with someone so I would have a place to sleep, or so I could change my clothes. But I have never been paid for sex."*

By not overtly seeking out drugs, or not having received monetary compensation for sex, Air believed she would not be categorized as a typical "druggy" or a prostitute. She drew lines for her engagement in these activities and refused to be labeled as a person of a lower social status as a result of her sexuality or drug use.

Avoiding Pain: Running Away

When Air talked about happiness, she did so describing it as an elusive entity, something she just could not grasp. Yet, even as Air did appear to suffer from severe depression, she often feigned happiness when she talked about her relationships with others. For Air, friendships were her lifeline, providing her with opportunities to temporarily forget the pain that coursed through her body. When sex and fun with friends was not enough to diminish the pain, Air either tried to escape it through drug use and self-mutilation or thoughts of suicide. As Air described, drugs dulled the pain and provided her with an artificial high. Similarly, self-mutilation was a way for Air to focus the pain in one place and to have total control over her pain, unlike the pain that was inflicted on her by her parents. She told me once that when she bled from the cuts she inflicted, it felt like there was a sense of freedom and peace as her body was cleansed of the evil she believed was harbored within. As a result, her left arm had multiple scars from self-inflicted cuts and burns. There was a prominent scar resembling a centipede near her wrist, which was a reminder of how she reacted during a fight with her mom right before school started, a cut so deep that it necessitated several metal staples to keep it closed.

Contemplating suicide was another way Air envisioned escaping the realities of her life, and the self-mutilation may have been successive approximations of this desired end. These tactics, sex, drugs, self-mutilation and suicidal ideations, were all ways for Air to run away from her problems. While she used to escape by literally leaving her home and running away, she now resorted to more figurative forms of avoidance. Even her marriage was an effort to escape discomfort, both at home and at school.

Aside from negative peer relationships, Air tried to avoid her schoolwork as well. One of the ways she did this was simply by not attending school. She averaged only two days per week of attendance over the course of six months. Air had countless truancy charges filed against her and had even spent time in detention due to her extensive absences. Although various schools along the way had tried to address her absenteeism through retention and summer school, they apparently did not address the issues that caused Air to be absent in the first place. School had not effectively provided Air with a safe and nurturing place in which she could thrive and maintain positive relationships with others.

School Competence

As mentioned earlier, Air's responses to oppression actually contributed to further oppression. In relation to her school performance, there appeared to be a snowball effect occurring, because the more school Air missed, the more academic skills she lacked, leaving her to perceive herself as an incompetent member within the school culture. As a result, she tried to avoid schoolwork as well as the entire school environment. The following are several excerpts from classroom observations that illustrate this point.

> Air: *Isis, come help me.*
> Isis: *Come help you? Why?*
> Air: *Because I don't understand this.*

Air gets easily frustrated when she doesn't understand the directions to an assignment and often begs for assistance from either her teacher or peers, particularly Mark.

"Mark, come do my work for me?"

"Ms. Casper, how do you do this?"

Each time Air became frustrated with her work, she would hold her head in her hands and moan that she was getting a headache.

Air asked Isis for help on a worksheet. Isis stopped by her desk to show her where to find the information. After a few minutes, Air asked if she could go to the office because her stomach hurt.

"I don't understand this."

Everyone else in the room was working well. Air complained several times, "My ovaries hurt."...Putting down her pencil, Air moaned, "Oh, my ovaries hurt. I've been having a lot of problems with my ovaries." She laid her head on her desk and continued to moan.

"Ms. Smith, you need to help me. What is wrong with my paper?"

"Ms. Smith, help me please."

> *As Air sat back down to complete her work, she discovered that she had some additional questions to complete on the back page of one worksheet. "Shit." Ms. Smith asked, "Air, what did you say?"*
> Air: *I said shit.*
> Ms. Smith: *Air, you need to use another word.*
> Air: *You don't understand. I've been working all freaking morning.*

When she finished her geography, Air turned the page and saw that the next assignment was math. She started working on it, reading the questions aloud again, but becoming increasingly agitated. "I hate math. I don't understand this." Air got up to get a pencil off of Ms. Fields's desk.

"I hate this fu... fricking math."

Breaking the silence in the room, Air announced that she was taking a break. "I've been working all morning. I only have three more to do." After a few minutes, Air seemed to provide herself with some self redirection "I need to get my fricking work done so I can get started on all my make-up work." However, she continued on her "break." She again announced, "I've been working all damn morning... Can I go to the restroom?"

These examples occurred over an extended period of time in a variety of academic subjects. As one can note through these excerpts, because relationships were so important to her, Air used a lot of attention-getting behaviors to avoid working, getting others to provide her with assistance. However, when left to her own devices, Air usually simply procrastinated by carrying on conversations with her teachers or peers or leaving to use the restroom or to get a drink. It often took Air all day to finish a packet of papers that most students finished before lunch. Yet, when given assistance, Air was able to learn the material. With just a little direct instruction from her teacher, Air was beginning to master multiplication and division calculations. It was not that Air did not have the ability to do her academic work, but rather that she had simply missed the initial instruction and opportunities to practice needed in order for her to master many academic skills.

Sick Like Me

Air seemed to gravitate toward people who were like herself. She considered Jake her friend because they swapped stories of how they envisioned committing suicide. When she switched classes, she immediately related to Isaiah when she saw that he, like her, self-mutilated on his left arm. She told me that she figured he had gone through a lot of the same "*shit*" she had gone through. Air also told us about Tom, a good friend of hers who, as she explained, *"When he was my age he went through a lot of the same things I'm going through now."* The best I could tell, Air came to school periodically, simply to see her friends. *"I wouldn't even come here at all if it weren't for Mark. He's the only reason I come, because he listens and will counsel me when I need it."* Air craved attention and needed to have

someone willing to listen to her. Perhaps that is why she was always so willing to talk with me.

Secrets

Yet, even though her need for attention was being met through our conversations, prompting her to openly share her life story, Air remained reluctant to divulge some important events in her life. During one of our conversations, when Air was explaining why she chose to confide in Bobby Clinton about her parents doing "rock," she explained, *"Because sometimes it just gets bad. I guess I saw some stuff I shouldn't have seen, and I just needed to talk with someone."* At that moment, Air made a conscious decision to keep something from me about her life. Why this bit of information was sacred while other private stories were not remains a mystery to me. Rumors were whispered throughout the school about what that traumatic event might have been, and if those rumors were true, then perhaps there are some things that are better left unsaid. By saying them, it makes them more real and perhaps this was one pain Air could not reconcile. Whatever the reason for the secret, no matter how safe Air felt with me, she could not disclose all the horror that signified her life. While Air may identify with being a victim, I also perceive her as a survivor. Her use of avoidance, of her sexuality, of finding friends who were like herself, and keeping secrets, were all a means of survival in the world of which she was a part, both in and out of school.

Disappearing into Thin Air

When Air shared with me that she would be getting married soon and possibly dropping out of school, I told her that I didn't want to lose touch with her and asked her to please call me and let me know how she was doing. I explained that I was concerned about her and that we both knew she needed someone to talk to when things got a little tough. I shared with Air that I would like to be that person for her, attempting to convince Air that my desire to keep in contact with her had nothing to do with the study, which was true.

Air smiled and seemed genuinely pleased that I would want to maintain a relationship with her, and she told me that she would put my phone number in her backpack, right where she kept everything that was important to her. She promised that she wouldn't lose my number and that she would give me

a call. I have yet to hear a word from her and she has not been back to school. Ms. Oneida informed me, however, that Air's boyfriend, Joshua, had called the school requesting Air's records and asked if the school had a copy of her custody papers, which they did not. Another phone call to a friend who attended the ED program left the message that Air was alright and married and living in another town, but missed coming to school. No other hint of where she was or how she was doing has been given. Her desk remained untouched, pictures of her boyfriend and several other friends taped securely to the surface. The book I had given her as a holiday gift left on her desk, along with her unfinished homework and scant remaining journal entries strewn across it. I guess Air meant it when she wrote in one of her last journal entries, *"Well, I guess I have nothing left to say."*

Two Sides of Isis

The cat only grinned when it saw Alice. It looked good-natured, she thought: still it had very long claws and a great many teeth, so she felt that it ought to be treated with respect.

Lewis Carroll
Alice's Adventures in Wonderland

Getting to Know Me

God's Gift. I'm Isis. I decided to use the name Isis as my fake name in this research project because I've always thought it was a neat name. I read somewhere what it means, but I can't remember exactly what now. It means "God's gift" or something like that. No, I'm just kidding. I don't really remember what it means. I love my real name and I would not change my name if I could cuz my mom and dad picked my name special, and that means a lot to me. I'm 16 and I would describe myself as loud, little, hyper, and a tomboy. My favorite toy of all time when I was a kid was a toy dump truck, and my favorite place is my bedroom cuz I do my favorite thing in there—sleep. My room is all dark and cozy, so I can sleep in for a long time. My bed isn't very comfy, but hell, it's something to sleep on that's not the floor. I really love sleeping. It's the thing I do best. But sometimes I get pissed when I can't remember my dreams. Yeah, sleeping is by far the thing I love the most. I'm in my second year here at this school. Last year, I was in an alternative school program for half a school year cuz of behavior problems I had at my home high school. An alternative school is a place you go instead of getting expelled from your home school, and it's actually just upstairs on the third floor of this building.

A Bad Temper. One of the reasons I ended up at this school is because I have a bad temper. I've had a bad temper most of my life, but it seems to get worse the older I get. I know that some of the reason why I have a bad temper is cuz of the way I was raised and stuff, but a lot of it also has to do with who I am and traits I inherited. My dad has a bad temper and my mom told me I'm definitely my father's daughter. I have ADHD [attention deficit hyperactivity disorder], and my mom thinks that my dad must have it too.

When I was diagnosed with ADHD, my mom learned a lot about it, and although my dad has never been diagnosed, she can see the signs now. He's real fidgety and stuff.

I'm the youngest of eight kids. My mom had four kids and my dad had three kids, and when they got together, they both had me. I'm the only one from both my mom and my dad, but my parents are no longer together. They were never married to begin with, but we were still all one big family. Being the youngest, I've always been able to get my way, especially when my dad was around cuz he was the one who always gave in to me. Like, if my dad was making a pot of chili with beans and onions, and I said I didn't want beans and onions in my chili, then he'd make up a special pot just for me. My mom, on the other hand, would probably just tell me to make it myself. Now that my parents have split up, I live with my mom. I lived with my dad for awhile, but I haven't spoken to him for almost a year cuz of something that happened between us when I was living there. I really would like to see him, though.

It all started about a year ago. My dad hit me, giving me a black eye. Cuz of that, my mom now has sole custody of me and my dad thinks there's a court order against him talking to me, but I don't really think there is. It's all really my fault cuz I kept pushing him to see how far I could go. I kept pushing and pushing and finally he just lost it. My dad isn't an abusive man. I don't think he ever hit any of his other kids, besides probably spanking and some hitting, but in those days it was accepted as how a parent should raise a child. I don't think my dad ever hit my mom either. They fought a lot, but they always did it in another room. If they started to fight around me, I just yelled at them and told them to stop fighting and they usually did.

I can understand what made my dad lose his temper that day cuz the same exact thing happened to me in school last year. I really went off and was banging my head and had to be restrained in the time-out room. I can barely remember any of it, or what I was thinking at the time. It just happened so fast! What I do remember is that I'd gotten in trouble in the classroom and had to be restrained and removed from the room. I mean, I was really losing it! They had to get the school cop and several teachers to carry me out of the room. They took me to a Level III so I would calm down. While I was in Level III, Ms. Johnson, a teaching assistant, had me call my mom to tell her what was going on, but I was so upset that I began yelling into the phone. I wasn't yelling *at* my mom but rather *to* my mom, but Ms. Johnson thought I was yelling at her and told me if I couldn't stop yelling, she'd hang up the phone. I was so upset that I couldn't stop so Ms. Johnson hung the phone up on me. That's when I really lost it, banging my head on a table. It was really scary. I missed hitting some glass by an inch! The whole

thing was so weird, like I just snapped and couldn't control what I was doing. That's probably how my dad must've felt when he hit me. I just kept doing things that built up to make him snap. My sister told me that my dad says I'm a liar and he doesn't want to talk to me. He says the black eye didn't happen that way, but it did. It makes me really sad. I would love to talk to him, but I'm afraid of what he'll say. Well, not really afraid, but, oh, I don't know.

They're Just Words. Besides my temper, another reason I'm at this school is because I cuss a lot. I think if I could change one thing about myself it would be that I would quit cussing, but I've been doing it so long I don't think I can change. Most of the time I don't even know I'm cussing — it just comes out! I think I cuss the most when I'm frustrated, like with schoolwork and stuff. During those times, I don't even know what I'm saying. It's part of my ADHD. Sometimes when I'm out in public I won't even know I've used a cuss word until I notice how other people are looking at me, and then I feel retarded. I swear at home sometimes, but not as much as I do when I'm in school. It hurts my mom's feelings when I swear and I don't want to make her feel bad. In fact, I don't mean to hurt anyone's feelings when I swear, they're just words I use, like the word "retarded."

To me, the word retarded means stupid. When I use that word, I don't mean anything about people who are mentally retarded. It has nothing to do with them. I don't make fun of people. I always stick up for people when other people make fun of them. I always tell people to shut up when they're making fun of someone else. I just use that word like any word. It's the same with cuss words. I don't mean anything by it, but people take it the wrong way.

I guess I started cussing a little bit when I was younger, but I think my behavior got worse when my parents split up. They say sometimes something can happen that you don't remember, but can mess you up for a long time. I'm not sure what it would have been in my case. The only thing I can think of was one time my mom backhanded me and my dad got mad at her for it and got custody of me. It wasn't the fact that she hit me that upset me so much, cuz her hit wasn't anything like when my dad hit me. The problem was that I'd lived with my mom for 13 years and suddenly I didn't any more. I think that was pretty traumatic for me at the time. Now, since this whole thing with my dad happened, I'm back living with my mom again.

I try not to take advantage of my mom, like I hate taking money from either her or my best friend Kara. It's easier to take money from my dad or Kara's dad, even though that bothers me too. But I know that my dad and her dad make more money than my mom and Kara do. See, with my mom and Kara, I hate thinking that because they bought me something that they

wouldn't have enough money to do something they wanted to do. They don't have a lot of money to begin with. My dad, on the other hand, has a lot of money. He may not look like it or live in a house that looks like it, but he does. He gives me $500 a month for child support, so I know he has plenty of money.

I've learned though, that I can't always get what I want, and I think I've taught myself that. When I lived with my dad, he did everything for me. I don't even know what kind of ham I like, or what kind of cheese. My dad just knew and he got it for me. Like if I had three cans of ravioli and I used one, my dad would just automatically go out and buy it without me saying anything. But I would have to tell my mom. Like when I started to live with my mom, I had to tell her to get me ham, but then she would bring home the wrong kind, and I'd tell her that I didn't like that kind. But then she'd ask me what kind did I want and I couldn't tell her. I still don't know, and I don't like that about myself. I mean, what am I going to do when my parents are gone? I need to be able to take care of myself.

The words of wisdom that someone has told me is: "You can't always get what you want but if you try sometimes you just might find you get what you need." Those are the best words someone can tell us and I've tried to learn from them. It was hard to learn, but I learned it. I think it sucks kinda. In some ways it doesn't suck but in other ways it does suck cuz I would love to get what I want.

Sometimes I can tell when I wake up in the morning that today is going to be a bad day. I don't decide I'm going to have a bad day, I just know. And I only think about it once for a second. I don't dwell on it. And then later I'll have a bad day and I'll think, "Man, I knew this was going to happen." Ms. Kren, my teacher last year, understood that about me and she told my mom during an IEP meeting that if I wake up in the morning and say that I'm going to have a bad day, that she should just let me stay home. I liked Ms. Kren, except when I was mad. I don't like anyone when I'm mad. But I've gotten better.

I really think I am the way I am because of my parents. It's like when you put baking soda and vinegar together. My mom was like baking soda and my dad was like vinegar, or my dad was like baking soda and my mom was like vinegar. When you put them together, they foam and explode. Well, I'm what you get when you put those two together. My genes are just messed up. Like someone else's are all round and stuff, but mine are long and bent. They're just different.

I've learned you can't do anything about stuff, so why bother. Like, I don't care if I live or die. I mean, I'd never do anything to end my life, but I don't care if I live or die. I think that God has a plan for me and if it's my

time to die then I will and I can't do anything about it. I never understand why people try to kill themselves because if God doesn't want you to die, then the suicide isn't going to work. I think that I can make choices about what happens in my life to get me to my fate, but my fate is already planned.

Even though not everything has gone great in my life, I don't think I would not want to live one day over cuz I think everything happens for a reason, both good things and bad things. When it happens it's there for you to learn a lesson. If you don't learn a lesson something real bad might happen to you.

Boys Respect Me. I've never considered myself lonely, either at my old school or here. I don't want to sound full of myself, but I've always had a lot of friends and still do. My friends like everything about me. There is nothing they don't like. HA! HA! Just kidding. Really, I don't know what they like about me, ask them. They might like me because I am who I am and I don't give a fuck. Also, I tell it like it is.

When I was little, I was very athletic. I played peewee football and all kinds of sports and I was a real tomboy. I had a bunch of injuries when I was little, but one I can remember real good is one day at football practice me and two guys were all trying to catch the ball and my elbows got smashed between their two helmets. It broke my elbow. I don't play sports anymore, but I think cuz I used to, the boys here at school probably just look at me as one of them.

Sometimes that bugs me, but most of the time I guess I don't really mind it. I've always gotten along well with boys and always had a lot of friends who were guys. I guess they're more comfortable around me cuz I don't act the way a lot of girls do, putting on makeup and flirting and stuff. Cuz of that I'm treated differently here than the other girls. It's more like I'm an equal with the boys. At school, I don't get harassed like the other girls because the boys know I won't tolerate it. If one of them came up to me and tried to touch me inappropriately, they know they'd probably get hit, so they don't really mess with me. I've earned their respect cuz they've seen me fight, like the time I already told you about when I had to be carried out of the classroom. I may be small, but I have a lot of strength when I'm pissed, and the boys know it.

I don't act like the other girls here at this school anyway, leading boys on and stuff. Like Amber, she tries to get the attention of the boys. Once, when we were walking down the hall Amber yelled "Quit looking at my ass!" to some of the guys. I think she yelled that to actually get them to look at her ass because she wanted their attention. Boys don't respect girls who act like that. I've seen it happen to Air too. The first day she was in our class, she

told Brady to shut up, so he cussed her out. Brady would never have spoken to me like that. The boys just don't have any respect for her because of the way she acts.

I guess you can tell that the boys respect me, cuz most of the time they listen to me. Sometimes, they drive me crazy in class cuz they say some pretty stupid things, but I just tell them to quit and they usually do. For example, one morning Arty was cussing and giving Ms. Fields, the teaching assistant, a hard time about losing points. I told him to shut up because he knows the rules. If you cuss you lose points and it's been that way ever since he's been here. I told him the rules weren't going to change and he should quit bugging Ms. Fields about it, so he did. I think it's helped to gain their respect by telling it like it is, which you can tell I do a lot.

If I Don't Get My Medication, I'll Flip Out. I know that I have a disability, that I'm SBH, and that means severe behavior handicap. All I really understand about it, though, is that it has something to do with my behavior keeping me from learning. I'd like to learn more about it, like why I have this. Was I born with it or did I get it later and why? Once, when our class went to the public library, I typed in "severe behavior handicap" on the computer so I could find a book about it, but I didn't come up with anything. I found one book, but it was geared more toward parenting of *deviant children*, so I left without taking anything out. When I was in the hospital one time, a psychiatrist told me I was bipolar and he wanted to put me on high doses of lithium, but my mom didn't want that. I do take Aderal though, for my ADHD, and I can really tell when it's time for me to take my meds cuz I get really irritable and jumpy and I just know if I don't get my medication, I'll flip out. I go to a therapist (I don't know if he is a psychiatrist or a psychologist), but he told me I'm the only one of his patients that hasn't gotten any better after coming to see him. I've been going there for years, but I don't really like him and I don't really like to talk to him about stuff. He kinda pisses me off.

Friendships

The Perfect Friend. My real best friend is Kara. She doesn't go here, but we hang out a lot after school and on weekends. Kara and I kinda grew up together. See, my mom babysat Kara for like forever and I really can't remember if we were close or not. Then my mom didn't babysit her anymore so I don't think we saw each other outside of school. Kara and I have always been in the same grade but we were hardly ever in the same class cuz Kara

was in a smarter class than me. We went through school without really talking that much but when we did it was really weird cuz it was like we had talked every day, even though we hadn't. It was like a connection that we had or something. About tenth grade we started hanging out more, and more, and more. Now we're together almost every day and if we're not together we're talking on the phone. It's so cool and fun and even scary. Cool cuz it is so awesome to have that good of a friend. I always wondered if I was going to find that perfect friend that I would be friends with until I die. I did and it's the best thing. We can talk to each other about anything and everything. It's scary cuz sometimes we don't even have to talk to know what each other's thoughts are. It's kinda like we read each other's minds.

Scary things always happen to us when we are together, like her car tries to kill us. It's possessed. It's been wrecked a whole bunch of times and every time we go somewhere in her car we seriously almost wreck or die. The car speeds up in sharp corners, acts like it's gonna break down in the middle of nowhere or on a scary road. But nothing really bad has ever happened to me and Kara (knock on wood) while in her car. I know what you're thinking. Probably that Kara can't drive, but she can when she drives her dad's truck. She's fine. No almost wrecking or dying in dad's truck or in any other vehicle she drives. She might drive a little fast sometimes, but that's all.

Something else that's scary is we get hurt in the same spot and we aren't even together when it happens. I was talking to Kara on the phone one day and I was cooking something on the stove. When I got it out I burnt myself and I yelled "Ouch! Shit! I burnt myself." Kara asked me if I was okay. I said "Yeah, but there's already a blister on my finger." She was like "No way! I burnt my finger the other day!" She told me what finger and what hand. I said, "Oh my God! My burn is on the same finger and hand!" I told her what knuckles it was between and she said, "That's fucked up! We got burned in the same exact place!" I was like, "That is fucked. I want to see it when I see you next." I saw her that night and sure enough we were burnt in the same exact spot. I think that shows that we will have a lifelong friendship.

Kara and I are also a lot alike. We both like the same things. We both believe in no dicking friends for guys. See, we have this one friend, Shila, that dicks us for a guy every time she can. Me and Shila used to be bestest friends. She dicked me so much I don't even hang out with her any more unless I'm bored and there's nothing to do and if she's going to hang out with guys that are my friends too. She won't call us if she's getting along with her boyfriend and not fighting. But as soon as they get in a fight she calls Kara. She used to call us both, but when she calls me and they're fighting I don't

tell her what she wants to hear. Kara does cuz she just can't be mean. Well, she can but it's real hard for her. I'm trying to teach her to be mean and tell people what she thinks.

I think I'm teaching her well cuz yesterday she told off what used to be one of her best friends cuz she dicked Kara for a guy. All of our (me and Kara's) other friends always dick their friends for guys. That really pisses me off when people do that and I don't really like to hang out with them after they dick me or Kara (I get more pissed off if someone does something to Kara like dick her, hurt her feelings, etc.).

I don't have a boyfriend right now. I don't want to be one of those high school girls with a different boyfriend every week. I want someone who is boyfriend material, someone who is nice and who's not a loser. I used to like Brady, but I don't really talk to him so much anymore. I told him he's changed, but I can't really explain how. I talk to Isaiah on the phone a lot now. I don't think he cuts himself so much anymore. He said he does it when he's bored or upset, so I told him that when he's upset, I want him to call me. When he's bored, I want him to call me. I don't think he's cut himself since we've started talking and I told him that if he does I won't have anything to do with him. Well, maybe he has cut himself a little bit, but not like before. I like Isaiah, but not in that way. He's a nice guy, but I think he has a lot of problems.

Everybody always says how after high school, you never really see any of your friends. Well, Kara and I are going to have Dad build us a house cuz he owns his own construction business. I call Kara's dad just plain *Dad* now. He's like my adopted dad since my own dad won't talk to me. I can talk to him about stuff you would talk to a dad about. He does those dad kinda things for me. Well, Dad likes me a whole lot and he told both Kara and me that he was going to build us a 3,000 square-foot house. It's going to be so cool!

I might work this summer for Kara's dad in construction. He's a subcontractor. In fact, I think I might want to work in construction when I'm older, so I should be able to make enough money to help pay the bills. I don't want to work around food and take orders for anyone. I don't like to be around a lot of people. I feel trapped when there's a whole bunch of people around.

I just hope Kara's and my dream really happens. Even though Kara will be in college, we will live near campus. There is only a year left til we are 18 and it is really strange because everything is going by so fast. I'm really sick and tired of all the people that shoot down my dreams, because this will happen and nothing could interfere in our friendship. We will succeed, and

our lives will change, but we will always have each other and our families. I'm just worried about being homesick.

Another thing that worries me is Kara's mom. Although Dad likes me a lot, Kara's mom thinks I'm a bad influence on Kara because I have "an attitude problem," but I think she's just jealous cuz Kara doesn't talk to her anymore. She tells me all kinds of stuff she would never tell her mom. I don't think she'll get in the way of our dreams, though. Kara wouldn't let her.

If Kara and I don't end up living together, then I won't be disappointed. I don't get disappointed. I don't let people get to me like that. Disappointment is for losers. People who get disappointed expect too much of themselves. Sometimes I think that in two years I will probably be dead anyway. I don't know how I'm gonna die but I will probably be dead. If I'm not dead I will live with my husband and my kids. I will have a good job with a good house.

My Other Best Friend(s). I have other friends outside of school too, and I go to games and dances with them at my home high school, and just hang out. But here at school, I guess my best friend at the beginning of the year was Brady, a kid in my class. Besides Amber, who's not here anymore, he's the only one I ever called and talked to outside of school. We talked all the time about a lot of stuff, most of the time late at night when we were bored. But Brady had a lot of trouble in school, and he didn't get along with our teacher. One day he got so mad that he had his mom sign him out, so he doesn't go here anymore. Now that Brady is gone, I guess Maury is my closest friend in school because we are a lot alike. He has ADHD too and sometimes he talks so fast I can hardly understand him. The only problem is that we tend to set each other off. When Maury is having a bad day, I tend to have one too, and it goes the other way around too.

My other best friend at school is Bobby Clinton. He's a mental health worker here. He comes in to my class and talks with me and stuff. All the kids really like him and the boys really look up to him. For awhile, Bobby had his arm in a sling because he was jumped by 15 guys downtown. He told us that when he was a kid, he was a real fighter, and was even a bouncer in L.A. for two years But Bobby says he doesn't fight anymore. He fought back the night he was jumped, though, and broke one guy's nose and shattered another guy's eye socket. Whenever Bobby comes in to talk to me, all the guys in the class usually come over and sit by us and start talking about sports and stuff, which used to kinda bug me cuz we never had time by ourselves to talk.

Having Girls Together Doesn't Work Anyway. I don't really know the other girls in this school like Mandy, Emily, and Air. Mandy is a lot younger than me and we don't have a lot in common. Emily is from the same home school I'm from, so I know her a little bit. I used to not like her, but I can't remember why anymore. I think she's okay now. I've heard that Emily has had a real shitty life too. I mean really shitty. I also heard she brought it on herself. It's been hard to get to know Air because it seems like whenever I'm here, she's not. She doesn't come very much and when she does, that's the day I miss. And Amber is gone. She got caught dealing drugs here at school so she's been sent to a locked drug rehab facility somewhere in another county.

Just recently, we got a new girl in our class. Her name is Holly. She and Air seem to be hitting it off okay. I don't know what to think or believe about the stuff they say they do together. Some stuff is probably true, but I think that sometimes Air stretches the truth, and Holly goes along with it. Other times both of them make up stories, I guess so people will listen or pay attention. Maybe even to get attention. I don't know if it's a good match cuz it seems like Air is kinda a bad example but I don't know how they are outside of school so I really can't say. I can't do anything about it cuz I guess I really don't want to. It's not my life so I'm not worried about their friendship.

Besides her relationship with Air, I don't think Holly is really fitting into our class yet. I know she fits in with Air, or I guess she does. I don't think she fits in with the class cuz she doesn't really talk and when she does talk it seems like she's trying to be someone she's not. It's kinda like she wants to be like Air. When other kids in the class try to talk to her, sometimes she's rude with her answers. Other times she doesn't answer or she gets real hyper. Well, not really hyper but she gets more talkative. In lunch she'll sit at the table where the students are but she won't really talk even if we talk to her. So I don't really think she's fitting in yet, but I guess it's bound to happen.

I'm rarely in any classes with girls because this school doesn't like to put us together. Air is in my class now, but that's for a different reason than us socializing. She was having some real trouble with the boys in her class so they had to move her to our room. I don't think they really wanted to do it, though, and I'm not sure how well it's going to work. We got along fine before, but there's been a few times when she's really bugged me. For the most part, having girls together doesn't work anyway. They tried it last year by putting me and Amber together in the same class, but we never got any work done. We tended to focus on each other, talking and laughing instead of doing our work. If all three of us older girls were together, we'd probably

never do any work! When they separate us, I think we work harder. I don't think having a girl in a class is distracting to the boys either. It doesn't seem to make any difference.

I Would Prefer They Be More Like Me. I get along okay with most of the kids at this school, although I wouldn't say that they're my good friends. Most everyone here has a bad home life or something that makes them the way they are, so I can tolerate the way they act because I understand what causes them to be that way. Take Arty, for example. He's always mouthing off and getting himself into trouble because he wants attention. Arty has a little flame burning inside of him. As the day goes on, little things happen that don't have anything to do with his home life, but they make the flame grow and grow until he finally explodes. They don't have to be big things, just stuff like the teachers asking him to do something that he doesn't want to do. Sometimes I think that I probably make Arty pissed off too, because I'm always telling him to shut up. I don't really feel bad about that though cuz sometimes he needs to be told to shut up. No one else ever tells him that so someone needs to do it.

I guess I like people best when they're not afraid to be themselves. I hate it when people think they have to act a certain way in order to have friends. I would prefer they be more like me and tell people what they think instead of saying what they think other people want to hear them say. I guess what I would want people to know about me is that I'm my own person. I don't follow anybody. I do what I like and if they don't like it, they can screw off.

The Problem with School

This Is Better than My Old School. This school sucks! I don't like this school as much as I did when I first came here. There are a bunch of stupid rules. I don't really like my teacher, either. She can be a bitch sometimes, but she is cool sometimes too. Sometimes our relationship is good, and sometimes it's not so good. It's both of us. It depends on what kind of mood we're both in. When things get bad, I always think to myself, this is better than my old school. Overall, I think going to this school has really helped me control my behavior. I don't really know what they've done specifically to help, but I know that I've gotten a lot better about not mouthing off so much and I don't cuss as much as I used to. What I like least about this school is that they can treat you like shit and you can't do anything about it. What I like most is that sometimes they're nice and treat you like an equal.

I don't think I'd ever want to go back to my home school, either. Well, maybe I would agree to go there for a class or two in the morning, but I know that if I go back they'll try to set me up like they did the last time. Cuz of my reputation, I'm sure they'll try to get me angry so they can throw me out again. It won't even have to be a big thing, just something stupid, and they'll use it as an excuse to kick me out like they did in middle school. I was suspended for three days for saying 'shit' to my friend. I wasn't calling her shit, and I wasn't cussing out a teacher. I just said 'shit!' in a sentence and they suspended me for it. That wouldn't happen here. I might lose a point or something, but they wouldn't suspend me for cussing. They know it's something I'm working on and most of the time they try to help me with it, so I guess I'll probably graduate from here.

The Pit Bulls. For a long time we didn't have a mascot for this school. I told Ms. Oneida, our principal, that we should call ourselves the Pit Bulls, but she wouldn't go for it. I even made a formal proposal to her about it, offering to organize a schoolwide vote. See, there were two other ideas for a mascot that the teachers had been talking about. One was an armadillo because they are soft on the inside but hard on the outside. The other was a sunrise to represent new beginnings for students. But the third one, the one that I liked was a pit bull because it depends on how they are raised, just like us. The entire school could then vote on the mascot of their choice. At first, I didn't want to talk to Ms. Oneida about it. The other two mascot ideas were retarded and I thought that if it was put to a vote, most of the students would vote for the pit bull. But I knew that someone on the staff wouldn't like that so the majority vote wouldn't count anyway. Then I'd be mad, so I didn't want to bother presenting the idea to the principal.

Even though I didn't want to do it, the Yearbook teachers talked me into presenting the idea anyway to Ms. Oneida. So I did, but she simply said no. She thought that there are already negative stereotypes about the kids who go here and she didn't want to make it any worse. That was the very reason I wanted to call ourselves the Pit Bulls! I know that people stereotype those dogs as being aggressive, just like the students here are all stereotyped as being bad kids. Whenever anyone mentions a pit bull, there is the assumption that they are all wild and vicious dogs, but it isn't a fair assumption for someone to make. I did some research on pit bulls at the library and really, for the most part they are very nice dogs. I even hope to own a pit bull someday. If someone raises them to be mean and aggressive, then they are. No matter what I said though, Ms. Oneida wouldn't go for it so the vote was off. And guess what? Our mascot is an armadillo.

What people think about pit bulls is just what they think about us as students at this school. Because it's a behavior school, people assume we are all troublemakers. One time my best friend, Kara, picked me up from school. On the way home, she was pulled over for speeding on a back road. As the cop was looking over her driver's license, he asked her where she was coming from and she told him she had just picked me up from school. So the cop stuck his head in the window and asked me where I go to school and I told him. As soon as he heard the name of the school, his attitude towards us changed and he started giving us a real hard time. If I had said the name of one of the local public schools in the area, like the name of my home school, he wouldn't of treated us like that.

A Lot of Us Kids Here Are Racist. All of the kids at this school are white, although we have had a couple of black kids here from time to time. I'm not very tolerant of them, though, and a lot of us kids here are racist, so a black kid would have a pretty hard time at this school. I guess, if a black student were in my class, I'd probably be nice to him and stuff as long as he left me alone. But as soon as he said something to me that made me mad, I'd probably go off on him about all kinds of stuff about blacks that makes me mad. I might even like the kid, but underneath there would still be this little bit of hate that I wouldn't be able to get rid of, and if he set me off, he'd probably want to shoot me because of the things I'd say to him.

It's just not blacks that make me mad, though. It's all those foreigners. Like those people who own *Dunkin' Donuts*, and the Mexicans. They don't even speak English and yet they come to this country and the government probably gives them money to start up businesses. The government doesn't give money to white people to do that and I don't see why blacks and foreigners should be getting all these special privileges! They even have their own organization, the NAACP, and still black people and people from other countries are always complaining. White people don't have an NAACP, and they don't get free money. Why should people from other countries? It all makes me so mad I can hardly even talk about it cuz I know its gonna make me lose it!

Our teacher is always trying to get us to not be racist, like by reading to us in the afternoons about the Holocaust and stuff, but that's not going to change anything. I know what I believe. It's just me. I realize I was probably influenced some by my family, especially my dad's side of the family, but I can think for myself. No matter what anyone says, I still believe that people shouldn't be allowed in this country who don't speak English. They should just all go home. Nobody would miss them. These feelings just come from my heart, and that's the way it is.

Too Many Stupid Rules! Although I like it better here at this school than at my old high school, it was even better last year. This year there are too many stupid rules! We have rules about points, and rules about levels, and rules about electives. Sometimes I feel like I'm gonna suffocate because there are so many rules! That's one of the reasons I come to school only three or four days a week. I just can't make it through all five. I usually always miss school on Mondays because that's when I have group, and I don't want to go to group. I think it's stupid and I don't like Anna, the mental health worker in charge of group. But it doesn't really matter to me which days I miss, like sometimes I miss a lot of Tuesdays and Fridays too. I even asked one of my teachers once which day we do less work so I could plan to miss that day, but she said "Saturday and Sunday." Duh! I like to come only three or four days because it makes the week go faster. I hate to come to school. I hate waking up early. I hate putting up with people's shit. Another reason I hate school is people have a tendency to piss me off.

To get me to come to school more, Ms. Oneida made a deal with me. She told me if I come to school all five days each week, she'll take me out to lunch on the following Monday. Well, I've managed to do it a couple of times, and she followed through on her end of the bargain by taking me out to lunch, but I didn't keep it up for very long, coming to school five days in a row. Usually I don't work for rewards, but this one I did, for a little while anyway. I guess it's cuz it got me out of here. I never eat lunch, so it isn't the food. It's just great getting away from school for awhile. Next time, though, I'm going to pay for my own lunch when we go out. I hate that Ms. Oneida has to spend her own money on me because I know when she does she can't use the money to buy something for herself, and I know teachers don't make a lot of money.

Although there are a lot of cool things about this school, there are also a lot of uncool things too. For example, the assignments at this school suck! They don't have anything to do with anything and we learn absolutely nothing from them. It's all just work to keep us busy and out of trouble. We do the same things everyday, like writing in our journals. Every morning, as soon as we get to school, we're supposed to write in our journals, but lots of times I simply refuse to do it. It's senseless! When I do write in my journal it usually has nothing to do with how I really feel anyway cuz I can't write what I truly think or I'd get in trouble. It's happened before. They really don't want to hear the truth.

After we finish our journals and get back from electives, Ms. Smith gives us thick packets of worksheets to do, which I don't even think she ever actually reads before giving to us. You work all morning on one packet of papers, and then when you get done with that set of worksheets, she just

gives you another one! It's just way too much fucking work to do and Ms. Smith doesn't give us five minutes to rest! You can't even lay your head down for a minute without someone barking at you! Sometimes I just can't take it and I tell her that I ain't doing all this fucking work. It isn't even challenging work. Shit, it's so easy, I can miss two days of school a week and easily get caught up on my work. But sometimes my damn brain needs a rest anyway, but she won't give it a chance to rest.

It was better last year. The teacher I had then gave me all of my work in the morning and when I got it done, she let me sleep. I told my teacher this year that she should do the same thing, and eventually she agreed to it, sort of. Ms. Smith said I could sleep after I get my work done, except I have to stay awake when she reads to us in the afternoon, and she said I had to be quiet. Also, she said that if the class leaves the room, I'll have to go with them cuz she can't leave me in the room alone. She said I have to participate in group and her activity period too. In addition, Ms. Smith said that if I wake up hateful and mean and nasty, she's not going to let me sleep anymore. She added that rule cuz one time she tried to wake me up and I practically bit her head off. Well, I say she needs to wake me up the right way, SLOWLY, and I won't be mean and hateful. It's just a way for her to make more rules! Ms. Smith is such a control freak and she can be such a bitch!

A Real Control Problem. Control is so important to Ms. Smith that I think she goes home at night and tries to think of ways to control me, and she thinks I hate her cuz I react by trying to control her. I can't help it, it's just what I do. I was suspended last fall because of her and her control issues, and we had to have a big meeting and everything before I could come back to school. Ms. Oneida said she wanted to switch me to another teacher, but my mom and I agreed that I needed to work things out with Ms. Smith. After all, she's my teacher and I'm gonna have her all year and I can't do anything about that, so I might as well get along with her. After that meeting, my mom was really upset because she said the Isis they see in school is not the Isis she sees at home. She says I change when I come here and that she noticed it the second we pulled into the parking lot that day. But I don't really see what she means. I think I'm the same person.

What got me in trouble that day was really retarded. I was messing around with Brady and the chalk erasers. I tried to throw an eraser at him, but I missed and hit Ms. Smith in the head. Everyone thinks I did it on purpose because I'd written in my journal that I hoped Ms. Smith would get hurt. Even though I really don't care if she gets hurt or not, I didn't hit her on purpose. They pressed charges on me and everything. Since I couldn't

convince them that I didn't mean to do it, I just let go of the whole thing. That's how I handle everything. I just don't let it bother me.

I have to do the same thing when kids lose it here. Every day you hear someone yelling or cussing a teacher out, or hear someone hitting a locker or throwing something, but you have to tune it all out. I feel sorry for kids in my class or in other classes when they're having a rough day and I care what happens to them, but I can't do nothing about it so I don't say anything. I mean, why bother cuz I have no control over what's happening, so I just keep on with my work. It's not really any of my business anyway.

I was nervous about going to court over the whole eraser thing, but it turned out to be no big deal. The judge gave me twenty hours of community service and if I serve it within the next couple of months, the incident will be removed from my record. I've started doing my community service by washing dishes and rolling silverware at a nursing home and I hate it! I get to talk to the patients sometimes, but for the most part I stay in the kitchen. The whole thing really sucks! I feel like I'm black, or let's just say I feel like a slave.

Lunch is another time when Ms. Smith has a real control problem. Even though she knows I never eat lunch cuz I take my medication at that time and it makes me feel sick, she makes me go to the lunchroom and sit with the rest of the class anyway. So, I just sit there and wait until everyone is done, but I really think I could use a break during that time. I noticed that I get in trouble more in the afternoon. I think it's cuz I feel too closed up in the classroom. It feels like a prison and I can't stand that. Ms. Smith changes over lunch too. Everyone sees it. She gets harder to deal with. I compared my point sheets once and noticed that the trouble usually begins sometime around lunch, so going to the office during lunch would probably help me by giving me a chance to get up and move around and talk to people before having to go back into the classroom. I just can't sit still all fucking day!

I used to be able to go to the office and talk with Gerta, the school nurse, but now Ms. Smith won't let me. Last year, I actually worked in the office answering phones and stuff. Ms. Oneida told me that I make a pretty good secretary, and she said she doesn't mind me coming down there at all. I wanted to do that again this year and we even put it in as part of a behavior plan. The agreement was that I could go to the office if I get my work done, but Ms. Smith seems to think that she can ignore that plan whenever she wants to. I can give you an example of this from the other day.

I'd been having a perfect day, getting 10s on my point sheet all morning for completing my work and not cussing. Since my day had been good, I asked Ms. Smith if I could go to the office for awhile. She told me no, which really made me mad. I went to the restroom instead, and while I was upstairs

I talked with someone (I can't say who) who told me that if going to the office is part of my behavior plan, then my teacher couldn't deny me that privilege if I'd earned it. When I got back to the classroom, I confronted Ms. Smith about it. She took a copy of the behavior plan out of her file and read it to me: "Isis can go to the office at teacher discretion." She said that last part in a real spiteful way. She said she didn't want me to go to the office that day and that she had the right to make the decision as to whether or not I could go, regardless of how many points I'd earned. At that point, I was ready to blow.

I Just Got More Pissed. That was the beginning of how she tried to control me that day, but I had already had enough. During lunch, I sat with Air and Mark, leaning my chair back against the wall like I always do. I saw Ms. Smith watching me and knew she was going to say something, like she always does. I just waited her out. Sure enough, Ms. Smith told me to put my chair down. I was still furious about her not letting me go to the office so I ignored her, acting as if I didn't hear her. Ms. Smith told me again several times to put my chair down, but I just kept acting like I didn't hear her. Eventually, she walked over to me and told me again to put my chair down. At first I didn't say or do nothing, but all of a sudden I just couldn't take it any more so I yelled at Ms. Smith, telling her that I wasn't hurting anyone and for her to leave me alone. Air told me to put my chair down, that it wasn't worth getting in trouble over it, so I ended up lowering my chair, but as soon as Ms. Smith walked away, I leaned my chair back again. Ms. Smith started to fuss at me again, but I didn't listen to her, so I ended up losing points. It was worth it! But Ms. Smith wasn't done with me yet.

Later during lunch, I asked Brady if I could have one of his potato wedges, so he gave me one. I usually don't eat lunch, but they looked good and I knew Brady wouldn't mind. Brady had earned the privilege of ordering out lunch but I hadn't, so I got in even more trouble at lunch. I lost more points and Brady ended up losing his ordering out privileges since he had shared some of his food with me. After that, I just got more pissed.

At the end of the day, Ms. Smith was doing point sheets. My bus had arrived, so I told her to hurry up cuz I needed to take my point sheet home for my mom to sign. That's one of the rules here. Instead of hurrying up, she stopped writing and just stared at me. I couldn't believe she was doing this! Just cuz she wanted to have control over the situation, she was going to make me miss my bus! At that point I started cussing her out. When Ms. Smith finally gave me my point sheet, I was so frustrated I crumpled it up and threw it on the floor in the hall as I went to the bus. Another teacher saw me drop my point sheet and ran after me, telling me I needed to go back and pick it

up, but I just kept walking to my bus, telling him I didn't want it. This teacher actually followed me onto the bus and we started shouting at each other. They eventually made me get off the bus, but it still wasn't over.

This entire thing happened on a Thursday. There was no school on that Friday and I was absent the next Monday. Tuesday morning I came in and apologized to Ms. Smith. I knew I'd been reacting to everything that had happened earlier that day and was ready to put it all behind me. Ms. Smith accepted my apology, but wanted me to apologize to the other teacher who had followed me onto the bus. That's where I drew the line. He had no business following me onto my bus and yelling at me like that, so there was no way I was going to apologize to him! He should've just left me alone. So, since I wouldn't apologize to that other teacher, I was sent to a Level II. I couldn't believe it! It was totally unfair to be sent to a Level II for something that happened five days before. Just another example of teachers trying to take control!

I realize I have control issues too, like when I wouldn't put my chair down during lunch, but the stuff that teachers do around here is ridiculous. Kids need to have some power and freedom, but this school is just like a jail, where the teachers have all the control. They say they give us power by offering us a chance to earn rewards, but we really have nothing to work for that's worthwhile. I don't believe I would ever work for a reward like Friday Clubs because I'm too impulsive. What happens, happens, and I can't really control how I behave. But if I should have a good day and was able to earn something, I think I should be able to get it, like going to the office when I've finished my work. The opportunity to go to the office should be based on the number of points I earn in the morning, not on the "teacher's discretion."

The whole school is based on a points and rewards system. If you earn enough points, you can go to clubs on Fridays. If you don't, then you have to go to the ineligible room where you have to sit quietly and do work. I spend most of my Fridays in the ineligible room, but I've earned clubs a couple of times. Sometimes it's not so bad because you can work on word searches and stuff, but I hate it when Ms. Smith gives me work to do. Even though I know I'm supposed to do it, the way Ms. Smith acts about it makes me want to tell her to screw it. Like one time, I'd been absent on a Monday. I'd been working on a word search that Ms. Stacks, the ineligible room teacher, had given me. After a couple of minutes, Ms. Smith came into the room and handed me my makeup work. I told her I wasn't going to do it, that it was fucking stupid. I had been doing okay until Ms. Smith had come in and fucking pissed me off. After she left, though, I did end up completing my makeup work. I didn't really care about the work, it was just the way she gave it to me and tried to force me to do it. Ms. Smith is just a real bitch.

But I've learned since then to just shut everything out. I don't let stuff bother me. Like, if someone says something to make me mad, or if a teacher is going to make me do a worksheet, even though I don't want to I just do it because no matter what, I'm going to have to do it anyway. There's no use getting all upset about it because it doesn't change anything. I think that realization has helped me achieve at least one major accomplishment in my life, and that is not going to Level III for awhile. Also, I have not gotten restrained in a long time (knock on wood). When I think about it, I guess another accomplishment I've had is getting kicked out of my neighborhood school. I did not want to get kicked out but it shows it was the best thing for me.

Respect... It's a Two-Way Thing. I understand that in this school, cuz some of the kids can get pretty violent, teachers sometimes struggle with knowing what to do about it. But I feel that freedom should be given on an individual basis, and there should be respect for students. For example, I can tell when someone is interested in what I'm saying. And I can also tell when teachers aren't interested. I can tell by the way she acts that Ms. Smith doesn't want to get to know me or her other students and that she doesn't respect us either. When I say the word *respect*, I mean the way we communicate with each other in a polite manner. When I respect someone, I try to understand their views and relate those views to different situations so I can better understand them. I do this by listening to what someone has to say and by giving them a chance to say what they are thinking without interrupting them while they share their value or beliefs.

Basically we all, including most of the students here, have learned that you must give respect in order to receive respect. There is equality in exchanging respect no matter what age, position, or seniority. So what I'm trying to say is that no matter who you are you still have to give respect to get respect or it must be at least a neutral understanding or bond between people. Sometimes, however, people don't treat each other as they want to be treated themselves and they don't realize that they are guilty of doing the same thing they preach to others not to do. We've all done our share of being disrespectful but many of us have at least admitted to ourselves that it was the immature thing to do and tried to move on. But when I'm being disrespected by someone cuz they are yelling at me in an improper manner, or acting in a way which has annoyed me to a point of rage and uncontrollable hatred, then I am forced to disrespect them back. Yet, they want me to act as if I'm not being manipulated into being disrespectful.

I don't believe in one-way respect. I believe it's a two-way thing. So when I get no respect from an elder I give no respect to that person back,

even when they expect it from me. What I'm trying to say is that if teachers would be respectful to me I would be respectful to them. When I've said this to teachers, they usually ask me to give them examples of how they are being disrespectful to me. That's hard to do because it's not anything big most of the time, usually it's little stuff like the tone of voice they use. Sometimes they talk to me like they want me to feel real small (like shit). And it seems like teachers do stuff to intentionally piss students off. It's a control issue with them. They act like someone is trying to steal all the control when really they're not. It's like teachers won't give us freedom or anything because they're afraid they won't feel totally in control. What they don't realize is that when they make everything so controlled, we have no fun. They also don't realize that when they yell at us for breathing wrong, teachers don't have any more control than if they would have been nice to us or if they had let us have some freedom.

I don't know if it's just me, but it seems that the control issue for Ms. Smith is more directed toward me than it is toward the boys in this class. I don't know how to explain it but I know it's like that. Her disrespect towards people has something to do with her own so-called control issues. I think she thinks she is not in control when, in fact, she has a lot of power and control. She pushes us too hard in order to make her feel like she is in control over us, but she doesn't need to do that because she already is in control without that. Sometimes I think Ms. Smith does stuff to piss us off on purpose, but now that I think about it, it's all about a power struggle. Perhaps she has to prove to other staff and students that she has all the power in her class. Like she picks little stuff to gripe about to show other people that she has "total control" over us.

I don't mean to blame everything on Ms. Smith. I do try to get along with her, but she always messes it up. Well, not all of the time, but most. I know that I do stuff wrong lots of times, so I'm not denying that I do things wrong, but the way I handle things sometimes, like yelling and cussing, can be prevented by the way she reacts to things. Most of the time she tends to blow everything out of proportion. So the whole respect thing leads back to the power struggle and control thing.

As part of one of my punishments once, I had to write an essay on respect and in it I said most of the things I just told you. I saw my essay in Ms. Smith's mailbox, so I assume that she had shown it to other people, but she hadn't asked my permission to do that. It's just another way the teachers here show they disrespect us students. Not all teachers are like Ms. Smith, though. Take Ms. Casper. Once when I took my red sweatshirt off I noticed that it had left red lint on my white shirt underneath. Ms. Casper used tape to clean the lint off for me. I told her she was just like a mom because she

always knows just what to do. Ms. Casper reminded me that she was a mom, and I knew that because she has her kids' pictures up and stuff, but it was still really weird. Usually teachers don't act like that in school.

It's Just Different for Us Girls. For the most part, I think schools like this one, tend to structure themselves around boys and what they need. Even though it's probably not a great idea to put us girls together in the same class, I think they need to allow us girls to have more interactions with each other. We need to be able to make contact and talk. Until recently, they pretty much kept us all separate. I don't mean we need a group time together or anything, but when we're in the hall and we see each other and we say "Hi, how ya doing?" the teachers say "Don't talk in the hallway!" Other ways they don't consider what girls need is like in AT [activity therapy]. I would participate, but I don't want to get my clothes all sweaty. I want to change, put on a sports bra and stuff, but they don't really allow for that. It's the same in gym class. Since I never participate in gym I got an "F" on my report card. I don't know. It's just different for us girls.

Fire and Isis

" 'Be what you would seem to be'— or, if you'd like it put more simply—'Never imagine yourself not to be otherwise than what it might appear to others that what you were or might have been would have appeared to them to be otherwise.'" -The Duchess to Alice

Lewis Carroll
Alice's Adventures in Wonderland

Dual Personalities

As I tried to gain an understanding of how Isis saw herself in light of the ED culture, I was struck with the realization that perhaps what we saw and heard Isis doing may be an effort on her part to gain control of her life in a not so small way. As I watched Isis day after day, I came to understand that she truly had an impulsive nature. Her ADHD was severe enough to cause her irritability when not medicated and often caused her to react without first considering the consequences. Perhaps because she had lived with this condition for 16 years, often feeling jittery and out of control, and since so much of what had happened in Isis's life was beyond her governance, Isis felt a need to take command wherever and whenever she could. Her entire being had become one great binary, taking control while at the same time being out of control. This manifested itself in a variety of ways.

For the most part, it appeared that Isis's attempts to take command of her life occurred most often in arenas in which she felt unsafe, such as with academics, or poorly structured lessons, or unstructured situations altogether. It took so much effort for Isis to remain in control of her behavior in the early morning that by late morning she was ready for a release from the intensity of the classroom. She worked hard to ignore the stimulation that surrounded her, seemingly using her mantra of *"I don't care"* as a way to detach herself from the chaos, keeping her focused or otherwise occupied so she would not *"flip out."* It is this recognition of Isis's struggles with control through which I will further investigate Isis's sense of identity in the ED classroom culture.

Understanding and Using Disability

Isis understood that she has a disability and was able to name the formal labels that had been imposed upon her. She was also able to aptly recite the general definition of her school-related disability label of *SBH*. She identified herself as someone with a disability and attributed most of her own explosive behavior to her inherited impulsivity. In an effort to learn more about herself, Isis requested I share information with her on what it meant to have an emotional disturbance or severe behavior handicap, ADHD, explosive disorder, and bipolar disorder, which I did throughout the course of this study. It was hoped that through our conversations and article reviews, Isis would gain insight that she could apply to better understand herself. Using definitions from the *Diagnostic and Statistical Manual of Mental Disorders, 4th edition* (American Psychiatric Association, 1994), we decided together that a diagnosis of bipolar disorder was probably not a match for Isis, but perhaps ADHD was.

Even though the intent of these discussions was to create an emancipatory end for Isis through knowledge, Isis had recognized her highly impulsive nature prior to this study, so the information we discussed about specific disability characteristics may have actually reinforced Isis's already fatalistic acceptance of the behavioral incidents to which she contributed. Instead of leading toward emancipation, freeing her from the chains of her disability label, Isis rationalized that due to her impulsivity, which she understood even better now, she could not control how her day would go, excusing her behavior because of her disability. *"I can't help it." "I can't do anything about it." "What happens, happens, and I can't really control how I behave." "I can't help it. It's just what I do." "I don't even know what I'm saying. It's part of my ADHD."* The following scenario exemplifies how Isis used her disability to circumvent responsibility for her actions.

> *Isis was acting overly silly and off task today. She asked to call her mom because she wasn't sure whether or not she had taken her meds. Her mom said ... it was almost time for her second dose anyway so she suggested that Isis go ahead and take it now...*

> *Even though Isis took her medication, she continued to act silly. Because another student had not taken his medication, and had none at school to take, he was very off task and spoke so quickly that it was difficult to comprehend what he was saying. After being redirected back to her work, Isis exclaimed, "Ms. Smith. You have a person half medicated here and one not medicated. And you expect us to sit here and work on this all day? It's just not going to happen!"*

In this instance, Isis was able to blame her behavioral difficulties on her ADHD, allowing her to relinquish responsibility for her actions. For Isis, knowledge about her disability prompted her to acquiesce power to her disability label, justifying her behavior through the very disability characteristics we had studied together.

Fate As Her Guide

This fatalistic attitude went beyond her acknowledgment of her disability, however, and actually pervaded her general philosophy on life in school and on life in general. Isis believed in fate and that her God had a plan for her, which she could not change. Several times throughout the study, when Isis was asked how she handled various difficult situations with which she was presented during the school day, she relied on her belief in fate to help her accept what was happening around her. *"I can't do anything about it." "I have no control over what's happening." "I've learned to just shut everything out... There's no use getting all upset about it cuz it doesn't change anything." "I've learned you can't do anything about stuff, so why bother?"* In these examples, Isis once again did not take on any ownership. However, this time she yielded to the entire ED environment and not simply to her disability label. Even when discussing the issue of respect among students and teachers, Isis claimed that she was sometimes *forced to disrespect* teachers, unable to identify alternatives for which she could be accountable. The only time Isis genuinely took responsibility for something was when her father had hit her. She harbored intense guilt about everything that happened between them and wished she could reestablish a positive relationship with her father. The irony lies in that this experience was probably the one time when Isis was not responsible for what had occurred.

Swearing

While Isis may excuse her behavior because of her disability status and fate, she did want to improve it. She stated that she felt uncomfortable or *retarded* when people gave her odd looks when she cussed out in public, and said that she did not mean to hurt anyone's feelings. She understood the societal parameters for acceptable swearing and had shown remorse on occasion when she realized she had overstepped those boundaries. The following passage depicts such a time when Isis acknowledged she had unintentionally hurt someone's feelings by swearing.

At one point in the morning, Ms. Fields asked if she could get behind Isis's table to hang some decals on the window and Isis responded "Shit no!" Maury let Ms. Fields get behind them, and Ms. Fields told Isis that she hurts her feelings when she talks that way to her. Isis seemed a bit surprised by Ms. Fields's statement and said, "Awe, Ms. Fields. You know that's just me."

Although Isis did not directly apologize for upsetting Ms. Fields, she did make an attempt to rectify the situation by implying that the swearing had nothing to do with Ms. Fields, but rather was simply something she just said. Once again, Isis may have been indirectly blaming her hurtful behavior on her disability.

Who's in Control?

While Isis was able to identify times when her teacher demonstrated that she had a control issue, Isis refrained from discussing at any length her own issues around power and control. At one point, I asked Isis if she thought that she too might have a control issue and Isis simply answered *"No."* I reminded her of the incident she relayed to me about purposefully ignoring Ms. Smith in the lunchroom when she asked Isis to put the legs of her chair down. I asked her if she thought that was about control on her part and Isis agreed, saying that she realized she had control issues too. However, Isis minimized her part in the incident by saying she believed her attempts to control Ms. Smith were in response to Ms. Smith trying to dominate her, not her own personal power issue. If so, Isis's response to Ms. Smith could be construed as a purposeful act of individual Power-Over as she defied attempts by Ms. Smith to impose authoritative power over her. The concept of using individual power to take back control in an oppressive situation will be discussed more thoroughly in Chapter 12.

One way Isis appeared to take control over her environment was through her strategic use of negotiation with and manipulation of her teachers. As one may recall from her Personal Life Presentation, Isis attempted to negotiate with her teacher the days of the week she should come to school. In addition, Isis also successfully negotiated sleep time in class. *"Why don't you just give me all my work for the entire day? When I'm done, you let me sleep. That's what Ms. Kren did last year. Be more like her and more people will like you."* As a result of this rather aggressive negotiation tactic, Isis was permitted to sleep in class after her work was completed.

Wanting to Look Competent

Isis was a hard worker and was diligent about her classwork. She was willing to ask others for assistance but attempted to do her own work independently whenever possible. She was often on task for prolonged periods of time most mornings and made efforts to do her work correctly. For example, during Yearbook one morning, Isis was given the assignment of writing an introductory letter to the student body about an upcoming school newsletter. Although she asked for ideas of what to write initially, once she had the information she preferred to do it on her own. The teaching assistant kept trying to dictate to Isis what to write, but Isis preferred her own words, saying she wanted it to sound more like a *kid* talking, not a teacher.

While Isis was an accomplished negotiator and would rather work independently, she was actually not confident with her academic skills. However, Isis did not want to appear incompetent in class, preferring the persona of a capable and self-sufficient student. One of the ways Isis demonstrated her desire to appear competent was by being the one in class who could provide assistance to others. Following are several examples observed during my field work in Isis's classroom.

> *During their academic period, Maury pulled his chair up to Isis's desk because he needed some help with his work. Another student, called out "Isis! What year did President Lincoln take office?" (It was a question on their worksheet) She responded by telling him where the answer was in his packet. Brady came in around 10:30 after a rough morning. He had a lot of work to make up before lunch, and Isis offered to help him get it done. Her teacher said that she would help Brady, however, so Isis returned to her desk. Later, Brady asked, "Hey, what do you do with this?" Isis once again got out of her seat and went to help.*

Originally, when I had looked at these and other examples of assistance, I organized them under the category of *caregiver*. However, after further observation and conversation with Isis, I realized that her reason for providing assistance was not because she necessarily wanted to help other students succeed, but rather because it was a way for her to feel capable. This was particularly apparent one afternoon when Isis was having a difficult time with her seatwork assignments. *"How come everyone's done before me? What's going on here? That never happens!"* Isis had identified herself as someone who worked quickly and independently and did not respond well when conditions were such that she was not one of the first students done with her work.

Coping with Frustration

Although Isis worked fairly well independently, she was easily frustrated when she did not understand the directions or did not have the skill to complete an assignment. The following quotes are an illustration of how Isis attempted to cope with her frustration when the work proved challenging to her.

Isis:	*How do you do this math?*
Ms. Smith:	*I'll be with you in just one second babe... Let's see. Reducing recipes. We've done this before... you have to divide.*
Isis:	*I don't know how to divide... I don't care. When I cook I don't have to do this stuff.*
Ms. Smith:	*Well, you have to eat baby.*
Isis:	*I'll get someone to cook for me.*

During another math assignment on a different day,

Isis refused to do her math unless she could use a calculator, even though Ms. Fields told Isis she had to show her work. Isis continued to argue for doing her math with a calculator. After she started her math assignment, Ms. Fields went over to her and asked to see her work, but Isis said "I erased it." Ms. Fields told Isis that if she did not show her work then she would put her in a Level II. Isis complied and worked quietly, occasionally calling out to ask a multiplication fact question, such as "What's 8x7?" or "What's 8x4?" After several minutes, Isis began to negotiate.

Isis:	*Ms. Fields! Ms. Smith said that I only had to do four problems.*
Ms. Fields:	*Well, she didn't tell me that.*
Isis:	*She doesn't have to tell you. It's between me and Ms. Smith. It's a deal we made.*
Ms. Fields:	*She didn't tell me that so do them all.*
Isis:	*I wouldn't lie. I wouldn't lie. I wouldn't lie.*
Ms. Fields:	*Isis, she has to tell me, and since she didn't there isn't anything I can do about it. So do them all without a calculator.*

Isis returned to her work. Several minutes passed.

Isis:	*Can I use the calculator for the rest? I did half of them.*
Ms. Fields:	*No.*

A similar scenario occurred on another day.

Isis requested help with her math worksheet. Ms. Smith asked Evan to help her... After he helped, she asked Ms. Smith to help because she said Evan had drawn all these lines and "see, now that just confused me...It's too many numbers. It confuses me... Just make me do one column."

Again, Isis had attempted to use her negotiation skills. However, in these instances she was negotiating in order to get out of doing work that she found demanding or laborious as she attempted to cope with her frustration.

Oftentimes, Isis showed her frustration with a task by yelling out to her teachers and asking a question, as seen in the next set of examples.

"Ms. Smith! Ms. Smith! Can I make this two papers because I can't keep flipping these back and forth. I get confused and it's frustrating."

"Hey, Ms. Smith! Would the C in chemistry be capitalized?"

"Hey, Ms. Smith. Is Maryland capitalized?"

"Ms. Fields! Help me with this!"

In addition to calling out to her teachers, Isis was also observed swearing when she was frustrated. For example, when trying to figure out answers to difficult questions on various worksheets, Isis could be heard saying *"Shit!"* or *"Fuck!"* On one particular day, Isis's frustration with her work grew to a point of sheer exasperation.

After some time, Isis turned in part of her work and said, "I'm not doing any more of this. I'm going crazy over there." She then returned to her desk and continued working on her math worksheets.

Isis:	*Do we have to do time-and-a-half?*
Ms. Smith:	*You have to read the question.*
Isis:	*Duh! But it says here she works over 40 hours a week!*
Ms. Smith:	*That's right. So, it would be time-and-a-half for the time she worked over 40 hours.*

Ms. Smith sat with Isis and quietly redirected her, asking her to watch the tone of voice she used when asking for help.

Isis:	*I don't have a tone of voice. I'm monotone... Can I take my medicine? I'm about to flip out?*
Ms. Fields:	*I'll have to go get it for you. (She left the room).*
Isis (loudly):	*Can I just use a calculator?*
Ms. Smith:	*Watch your tone.*
Isis:	*I don't have a tone of voice, Ms. Smith... Isn't Sunday double time?*
Ms. Smith:	*I'm not sure.*
Isis:	*I have to know. It says here he worked 40 hours during the regular work week, and five hours on Sunday.*
Arty:	*Sunday is just time-and-a-half. Double time is only for holidays.*
Isis:	*Will you tell Ms. Fields I need my medicine?*

Ms. Smith: *She's probably talking. She'll be here in a minute.*
Isis: *Well tell her to quit talking and get me my medicine!*

Several minutes passed.

Isis: *Will you tell Ms. Fields to hurry up?*

Ms. Smith called to Ms. Fields over the walkie-talkie.

Isis: *Will you check the answer to number two so I will know
 if I need to use double time or time-and-a-half?*

*Arty went over to provide assistance to Isis. Ms. Fields returned with Isis's
medicine, apologizing for taking so long. "I had to find it." After taking the
medicine, Isis said to Arty, "I'm like so aggravated." After a minute or so, Isis
said out loud, "Thank you. Thank you so much." This comment seemed to be
directed to no one in particular. Arty said, "She was about to kill somebody back
here."*

Maury: *Is Memorial Day time-and-a-half or double time?*

*Ms. Smith looked up the answer in the teacher's edition of the math book and
read this explanation: "Time-and-a-half is for time worked beyond an eight
hour day during the week, and on Saturdays. Double time is for holidays and
Sundays."*

Isis: Fuck this math!

*Isis threw her extra notebook paper behind her and got up and stapled her
worksheets together, turning them in. She sat back down at her desk. "I'm not
doing it!" Maury tried to calm her down, saying quietly, "Hey, don't get mad."
Isis sat quietly, crying at her desk.*

While Isis had good reason to be frustrated in this scenario, and her
frustration may have been in fact amplified by her need for medication, in the
end she could not continue to hold her emotions in check and clearly
demonstrated her frustration with not being able to complete the assignment
correctly.

Isis's need to be competent in academics often led her to disagree with
her teachers about their answers, accusing them of making an error in their
grading or their explanation. *"Ms. Smith, this isn't wrong!"* or *"You marked
this wrong."* In these examples, Isis attempted to justify her incorrect
answers by telling her teachers that they were mistaken.

Dodging Work

As noted previously, sometimes when tasks were either too hard or boring to Isis, she would engage in a variety of avoidance behaviors in order to evade participation in the required task. Each of the following scenarios occurred on a different day during my observations of Isis's classroom.

> *Isis completed two envelopes and then complained about a headache. "I've got a pressure headache. It just came on. Can I go to the office to get a Tylenol?"*

> *Ms. Smith began a discussion of the book. Isis interrupted. "Hey, I need to go get my medicine. I took it too late yesterday." The teacher called down to the nurse and let Isis... go to the office. When Isis returned, she asked me "Has she finished reading yet?" I told her that she hadn't even started. Isis grimaced.*

> *In Yearbook, students were writing out ballots for the presidential elections next week. In the course of half an hour, Isis only filled out two ballots. She begged her teacher at the beginning of the activity to be exempt from doing it, saying that her handwriting was not good enough. However, her teacher would not let her out of the activity. Her next strategy was to ask me to help her, so I did. As it turned out, I ended up making 10 ballots to her two.*

Whether by interruption, negotiation, manipulation, or simply engaging in something other than what she was supposed to be doing, Isis often effectively avoided participating in challenging or undesirable activities.

Independence

Isis considered herself to be a very independent young woman, defining her autonomy by not allowing anyone to tell her what to do, or how to dress, or how to act. As she put it, Isis was her *"own person"* and was quite proud of that fact, once again justifying her actions and attitudes toward teachers and peers. It is possible that Isis considered her *straight talk* as a way to exert her independence, defining herself as a maverick who was not afraid of being unique, cherishing her nonconformist character. One way Isis portrayed herself as an independent woman was through her interactions with peers. She was often observed setting her peers straight and redirecting them in a straightforward manner. *"Shut up Arty!" "What's it to you anyway?" "She wasn't talking to you."*

In addition to perceiving herself as being straightforward, Isis did not respect others who she felt were not *"true to themselves,"* succumbing to typical social standards of dress or behavior. *"What's up with girls these*

days? Have you noticed that? They all look alike. They all dress alike, wear their hair the same. All those girls are blonds!" Isis was referring to a small group of girls from the alternative school that she passed in the hallway. As noted by this and other statements, Isis has little tolerance for others whom she deemed conformist and preferred people who were confident in their individuality.

Being a Girl

Coinciding with her intolerance of conformity was Isis's intolerance for stereotypical ideas of femininity, recognizing that she did not act like the other high-school-aged girls in this ED program who *lead boys on.* Isis explained that boys do not respect girls who act like that and felt that because she was the exception to the rule, refraining from such attention-getting behaviors, the boys in this ED program seemed to respect her, treating her differently than they did her female counterparts. Isis recognized that although she was a female, she was not subjected to the same unequal status as the other girls in the school because of her aggressive nature. *"I'm treated differently here than the other girls. It's more like I'm an equal with the boys,"* hinting at the recognition that boys are somehow better than girls. Several of the boys in her class concurred, as noted in the following passage.

> When I first met Isis she was in Ms. Smith's class, sitting at her desk. Surrounding her were three male students, Maury, Isaiah, and Arty... I asked Isis if she liked it at this school, and Maury replied "She likes it here." Arty said, "Yeah, she's just one of the boys." I asked Isis if she wanted to be one of the boys and she answered "not really." Isaiah explained "She fights like one of the boys" to which Arty replied "Yeah, she wants to be able to stand up and piss in the snow like the rest of us."

One would think by Isis's and the boys' description of her and by her demeanor that Isis would resemble a boy in looks and dress as well. The irony is that Isis was actually very feminine in appearance. Although she wore jeans and a t-shirt or sweatshirt most of the time, the clothes she wore were fitted and fashionable. She was very petite and had striking features by conventional standards of beauty. Isis was one of those fortunate women who could meet those standards without enhancement from makeup.

While Isis considered herself an equal to the boys, she was also still a female and may, in fact, have been of interest to some of the boys beyond friendship.

During the morning, someone started mowing the lawn outside of the classroom window. Isis looked out the window and said, "Hey, are there any good looking landscapers out there?" Brady replied, "What's so great about landscapers? All the landscapers I know are fags." Isaiah chimed in in agreement. "All the landscapers I ever worked with were stupid!" Perhaps recognizing that this was purely a male perspective on the subject, Isis ended the conversation by saying, "You just don't know."

Although Isis seemed to recognize that the boys had a different perspective about the landscaper than she had because they were boys, she had not considered the possibility that they may have been jealous of her attention to the young man on the lawn mower. I brought this up to Isis later in the day when I had a chance to talk with her alone. I told her what I had observed in the classroom and asked Isis whether she had ever considered that the boys' reactions might have been because they were jealous.

Isis:	*I don't know. I guess. I never really thought about it. I didn't realize they said that. Well, I guess I did, but I didn't really think about it. What do you mean?*
MJ:	*I don't know what I mean. I guess I was just wondering if you had ever considered that they really do like you as a girlfriend and that they could be jealous of you being interested in another guy.*
Isis:	*I never really thought about it.*

Isis seemed to warm up to the possibility that the boys might want her attention. Later in the afternoon, when we had returned to the classroom, the lawn mower started up again outside. Isis turned to Brady and asked *"Hey, is he good looking?"* Brady replied, *"I don't know. I don't look at them."* Isis smiled at me and then said, *"Ah, come on Brady. Find a good looking one for me."* Although Isis may not have previously considered her relationships with boys beyond friendship, she was beginning to change her views. [1] By

[1] As I reflect back on this scene, I am reminded of how precarious the researcher's position is during a study such as this. I must question my influence on these students. Was I responsible for Isis's sudden realization that she is attractive to her male peers? As noted, by the end of the school year, Isis began dating a young man who also attended this special education program. She was frequently seen with multiple "hickies" on her neck and openly displayed affection with her boyfriend. Did I do that? If so, then I must consider other ways in which I may have influenced these students. I cannot claim objectivity, and ethics require me to be open about the ramifications of being a participant researcher. Is it alright to have an impact on the other research participants? What I have learned is that I do not believe it is possible not to, nor perhaps, is it even necessary. In order for the trusting relationship between researcher and participants to develop, which is tantamount for this type of research, there must be some influence

April of the school year, Isis had come in to school with a display of "hickies" on her neck. She had just recently started to date a boy from another classroom in this ED program. Yet, while Isis's opinion of boys obviously changed during the course of the school year, there was little change in her views about people of color.

Racism

During our individual conversations and whole class discussions, Isis openly shared her hatred for African Americans, immigrants, and other people of color. She felt so strongly about her convictions that she often became quite agitated, raising her voice during the discussions and talking over others. During one private conversation she and I had, which is reflected in her Personal Life Presentation, Isis eventually asked that we change the subject because she knew her passion for supporting racism was escalating and she did not want to do something or say something that would get her into trouble. *"I don't want to talk about this anymore because it's making me mad."* This comment came after I had questioned Isis's rationale for not allowing people who do not speak English in this country. When she said that *"They should just all go home,"* I had reminded Isis that some people were forced to come to this country, but that now this country is considered their home. My debating the issue was more than Isis could handle. Just as with academic tasks, Isis chose to avoid something she perceived as challenging, preferring the facade of self-assuredness over the confusion one feels when questioning one's own values and beliefs. During a whole class discussion,

flowing between all parties involved in the research as a result. The influence truly goes both ways and is even symbiotic in nature. Just as I have had an influence on these young women, so have they had on me.

During this research, it was necessary for me as the ethnographer to become a co-performer in these dramas and rituals as a method for gaining a better understanding of the meanings embodied in them. Pinar (1988) reinforces this idea, stating that "for understanding to have social use, it must be negotiated social" (p. 145). Therefore, it was necessary to gain access to and participate in these social performances in order to investigate what they mean. Inevitably, I became a part of the performance, having an impact on the other characters in the scene. As researchers engaging in narratives, we are not simply observers, but actually become part of the narrative process. Our narratives are also lived, told, and retold during the research, thus making the narratives between participant and researcher a shared narrative construction and reconstruction through a process of inquiry (Clandinin & Connelly, 1991). In a sense, the research becomes a joint venture and a mutual reconstruction.

Isis reiterated her feelings about people of color, which appeared to be a mirrored image of most of the class' racist beliefs. While Isis engaged in this discussion, she did not get quite as animated or angry as she had when we had been alone. It is possible that Isis was less compelled to push her opinion and less likely to debate when she felt supported in her convictions by her classmates.

Although Isis acknowledged that her racism may be somewhat influenced by her family, she was adamant that her racist beliefs were her own, which came from her heart. *"I know what I believe. It's just me."* She refused to consider the possibility that what she had been taught was purely one perspective and chose to ignore the plausibility of other *truths* about race and ethnicity. Isis was so sure that she was an individual with unique thoughts and true to herself that she failed to recognize other conceivably influential factors in her life. Although I had not anticipated that racism would be an issue in this educational environment because of the homogeneous race and culture of the school population, I was sorely mistaken. The issue actually went far beyond that of Isis's personal contempt of others who did not look or act like her. Therefore, racism will be covered more completely in Chapter 11 as issues of power in the ED culture are explored more fully.

One Great Big Contradiction

While maintaining ignorance of varying perspectives worked well for Isis when she did not want to confront opposing views, this strategy was in direct opposition to her personal definition of respect. As she explained in her Personal Life Presentation,

> *"When I respect someone, I try to understand their views and relate those views to different situations so I can better understand them. I do this by listening to what someone has to say and by giving them a chance to say what they are thinking without interrupting them while they share their value or beliefs... Sometimes, however, people don't treat each other as they want to be treated themselves and they don't realize that they are guilty of doing the same thing they preach to others not to do."*

I had seen Isis demonstrate this respectful behavior with me on many occasions, as well as with the principal, so I felt confident that Isis truly believed what she ascribed to above. The contradiction materialized, however, when she shared her perceptions about groups of *Others* who acted differently than she, such as other female teenagers, immigrants, or people of

color. This contradiction between philosophy and action was also apparent in her relationship with her teacher.

As alluded to in the initial discussion of Isis, she appeared to epitomize the term "contradiction." While she seemed to identify herself as someone who was in control, she acknowledged her lack of control due to her impulsive behavior, relegating responsibility for her behavior to her teacher. Although she desired to have the appearance of independence and competence, Isis avoided difficult tasks and became easily frustrated when challenged. Although Isis frowned upon girls who used their sexuality to gain attention, she had begun to explore her own sexuality and had even made no effort to keep her discoveries discreet.

Blinded by the Light of the Fire

Of the three girls, Isis seemed to have a better understanding of how the school environment influenced student behavior. Her metaphor of a burning flame slowly growing inside of someone was in recognition that there are slow triggers that the teachers contribute to during their interactions with students, which, in essence, put more coal on the fire (and sometimes even lighter fluid)! She was able to cite specific examples in her Personal Life Presentation of how teachers responded in ways that ultimately escalated a behavioral situation with a student. Examples included when Ms. Johnson hung up the phone while Isis was trying to talk with her mother, when a teacher tried to make Isis pick up her point sheet, and when her teacher tried to make Isis apologize to another teacher.

While this knowledge of teacher behavior was somewhat insightful, Isis continued to remain unable to recognize her own contribution to the problems she experienced. Although Isis spoke of respect as a *"two-way thing,"* she seldom acknowledged the part she or other students played in that two-sided relationship, avoiding responsibility for possibly damaging relationships with her teachers. Even though Isis did say that she knew she was not perfect, she contended that it was the teacher's ultimate responsibility to deal with her behavior in a way that did not continue to *feed the flame*.

Silencing Mandy

… she knelt down and looked along the passage into the loveliest garden you ever saw. How she longed to get out of that dark hall, and wander about among those beds of bright flowers and those cool fountains, but she could not even get her head through the doorway.

Lewis Carroll
Alice's Adventures in Wonderland

The Good and the Bad

My Fave Thing. I'm Mandy. I have always liked the name Mandy so I decided to use it in this research project. I have several other nicknames that I've been called that I could have used like "bone" because I'm so skinny and "crack head," but I decided to use Mandy instead. I got the name crack head not because I get high or anything. It's just because I'm crazy, you know, like wild and stuff. I'm 12 years old and I live with my mom and my stepdad in an apartment. My stepdad seems more like my real dad because he's been my dad since I was two. I used to see my real dad, but I haven't seen him in over a year. Whenever I saw him, he always left me with his girlfriend anyway. He always had something else he had to do. That isn't why I don't see him no more, but I don't want to talk about it. I don't like to talk about stuff that's happened to me. I'd rather forget about it. That's what helps me deal with things. I just forget about it. Even though some bad stuff has gone on, I really like my family because I think they are cool in a lot of ways. I can't tell you how they're cool because it's inappropriate to talk about.

My fave thing to do is to go roller-skating at the roller rink and see my friends and my boyfriend. I'm good at jumping rope and I like to read a lot too. If I could go anywhere in the world it would be to Florida because the Back Street Boys are there and I would love to meet them. I like to dream about the things I would like to have or do, like buy new clothes and shoes and have a trampoline and a swimming pool. If I had a thousand dollars, that's what I think I would buy. My dream bedroom would have blue walls, a blue ceiling, and a blue floor. It would have a big bed, big mirror, and a matching bedroom set with a dresser. I would also get a pet. I used to have a lizard, but our landlord won't let us have pets.

If I could wish for anything, though, I would wish for everyone to be good. And I wish for me to get to see my boyfriend tonight. And I wish for me to get good grades. I also wish for my mom to get a car, and a job. But what I think I would really like, deep down inside, is for my behavior to change. My dad said if I don't change my behavior, I'll have to go to foster care, and I don't want that.

I'm Bad... But I've Been Trying. I go to this school because my behavior is so bad. It seems like I've always gone here, and I can't really remember much about my old schools or where I went before. I was here for a little bit last year too, but I ended up spending a lot of time at a residential treatment center at the end of the school year. That's why I've been trying to be so good now. If I get my behavior up to 90 percent, then my mom says I get to go to another school. I want to go to a school in Kentucky. My mom and dad want to move there if they can, and I want to go with them. See, I'm bad because of the people I hang around with at my home and my cousins do stuff around me that they shouldn't. They're teaching me bad stuff so I need to get away from here. Also, I think we have a rapist where we live. One girl in another apartment was raped, and we keep telling the cops that a red truck has been hanging around my apartment complex, but they don't do nothing. There's woods around there too, and I don't feel very safe.

Sometimes my behavior gets so bad that I hit people and stuff. I broke a teacher's nose last year. I think what sets me off is when people tell me what to do. It doesn't matter if it's a kid or an adult. One time, when I was at my friend's house we were just talking. Her mom heard us cussing so she tried to pour detergent down my throat for a punishment. Well, I just reared my fist back and hit her. My friend ended up giving me a bloody nose because I had hit her mom, so I hit her too. When the cops got there, the policewoman didn't believe me when I told her I was defending myself. I wasn't going to take that kind of stuff from anyone.

I've been trying real hard to be good, though. I've been promising my mom that I will go to bed on time and I will eat better and I will be nicer. I won't go off and I will be good. To help me with my behavior, I take a lot of medication. I'm on five different kinds. I can only remember the name of one and that's lithium. I think it's all my medication that makes my belly hurt sometimes. I don't really know, though. I ask to get out of class a lot because it hurts so much sometimes, but I don't miss school very much, unless I'm in lock-up or a treatment center. I don't think my teachers believe me when I tell them that my belly hurts because they try to give me TUMS or something like that, but it won't help because it never helps. TUMS don't do nothing.

I'm not stupid. I know they don't believe me, and TUMS won't help my belly. It never does. So what's the use of even taking them?

My fave thing about last summer was I finally got home for good. At home I got to sleep in my own bed and I got to go swimming. I also got to eat some. What I liked the least about my summer was that I was at a treatment center for most of it, so I wasn't able to go to the pool a lot. I really didn't like not being home for a long summer break. I also didn't like not being able to buy something new or going to see some people.

I Don't Get Along with Girls. Stephanie and Lori are my friends. Lori is my best friend. She lives in my town and goes to the school near where I live. Stephanie used to live in my town, but moved away. Now she lives on the other side of the city. Lori's mom wants to have Stephanie live with her because her parents are messed up. That would be good for Stephanie. Most of my friends are boys. I don't get along with girls very well, that's why it doesn't bother me that I'm the only girl in my class.

There are actually a couple of girls I would like to beat up. I don't know why. One girl is prettier than me and is a prep and bugs me. Other girls just bug me. My friend Stephanie wants to beat up Jennifer, my cousin, because Jennifer started calling her names and stuff, and she doesn't even know her. See, I let Stephanie borrow some of my stuff, but she wouldn't give it back. We went over to her house and I knocked on her door, but they didn't answer. So Tommy started banging on the door. I didn't, but Tommy did. Her brother came to the door and said he would get the stuff for me later. I said forget that, and started cussing him out.

I'm not really friends with any of the kids in my class, except maybe Carl. When I was at the skating rink, one boy named Jack said that he liked to look at my butt, and now Carl is saying that. He wants to go out with me, but I only like him as a friend. He was my boyfriend for a little while, and this other kid in my class started telling stories about us, like how I rubbed Carl's leg in art and stuff, and that really made me mad. We didn't go out for very long though 'cause Carl told me that he never brushes his teeth. That's disgusting, so I broke up with him! I have another boyfriend, but not at this school. I also like Donald. He's in another class here, and he's in my group for therapy. Now that me and Carl aren't going out no more, I don't really have any friends here. But I've had a lot of different boyfriends at the roller rink and I hang out with a lot of people there. I like my teachers and Sheila too. Sheila's my therapist here at school.

School Rules

They Have Rules, but All Schools Do. This is my second year at this school, but I haven't gone a full school year yet because of going to the treatment center last year. The teachers are nice to you here if you are nice to them. If you're mean, then they're mean. But I like this school better than any other school I've been to. They have rules, but all schools do. They aren't as strict here, and they don't pick you up and slam you back into your seat, like Mr. Graves did. I was in an ED class in another school district and Mr. Graves was my teacher. He slammed some kid into his seat! He never did that to me, but he did push me down into my seat. This school is way better than day treatment too because they're less strict here.

I've learned a lot at this school. I've learned all about the rules and how you should be nice. I've learned how to make things, how to follow directions, how to listen, and how to have patience. They are teaching me that to get along with others you have to be nice and don't call names. And you have to trust each other. You also have to be truthful and take the time to get to know each other. I am proud of me when I make clubs on Fridays and when I have almost all of my homework done. I am trying to be good and follow the rules and not get into trouble. I guess I am proud of being here. Most of time I have fun in class and my teachers help me when I need it. I am most proud when I don't have to go to time-out or Level II or III.

Every morning when we come in, my teacher has assignments waiting for us. I work hard to get all my assignments done so I can have free time on the computer. I like it when I can get my work done and do good. But sometimes it's frustrating because I can't think of anything to write or I don't know how to do the work. Ms. Stacks, my teacher, always tries to give me help, like giving me pictures to use to give me ideas, but it's so hard to get started. But I wrote a story the other day that was two pages long and it was neat too! I was proud of that. I guess I ask for so much help because I'm lazy.

It frustrates Ms. Stacks when we don't do our work. One day, everyone was acting up so she gave us tons of paperwork to do. That's all we did all day! There were papers laid out all over the floor and we had to just keep picking new ones up when we got done with the old ones. I'd been one of the ones acting up a little bit. I had an attitude problem, but I turned it around.

One of the things we do here that they don't do at other schools is group [therapy]. Every Monday I go to group with Jonathan, Jarrod, and Donald. Sheila is our therapist. In group, we have to follow these rules. The first rule is about confidentiality. What is said in this room, stays in this room. If someone breaks the rule, they have to tell the group and then the group

decides the punishment. Another rule is that you gotta have respect for everyone in the group, like you have to keep quiet when someone else is talking. Other rules are that you have to listen, no cussing, no sleeping, and keep your hands and feet to yourself.

Sometimes the other kids don't follow the rules, though. Like Jarred. Sometimes I just want to hit him because he's always poking at me or trying to draw on me with a marker or something. I tell him to stop, but he doesn't unless Sheila makes him.

That Confidentiality Thing. Although I don't like to talk to people about stuff, I do talk to Sheila, except when I'm bad. Then I don't talk to no one. Sheila's easy to talk to for two reasons. For one, she's a therapist. And two, because of that confidentiality thing. If I tell her something she won't tell no one else. I have other people to talk to too. Missy [the researcher], my teacher Ms. Stacks, and Ms. Oneida. All the women here.

I Used To Get All of My Points. Sometimes things get a little wild at this school, like this morning we had a Code Red. A Code Red is when someone is in the school with a gun and we all have to line up against the wall and sit quietly and close the door and not move. I don't like having a Code Red but I can't really tell you why. Sometimes when we're working you can hear someone really losing it down the hall, but you have to stay in your seat and keep working or you'll lose points.

Sometimes we earn extra gym time if the whole class is being good. In gym the other day, we were playing this game of Red Light, Green Light. At first I didn't want to play it, but my teacher made me. In the game, you have to lay on your back and I didn't want to lay on my back. I was wearing my mom's shirt and I knew she didn't want it dirty. The game was too complicated anyway, and I just didn't feel like playing it, but I did. But my back hurt because of laying on the floor and when I was tagged by Arnold he made me hurt my wrist. Then I hurt my ankle and had to limp around for the rest of the day. I don't mind gym, but sometimes the boys get a little rough and I try to stay away from them when they do.

At this school, we earn points for being good. I used to get all my points, but lately I've been having some bad days and I haven't been earning very many points. My dad said that I have to get more than a hundred points in order to go skating at the roller rink on Friday, but Ms. Stacks keeps giving me a 98 or something like that. I don't get it. Even when I have a good day I only get a 98! God, sometimes I hate this school!

We also get lunch detentions if our behavior is bad. When a student has a lunch detention, when we are done eating we have to sit at our tables and

complete our work. Our whole class always eats in our classroom because we don't like the cafeteria, so usually after we're done eating we can have free time. But not when you have a lunch detention. We're also not allowed to buy chocolate milk when we have a lunch detention. It's been a long time since I've had chocolate milk. I used to get it a lot at the beginning of the school year, but not lately. It seems everything keeps getting worse.

I Didn't Care. Like there was this week in October that was terrible. One day I hit Ms. Stacks and had to go to Juvenile Detention. I didn't hit her very hard, though. Another day I went off and I guess I was banging my elbows on a table or something because now they're really bruised up. It all started because of some jerk on the bus. He was really bugging me so I beat him up. Ms. Stacks told me it wasn't appropriate to talk about it, but I told her I didn't care. Ms. Stacks got mad and wouldn't let me go to art, which really made me mad! The school had called Juvenile Detention to see if they could take me, but they didn't have any room so I had to stay at school all day in a Level III time-out. I had gone to Detention just the week before, and I didn't want to go back, so I was glad they didn't have any room. I stayed in Level III and did my work, but the next day it started all over again.

I was still mad about the day before, and all I wanted to do was sleep. I didn't care what anyone said, I just wanted them to leave me alone. Ms. Stacks said I couldn't go to electives because of my attitude, but I didn't care. I didn't want to go to electives anyway. I was already grounded at home. I wasn't going skating, so I couldn't lose nothing. Losing points didn't scare me. I told Ms. Stacks that I wasn't going to electives at all. She kept telling me that since I wasn't participating in class that I wasn't earning any points. But I didn't care. It was stupid and retarded. Points are for little babies. I didn't care if I was not participating and I decided then that I wasn't going to do no work that day anyway, no matter what she said or did.

Eventually Ms. Stacks took my book bag away from me, but I told her she had to give it back at the end of the day. It had my house key in it, and I had to be able to get back in the house, so I knew she had to give it back or my mom would be mad. Since I knew I had to get it back at the end of the day, I wasn't really worried. Besides, since she took my stuff, I couldn't do my work. Sometimes this place is so stupid!

I told Ms. Stacks I didn't care if I lost all my points. I figured I would just start skipping school. I was already grounded anyway for about two weeks. I didn't really care what happened. I thought about just going to live with my grandma. My mom doesn't understand me. She makes me baby-sit two kids everyday, and I don't want to do it any more, so I told her no! I started to tell Ms. Stacks about it so she would understand why I was so mad,

but then she started asking me all these questions. Every time I open my mouth she starts asking me questions! Ms. Stacks says it's because she needs to understand what's going on and that she wants me to start talking to her about it, but I'm not telling nobody nothing. They don't know me.

I didn't care about going to art. I'm not very good at art. I can't draw nothing. One time I asked Ms. Smith if she would draw the outline of things for me but she just said she would only do a couple of lines but not the whole outline. I told her to forget it, that I didn't want to draw anything then, but she just kept after me. If I don't like something, then I don't want to do it. I told her that I thought art was stupid, and lots of times I wouldn't draw nothing. Whatever I drew looked dumb anyway. I didn't want to go to gay art with those stupid gay teachers. I just didn't care.

One time it all got so bad that I totally refused to even go to art. I really lost it that day. I never did go to art, but Ms. Stacks made me write a letter to my class asking permission from the other kids if I could become a part of the class again. Here is what I wrote:

> I can change my behavior by doing what I am told. And I can change my behavior by not cussing, yelling, hitting things. And I can also change my behavior by not going to time-out. And I can also change my behavior by doing my work and staying awake in class. I think you guys should welcome me back because — I am turning my behavior around. And doing my work when asked. And I think I should be welcome back in the class because I'm not cussing, yelling, and hitting at anyone or anything. And I'm doing good well okay on turning my behavior. I am going to change my behavior around by not feeding into the bad cussing yelling stuff. And I am going to change my behavior around by not going to the time-out room acting like a big time fool. I also think that you guys should [let me] back in the class because — you guys can trust me. You guys can also let me back in the classroom because... I am not going to cuss, yell, hitting no body or at anything. I'm going to also change my behavior around by not being a poor leader. And I'm also going to change my behavior around by not going off when I don't get my way. And you guys can also let me back in the classroom because — I can do my work and be a great or good leader. Again. To others. If you guys will let me be one again.

I went back to class after that and when I asked Ms. Stacks if I was being good, she said yes. But there is something about art that just makes me mad. I hate fucking art! That whole week ended up being bad.

I Wasn't Going To Do Nothing! The next day after I wrote the letter to my class, when I had to go to art again, I couldn't bring myself to do any work. I just hated it in there. I decided I wasn't going to do nothing in that class for the rest of the year. They took me to a Level III time-out after that. Ms. Stacks told me I had two choices. She said I could either do my work in

Level III or I could do it in the Juvenile Detention Center. Ms. Stacks said that I wasn't going to get out of doing any work, and that I had to make the choice of where I was going to do it. I chose Level III.

I Wrote My Name in a Padded Cell Once. I didn't want to go to Juvenile again. I hate that place. There is a girl there who is really yucky and mean, and another girl who has lice. I like the workers there, though. They're pretty cool. See, you're not allowed to talk to the boys when you're there, but sometimes they open the doors so we can talk to each other from across the hall. But I never talked to them. I wrote my name in the padded cell once, and so did my cousin. That's where you go when you're out of control. But if you're just bad you have to be locked in a regular cell. The longest I was ever at JDC was a week, and I don't want to go back. In total, I ended up going to Juvenile Detention three times because of art. Eventually I got kicked out of art, so then I went to Yearbook. The teachers said they were giving me one more chance, but that this was my last chance. In Yearbook we were working on making collages with pictures of each class.

I was proud of me being able to turn it around after that. I learned to do my work and not complain about it. I'm glad I was able to turn it around with no more problems for awhile and I now understand my consequences. I was working very hard, completing my worksheets and all my other work. I tried to follow the rules so I could get out of this school for good. Something happened, though, after Thanksgiving.

I Kept Having Trouble. I had been having a lot of trouble both at home and at school. I ended up getting sent to a psych ward in a hospital. I came back to school for a little bit, but over Christmas I had a really bad time and ended up spending Christmas in lock-up at Juvenile. I was there for 24 days. I went in there on December 22nd and stayed there over Christmas and New Years. My probation officer gave me a 500 piece puzzle, which I already put together by myself. I had to wait until after Christmas to get any of my presents, though, because you can't have anything like that in there. I was in court just for a check, and I started yelling at my probation officer, calling her a bitch. That's why they put me in Juvenile. My cousin Jennifer was in there too. When I got back to school after Christmas, I heard someone talking about sending me to another residential treatment facility, but first I went back to the hospital.

Kyle [a mental health worker] came to my house to pick me up and take me to the hospital. I didn't care. I was happy to go. I packed up all my stuff and we left. My hospital room was okay. I put up all my pictures and stuff and it looked nice, just like my room at home. But it was boring there

and I wanted to go home. Eventually I did, but I kept having trouble. In school, I had to keep getting restrained. They put me in handcuffs and took me to Juvenile in a police car once. But I didn't care. I wasn't going to do nothing they told me to. They wrote a behavior plan for me, but I hated the fucking plan. Why did I have to talk with Ms. Johnson everyday. I hate her!

Me and my mom weren't getting along either. I ended up hitting her. They told her to file assault charges, so she did, and now I'm back in lock-up again, and I'm for sure not going to go back to school. I haven't been there in a couple of months. It's just like last year, except I don't think I'm even going to be allowed to go home this time. The judge said he wanted to send me to prison, so I cussed him out. He don't know me. He can't make me do nothing! They're trying to get me into foster care, but I don't think nobody would want me. So, I guess I'll just stay here. Its not so bad here sometimes.[1]

[1] The reader may note that Mandy's Personal Life Presentation is much shorter than the other two students participating in this project, subsequently affecting the analysis and interpretation of her story in the next chapter. Mandy's difficulties in school became so severe that she was removed from school and remanded to the juvenile authorities for more intense supervision and mental health services. When she was having a difficult day, I often refrained from seeing her because her teachers feared that her behavior would escalate. So beginning in November of the school year, my time with Mandy was limited. She was removed from school by mid February. In comparison, although Air was often absent from school, she did talk with me at length when she was there. She did not leave school to get married until March. Isis remained in school the entire school year, participating in this study throughout her junior year.

Finding Mandy's Key

"You're thinking about something, my dear, and that makes you forget to talk."

Lewis Carroll
Alice's Adventures in Wonderland

Mandy's Lock Box

Initially, Mandy was very difficult to decipher because she was a veritable fortress, building impenetrable walls of secrecy and distrust. In addition, her language skills were such that she often told stories in fragments, requiring me to ask multiple probing questions before even the semblance of a coherent story could be generated. However, over time I realized that by keeping secrets and talking in riddles, perhaps Mandy was saying more than simple words could have conveyed.

Many of the stories Mandy did tell about her life were typical stories of adolescence. Stories about her parents, girl friends, boyfriends, and fun times at the roller rink, all portray a very typical childhood. However, interlaced with these stories were tales of a lifestyle quite different from my own, such as her story about striking her friend and her friend's mother after the mother had attempted to pour detergent down Mandy's throat for swearing. At age 12, it is worrisome that Mandy seemed to be unbothered by the fact that she had experienced multiple run-ins with the police. It was simply a reality of her life.

Yet, it is the stories Mandy refused to tell that are most revealing. Many school officials and educators, along with Mandy's therapists and parents believed that Mandy had experienced some form of sexual abuse. I was told on several occasions that just when it seemed Mandy was on the verge of disclosing some atrocity in her life, she would clam up and refuse to talk further. For some reason, Mandy seemed to feel that if she spoke up, she would get in trouble. *"I'm not talking about yesterday. That's what gets me in trouble."* At one point, I told Mandy that I had noticed she did not like to talk about bad things that had happened to her. Mandy conceded, explaining that instead of talking about them she would rather forget about them. *"That's what helps me."* On one occasion, Mandy's teacher attempted to pry some information out of her after Mandy had inadvertently begun to share

something about a specific incident that had happened at home. Catching her error, Mandy quickly responded, *"Why are you asking me all these questions? Why do you want to know that? I open my mouth and you start asking me all these questions!"* Throughout the course of this study, Mandy kept quiet about most of the personal events in her life.

What is ironic is that Mandy believed she did actually talk with someone about her problems. As she stated in her Personal Life Presentation, Mandy claimed that she felt comfortable talking with Sheila, her mental health therapist at school, because of Sheila's code of confidentiality. Sheila, however, claimed that Mandy had never confided in her about anything beyond what Mandy shared in her Personal Life Presentation.

Avoidance As a Way of Life

Mandy's reluctance to share her problems, even with her family, had possibly kept her from confronting the ghosts that haunted her, which many believe was why Mandy became so obstinate and defiant. This desire to avoid what troubled her permeated the way Mandy dealt with all uncomfortable situations. When tasks were difficult, Mandy often refused to participate or begged for assistance from either her peers or teachers.

> *"Will you draw the outline for me, and I'll do the rest?" "Will you draw this?"*
> *"I can't do this. It's too hard. Will you do it?" "I don't like it." "I don't want to*
> *do it." "This is stupid! I don't want to draw!" "Will you pick that up for me?"*
> *"I don't get it." "I don't understand." "I don't want to play this. It's*
> *complicated. I'm not going to play... I don't want to play this one."*

In addition, when Mandy wanted to stop participating in an activity altogether, she often feigned injury or illness.

> *"Ms. Stacks, I have bumps on my arm and it itches." "I don't know... My belly*
> *hurts." "My back hurts." "He made me hurt my wrist." "I hurt my ankle."*

While it is possible that some of these ailments and injuries may have been real such as her stomachaches, it is probable that many were not, not only because of the number of incidents of injury reported by Mandy, but also through my observation of the situations in which Mandy was purportedly injured. Perhaps claiming injury was only a ruse on Mandy's part to escape uncomfortable or challenging situations.

Being Good

When Mandy was having a good day, as she often did throughout the first two months of the school year, Mandy presented herself as someone who prided herself on *being good* and being competent. Similar to Isis, Mandy liked it when she knew she had done well on an assignment or when she could demonstrate leadership in the classroom by following the rules. In the example below, Mandy's class was given a writing assignment on which she was having difficulty getting started.

> *During story writing, Mandy repeated "I can't think of nothing" three times. "I haven't even written the first line. It's too hard." However, after some encouragement by her teacher, Mandy ended up completing the assignment. "Here's my story. It's a little long. It's two pages. Is it neat?"*

Although Mandy initially tried to avoid the assignment, once she had completed it she was proud of the length and quality of her work. Another example follows.

> *When Mandy finished her activity, Ms. Stacks asked her to put her papers into her writing folder. Seeing other graded papers in there, Mandy asked "Can I look at these?" Her teacher said "Sure." After looking through them she held them up for me to see and told me "I got 200 points!"*

In the field note excerpt above, once again Mandy demonstrated a sense of pride in what she had managed to accomplish academically.

As mentioned earlier, following the rules was another way Mandy demonstrated competence. Throughout September and October, when Mandy had been on her best behavior, she seemed almost to chant in her journal entries how good she was feeling about herself for following the school rules.

> *"I am proud of me making clubs. Me having almost all of my home work done. And trying to be good. And follow the rules. And I am proud of being here."*

> *"I am proud of my earning clubs. And I am proud of me trying to be good. [A]nd help out. [T]ry to follow the rules. [M]e getting all of my work done. [N]ot getting into trouble."*

> *"I am very proud of me earning club's of [sic] year. And of my OK behaviors. And me having a fun time in this class. And not having to go to time-out level 2 or 3. And of my teachers helping me."*

"I am proud of me earning clubs 5 weeks in a row. And me getting better at my schoolwork. [A]nd me sharing my sticks. [M]aking a log cabin. And me learning about J[h]onny Appleseed."

"I'm proud of me turning it around. And I learned to do my work and not complain about it. And I'm proud of me getting my book done. And that I turned it around and I understand my [consequences]."

"I'm proud of me turning it around. Me getting my work done. And me being back in the class. And me doing my work. With no more [problems]."

As I read through each of these journal entries, I wondered whether this was truly how Mandy felt about herself and her behavior, or whether she was simply trying to convince herself to feel good about what she had accomplished.

Mandy appeared to not only gain a sense of self worth when she was able to follow the rules, but also when she was able to remind others to do so as well. On several occasions, I overheard Mandy prompting her peers to remember the classroom rules.

Today, as Carl left the room to run an errand for the teacher, Mandy said "Don't forget to take a pass."

A peer rushed by us and Mandy told him to slow down and walk.

Carl got up from his seat and left his chair out. Mandy said, "Carl, push your chair in."

Mandy seemed to see her school world through the black and white lenses of right and wrong. She organized her day around the rules and measured her own *goodness* by the number of rules she either followed or broke. On a particularly good day, I asked Mandy what she would do if there were no rules about having to go to school or to do work. Mandy replied that she would still come to school and she would probably not take any free time, but instead work all day. When Mandy was *good*, she prided herself on being self-motivated and behaving better than all of the other students. However, most of the time, Mandy seemed unable to govern her own behavior outside of the rules and the points she earned.

Being Bad

Since Mandy defined herself through either obedience or disregard of the rules, when Mandy was having a particularly difficult day, she consciously

disobeyed every rule that she could, openly demonstrating acts of rebellion against the school's definition of what it meant to *be good*. Therefore, Mandy often defined herself as *bad* and appeared to cling to this image she fashioned of herself as demonstrated in the following example. For one classroom assignment, the students were asked to create a hieroglyphic that would symbolize them. This was Mandy's explanation for the symbols she chose.

> *I picked sad because I'm sad.*
> *I picked bad because I am bad.*
> *I picked war—because that's what people want to do—fight.*
> *I picked girl because I'm a girl.*
> *I picked bear because I like bears.*

Even when Mandy was experiencing success in the classroom, as she was when she wrote the above, she considered herself to be *bad*. It is possible that if Mandy had truly experienced some form of abuse in the past or presently, as a result she felt she was a bad person, blaming herself for her traumatic experience just as Air and Isis blamed themselves for some of the bad things that had happened to them. Unless Mandy discloses such abuse, however, this remains purely speculation.

Aside from Mandy's disregard for the rules, like Isis she also often blatantly claimed that she did not care what others thought of her or what happened to her. It was as if Mandy was fulfilling a prophesy she had made about herself, which lies in stark contrast to the Mandy who had on other occasions been so proud of her behavior. Perhaps it took so much effort on Mandy's part to *be good* and follow the rules, that when she was unable to, for whatever reason, she was so disappointed with herself that she gave up trying.

> *"I don't care. I don't care if I lose all my points." "I don't care. I'll just start skipping school. I'm already grounded anyway for about two weeks." "I don't really care." "I don't really care what the teachers do."*

This constant refrain was replayed over and over within the body of her Personal Life Presentation as well.

Mandy Disappears

As Mandy's *noncompliant* behavior began to escalate, the members of her IEP team struggled to find what would work for Mandy to help her control her behavior. Her principal made a contact with the director of the residential

treatment facility Mandy had gone to the year before and together they agreed that perhaps returning to the residential facility would not be the best intervention for Mandy. Obviously it had not worked before since Mandy was still having so much trouble with her behavior. It was reasoned that it would probably not be beneficial to go that route again. Instead, the team agreed to further analyze the issues of Mandy's behavior and design a more intense behavior plan for her, even though several of the team members felt she should not be allowed to come back to school due to the severity of her behavior.

During the behavior-planning process, in collaboration with her case-worker and probation officer, it was agreed that Mandy would be hospitalized for 10 additional days. It was felt that the hospital would be the safest environment for monitoring Mandy's medications and making adjustments as needed. The school staff also decided to alert the hospital about the suspected abuse so that their therapists might be able to address it with Mandy during her therapy sessions.

When Mandy returned to school, her behavior continued to escalate in a similar pattern as it had the year before. The behavior plan had not been implemented with integrity, and the last time I was at Mandy's school when she was there, Ms. Oneida asked me not to see Mandy because her teacher claimed that Mandy's behavior worsened when she had visitors. Apparently, Mandy's therapist had visited her in school, resulting in a violent disruption in class. As Mandy mentioned in her Personal Life Presentation, she ended up handcuffed and taken in a police cruiser to the Juvenile Detention Center. She left the building screaming that she didn't care what they did to her. Since Mandy was not permitted visitors other than family while in detention, I have not seen her since. She was figuratively absorbed by the organizational structures of the juvenile court system and mental health services. Given my initial metaphor of Mandy as an impenetrable fortress, it has become an even more formidable task to gain insight from Mandy as she is encapsulated by yet another layer of walls and fences.

The Presentation Of Self

"Who are you?" said the Caterpillar... Alice replied, rather shyly, "I—I hardly know, Sir, just at the present—at least I know who I was when I got up this morning, but I think I must have been changed several times since then." "What do you mean by that? said the Caterpillar, sternly. "Explain yourself!" "I can't explain myself, I'm afraid, Sir," said Alice, "because I'm not myself, you see."

Lewis Carroll
Alice's Adventures in Wonderland

Becoming "Somebody" in ED Programs:
Combined Voices of Gender and Culture

Defining the Self. Philip Wexler (1988) claims that schools demonstrate a fractured organization of school culture, leaving a sense of emptiness in students. To fill the void, students work to create themselves into someone who is visible, similar to others, and yet unique at the same time. Proweller (1998) refers to this as a process of *becoming*, in which students engage in the public sphere of the classrooms and hallways of school. "[T]heir central and defining activity in school is to establish at least the image of an identity" (p. 155). However, Proweller contends that oftentimes schools fail to recognize that this identity formation process is engaged in by the students as a means of organizing and problematizing daily life in school within and against an individual's experiences with peer culture, family life, and broader social dynamics.

In order to uncover who these young women in the ED environment felt they had become and why, it was helpful to begin my investigation by initially focusing on the duet played between cultural and gender identities of the students, particularly the female students in the ED classroom. Oftentimes the behaviors exhibited by young students are telling us how the learner sees herself or himself in relationship to others and to the larger society. Particularly in early adolescence, one can observe behaviors that appear to be communicating a learner's personal identity, changing as the

learner grows and begins to develop a sense of who she is and who she wants to become.

One way in which identity formation can be viewed is through the eyes of the *self*. The self describes how an individual defines herself or himself based on the personal experiences she or he has, interpreting who one is in relation to other *selfs*. I am me, I am a daughter, I am a mother, I am a wife, I am a sister, I am a friend, I am a teacher, I am a learner, I am a researcher... each of the *selfs* influenced by the others. In this respect, the self is concerned with the inner experience of the individual and how the self arises within a social process (Mead, 1934).

As part of this social process, the *self* is created within the context of a production of culture. Identity formation as a cultural concept refers to a process through which group members gain an understanding of who they are based on their interactions with others in the environment (Pipher, 1994). Gaining a better understanding of the meanings that girls in ED classrooms attribute to the signs, language, gestures, and actions of others toward them in this potentially abusive school climate provided insight into the dominating politics and forces of power against which these young women were resisting. Understanding identity in this sense is about moving from the private to the public, from the individual to the community, restoring connections between these two entities (Herman, 1992).

Various researchers have addressed identity formation in a similar fashion. Lois Weis (1990) investigated ways in which identities are constructed around a particular culture, pinpointing an emergent *moment of critique*, whereby learners define themselves through a show of cultural forms and expressions. For Proweller (1998), identity formation is the making of meaning out of lived experiences and consists of a complex set of interlocking processes based on multiple relationships. These lived experiences are actually part of our personal and collective histories. In order for us to be able to make meaning from them, these histories need to be taken out of the underground, exposing the secrets hidden within them (Fine, 1992; Herman, 1992).

Previous studies have explored the cultural formation of identity for students perceived as upper (Proweller, 1998), middle (Anyon, 1984; McRobbie, 1978; Sadker & Sadker, 1994), and lower class girls as well as boys (Connell, 1996; Jackson & Salisbury, 1996; Jordan, 1995). Missing from the literature, however, is information on how girls who have behavior problems and are educated in ED classrooms have negotiated the identity formation process within the ED culture. Their experiences are unique from other girls due to probable histories of abuse, neglect, and failure (Miller, 1993). Left uninvestigated is how these traumatic experiences, including

those in the ED classroom, and their responses to these experiences have influenced their sense of cultural and gender identity.

However, it would be negligent if not impossible to attempt to study the identity formation of these girls separate from the historical, material, and political influences that had an impact on how these girls view themselves. As Herman (1992) explains, "The study of war trauma becomes legitimate only in a context that challenges the sacrifices of young men in war. The study of trauma in sexual and domestic life becomes legitimate only in context that challenges the subordination of women and children" (p. 9). And the study of girls in ED programs becomes legitimate only in a context that challenges the realities of power and domination against which these girls are resisting, particularly in school.

Performing Aggression. Confounding the question of how these girls are responding is the difficulty with discerning the intent of their acts of aggression or resistance. Kenway and Fitzclarence (1997) propose that since violence is most often perpetrated by males, it can be best understood as an expression of masculinity. Yet, there are girls in ED programs who also exhibit the same aggressive behaviors. What are they expressing if not a type of masculinity? Kurz (1998) suggests that women primarily use violence and aggression as a means of self-defense. What implications does this have for girls in ED programs? Perhaps for these girls, aggression is an act of resistance as they attempt to gain or regain power.

In order to better understand the meaning of these oppositional acts performed by girls in ED classrooms, the concept of identity as a performance was embraced. Goffman (1959), Conquergood (1991), and Kehily (1995) suggested that identity is acted out for the benefit of both ourselves and others. While engaging in the performance, we either recognize our actions as demonstrating something we are not, or we buy into the role that we play. Conquergood explained that it is through the lived dramas and enacted rituals that these performances become meaningful.

Sharing Identities

While all three young women have unique histories, there are a number of similarities shared between them as they too enact rituals and engage in certain performances as a means for demonstrating who they are or rather how they want to be recognized. These similarities bind these girls together, creating a sense of unrecognized solidarity among them. Bounded by the ED culture, one that I continue to contend is an artificial culture created by

educators, these girls have each generated a similar identity for themselves in response to that culture.

A Common Need for Avoidance. Given that many students with behavioral difficulties are also students with learning disabilities, and also frequently miss instruction because of their behavioral issues, students with ED often are not accomplished students, lacking skills in many academic areas. These girls were no different. They all struggled to understand the material and purposefully avoided challenging tasks. They had historically experienced minimal success in school even prior to their ED placement and shied away from continual failure. While each may have had her own unique way of avoiding challenging tasks, the commonality among them was in their need for avoidance. None of these girls wanted to feel unsuccessful and each had sought out ways to demonstrate competence and success. Mandy did it by following school rules, Air found it through her peer relationships and sexuality, and Isis achieved success through her nonconformity and self-righteous beliefs.

Rules and Relationships. When I first started looking at rules, I was focusing on the levels and points as well as Mandy's almost compulsive focus on rules. However, I can see now that Isis and Air were just as motivated by rules as Mandy. The difference was that the two older girls had been able to articulate the rules that governed them in a broader sense, while Mandy was trapped in the language given to her by the school culture. Rules seemed to govern everything for these girls, and in their minds there were some rules that should never be bent. The most important rules seemed to be the unwritten ones around respect and how people should treat one another.

Relationships played a big role in their lives, even those relationships some might consider nonproductive. I resist using the term *dysfunctional* instead of *nonproductive*, because I have decided that their relationships, no matter what they might look like to an outsider, had a function. In this light, perhaps the term nonproductive is not an accurate adjective either, because the relationships these girls had were constructed in a way to meet their individual needs, being both productive and functional.

Exploring Their Sexuality. As the girls began to cultivate relationships with others, they explored their sexuality in the context of those relationships, demonstrating an understanding of the expectations within traditional boy-girl friendships, even though they had demonstrated it in very different ways. Air, the most sensual of the three, used her sexuality as a means to feel good about herself and to get the attention she craved. She also conceded that she

had learned how to use sex as a bargaining tool to get her physical needs met as well, such as arranging to have a place to sleep or a change of clothes. As many middle-school-aged students do, Mandy defined her social self by the number of boyfriends she had either at school or at the roller rink. For most of the school year, Isis defined herself in opposition to her sexuality, condemning those who used it to gain attention, as Air had. However, Isis became intrigued by the possibility that her male friends might also see her in a different light, and by the spring of the school year, Isis had also begun exploring her social self in light of her sexuality.

While each explored her sexuality in a different way, they all agreed that getting along with boys was much easier than getting along with girls. Air told us that *"There aren't as many girls here either, and I don't get along very well with girls,"* and Mandy echoed that sentiment. *"Most of my friends are boys. I don't get along with girls very well, that's why it doesn't bother me that I'm the only girl in my class."* While Isis did have a best girl friend, she said that she had always been respected by boys and never had had any problems with them. In contrast, she depicted numerous tales of being *"dicked"* by girls and did not suggest having any other close female relationships other than with her best friend Kara.

Preferring the ED Culture. Contrary to what one might think given their open defiance against their teachers, these girls also shared a common preference for the current ED school program, recognizing that it was a better environment to be in than the other schools they had attended.

Mandy:	*I like this school better than any other school I've been to.*
Isis:	*I like this school in general because I think they have really helped me control my behavior.*
Air:	*I like this school better than the other schools I have been in.*

Previous school experiences for all three must have been fairly horrendous by comparison. Perhaps their preference for the segregated school program was due to the fact that there they were provided the arena in which to find success. For Mandy, the environment provided her with clear expectations through rules that she followed when she wanted to demonstrate competence. Isis thrived on the freedom she had to *tell it like it is* with no major reprisal. The ED culture provided Air with a venue in which she could *hang out* and interact with *friends*, or at least with others with whom she could empathize because they were a lot like her. Since teachers who worked in this environment were accustomed to the ways in which students with ED

displayed their identities, they were much more lax in their response to student misbehavior than perhaps their counterparts who taught in the general education public school milieu, setting the stage for the performances enacted.

Sharing Experiences of Female Adolescence

While the identities these girls had created were somewhat defined by the realities of the ED environment, there is also a sense that they were a part of something even bigger, beyond the boundaries of special education and even of school in general. The similarities among these three young women did not stop with them, but actually encompassed the identities of many female adolescents, being not so very different from their peers who do not have an emotional disturbance. Although the three young women may have defined themselves differently, in some instances generating performances of their *selfs* that were idiosyncratic to each, one can see how their personal descriptions of themselves add to the bricolage of *all* women's identities.

Even though these young women were segregated from their neighborhood peers, traveling miles to attend this special program, their issues were really no different than the issues many other young women face. It was just that they had decided to retaliate against oppressive powers and refuse further subjugation, fighting with every ounce of their being against those entities that they felt continually brought them down. They did so in a way that was deemed "unacceptable" by societal standards, such as refusing to do schoolwork, swearing in public, not attending school, abusing drugs, and being promiscuous, resulting in being labeled as having a disability and segregated into a more restrictive school setting. Sara Shandler (1999), a teenage author, used the analogy of a bird preparing for flight to describe this rebellion. She suggested that she may have on occasion flapped her wings too wildly as she attempted to spread her wings and exercise her newfound independence as a teenager. The girls in this study were flapping their wings as well in their attempt to free themselves from the bondage they experienced. Perhaps, however, they flapped more wildly than some. While other girls simply spread their wings, these girls flailed at the people closest to them, oftentimes injuring themselves and others in their struggle for independence.

Shared Tragedies. I had originally worried that by telling the stories of these young women I would be sensationalizing their lives, putting them on a stage on which others could view their sordid tales and comment on how

horrific and unrealistic their lives were from the mainstream population of adolescents. However, what I have come to realize is that although Air, Isis, and Mandy all have life stories made for unbelievable day time television drama, their experiences are surprisingly not so different from the experiences of many teenage females, regardless of socioeconomic status, parental support, friendships, race, or religion. All adolescent females seem to have experienced the same soul searching travels, demonstrated through their particular choice of resistance or accommodation as they try to discover who they are and who they want to become. For example, in Shandler's (1991) collection of writings by female adolescents from across the country, Kit Dewey, a teenage contributor to Shandler's book, explained that the true tragedy of her story was not in the mistreatment she had experienced, but rather in the fact that variations of this same story happened to so many girls. Yet, so many girls think that they are alone in their struggles. The stories to which Dewey refers are not so different as those shared by Mandy, Air and Isis. They are stories of abuse, anorexia, self-deprecation, self-mutilation, sex, drugs, alcohol, and rape. However, these stories were not written by girls with a diagnosed emotional disturbance, but rather by *average* teenagers who were coping with the same stressors as the students with ED.

Shared Hopes. Aside from the tragedies experienced by many *typical* teenage girls, there were also numerous other similarities among all of the girls, including those participating in this study. Many of these similarities included events of a less traumatic nature, such as pining for positive parent relationships. After soliciting high school students for responses, Shandler (1999) received many submissions about girls' negative relationships with their fathers. As Shandler herself explained,

> All the contributors to this section [of her book] divulge our need for our father. The often mixed emotions and loyalties of adolescence do not shake our desire for a loving relationship with our dad... [In submissions received] negative relationships with fathers outnumbered positive descriptions four to one. Repeatedly, girls wished for simple appreciation and recognition from their too often too-distant fathers. (p. 78)

As noted in the girls' Personal Life Presentations, each of the young women engaged in the study longed for a positive relationship with her father as well. Mandy did not see her biological father much anymore and conveyed disappointment that when she did have scheduled visits with him, he often did not prioritize the time to be with her. Although Air's father victimized her through sexual abuse, she still proudly displayed a recent picture of him on her desk. Isis longed for the resurrection of her once close relationship

with her father, allowing her best friend's father to fulfill that role now that her dad refused to speak with her. Just as the *typical* female adolescents described in their entries in Shandler's (1999) compilation of teenage stories, these *atypical* young women also wished for a positive relationship with their fathers.

Shared Identities as Victims. Victimization was another theme that existed among the experiences of these three individuals and much of the typical female adolescent population. As stated before, Air had been victimized by both of her parents and numerous other offenders. Isis was victimized somewhat by her disability characteristics as well as by her father and *the system* that was designed to protect her.[1]

Mandy had also possibly been victimized by someone, and most certainly was a victim of *the system* as well, through her extended stay in Juvenile Detention and multiple hospitalizations.

Yet victimization, a form of interpersonal oppression, is not reserved for only a few unlikely members of the population such as young women with an emotional disturbance, but is actually pervasive among all women in some form or another. Shakira Nesba Villanueva, another teenage contributor to Shandler's (1999) book, provides a definition of *victim* that I think is fitting. As Villanueva explains, "Victims have no right to decide the outcome of an action or event, which most times will affect them in a negative manner" (p. 260). Given this broad definition, probably most women (and perhaps many men) can relate to some form of victimization during their lifetimes.

Shared Voices. Another way the three young women participating in this study were similar to their non-disabled counterparts was through their shared need to find voice. An example that comes to mind involves Isis's best friend Kara. Isis frequently shared with Kara early drafts of our collaborative autobiography. Isis said that Kara had read through every draft hungrily, each time asking Isis when she was going to bring home another version. Isis's friend became so intrigued in the study I was doing, she submitted to me one of her own journal entries to include. As you may recall, Kara was Isis's closest friend, and although Kara attended a regular public high school and did not receive special education services, I decided to share what Kara wrote because it again demonstrates how a *typical* female adolescent's perspective is not all that different from Isis's.

[1] As a result of being hit by her father, Isis's father lost custody of her, even though Isis continued to want to have a father-daughter relationship .

I don't understand why girls dwell over guys so much. To a point it is fine but to drop one of your friends is really low. At this time of our lives (almost 18), we are supposed to have fun and just go buck wild. We don't need guys, but yeah it's cool to have them around, but not to choose him over your girl. Isis and I have never dicked each other over for any guy. If it came down to it we would all hang out together. Guys won't be there for you at this age. Actually I take that back because I have a real good guy friend, but a large percentage is very deceitful. I guess Shila is wanting to grow up before she can. She was engaged at sixteen and staying with her boyfriend all the time. She really confuses me, because when she's with him, she doesn't talk to me or Isis, but when she's not with him, she doesn't really call either anymore. Maybe she realizes that we are like her rebound, and she feels bad. I don't know.

Kara's willingness to write an entry for this project represents the common need female adolescents have to feel that they have a voice, to know that someone is listening to them. This need goes beyond students with disabilities, and is a need that many, if not all, girls may have.

While each of the three girls involved in this study were unique individuals acting out different performances for the audience in the ED environment, and somewhat in response to that environment, they also maintained identities similar to other female adolescents. In spite of their turbulent histories, these girls continued to personify the feelings and frustrations of their non-disabled peers. Although the issues these girls faced may seem magnified, looking larger and more encompassing than what most young women experience, perhaps it is not the experiences that are magnified, but rather their reactions to those oppressive experiences, hence the creation of the label *emotional disturbance*.

Powerful Influences:
Societal Power Makes Its Mark

The King and Queen of Hearts were seated on their throne when they arrived, with a great crowd assembled about them—all sorts of little birds and beasts, as well as the whole pack of cards: the Knave was standing before them, in chains, with a soldier on each side to guard him... "And that's the jury-box," thought Alice; "and those creatures... I suppose they are jurors!"

Lewis Carroll
Alice's Adventures in Wonderland

The Evolution of Personal Identities

As Mahoney (1994) suggests, there is a need to study women's experiences with abuse and oppression, not so much as victims, but as individuals caught in systems that perpetuate patterns of oppression, such as school systems. And when considering questions about identity formation, a relationship exists between power and knowledge that cannot be ignored (Proweller, 1998). Examples of such relationships exist in all schools, as every school can be viewed as an isolated arena of power. Within these arenas of power, the cultural identities of students are actively made on a daily basis through ongoing acceptance of, negotiations with, refusals toward, and struggles against oppressive practices (Jackson & Salisbury, 1996). Adolescents continually engage in this personal metamorphic process, pushing and pulling between the dichotomies of the self and the relationship of the self with the power structures in the community, resulting in a constant evolution of identity formation. Anyon (1984) refers to this activity as a process of accommodation and resistance. Through this process, students actively respond in both a personal and social way to the contradictions of power they encounter in the school environment. With this in mind, the configurations of power these girls were responding to in the ED classroom comes into question.

The Influence of Power. In feminist studies around issues of power, five different forms of power have been identified. While originally applied to businesses and other corporate institutions, this framework of power as a construct certainly applies to school systems as well and is of great use when taking a closer look at the issues of power with which these students contended in the ED environment. The five forms of power actually fall in to two distinct categories, "Power-Over" and "Power-To" (Smith, 1997; Yoder & Kahn, 1992). The terms themselves are quite descriptive and can be easily deconstructed. Power-Over refers to those realities, structures, or relationships through which power is exerted over someone as a means of controlling or influencing them. Four of the five forms of power are covered under the Power-Over umbrella, including societal power, organizational power, interpersonal power, and individual power (Yoder & Kahn, 1992).

Societal Power. When the focus of research is on women and power, societal power refers to the context in which power operates. Many of the students in ED programs come from families marginalized by poverty, culture, and the politics of Welfare and Children's Services, contributing to their sense of low status and powerlessness in the hegemonic social hierarchy exhibited in the media. How societal power has influenced the identities of these girls even prior to their eligibility for special education services would need to be a consideration as part of this research endeavor.

Organizational Power. Organizational power includes the systemic control over resources, rewards and punishment, information, and policies and procedures as well as the capacity to affect an organization's outcomes and goals. Although most often related to the work environment, organizational power is also pertinent to schools as educators control access to knowledge, privileges, choice making, and recognition. Success is defined by a set of predetermined standards and limits are systematically constructed to deny access to power by some students over others. While organizational power is prevalent in the general school population, its effects are perhaps even more obvious in special education culture, and in particular in ED programs. The very nature of the programs, having increased restrictions and decreased privileges in order to help learners control their actions, is an active example of how organizational power is intended to work. As educators in the ED program attempt to curb the disruptive behaviors of these students, their ethic of care does little to camouflage the structures created for the purpose of punishment and control, perhaps leading to further student oppression.

The ED environment is in essence an artificial culture sculpted by school administrators and teachers with certain expectations and outcomes in mind, constructed without regard to the resistance of such expectations already demonstrated by these students, particularly female students. The creation and structure of the ED class itself is a material relation with which these students must contend.

Interpersonal Power. While societal and organizational power refers to forms of Power-Over by institutional and societal systems, interpersonal power and individual power are centered around the power inherent in personal relationships. Yet, there remain distinct differences between the two. Interpersonal power refers to one person having power to influence another within a specific relationship. Oftentimes, students with ED, regardless of gender, have experienced and continue to experience domestic violence encompassing emotional, physical, or sexual abuse, including rape or incest (Miller, 1993). Such experiences are all related to interpersonal relationships dominated by fear and control. This continual victimization by others further contributes to the marginalized status of these students.

Individual Power. Individual power, on the other hand, refers to factors unique to individuals such as personality traits, motives, or attitudes. On this level of Power-Over, the focus of analysis is on the characteristics of an individual as they define a person's ability to influence others or get others to behave differently. Individual power for the female students in ED programs may have to do with their desire or need to indirectly take power back that was stolen from them. They do this through the demonstration of their own acts of domination, possibly attempting to control relationships in one setting such as peer and teacher relationships in school, because they feel they have no control over relationships in other settings such as sibling and parent relationships ("The educational needs," 1995). As we will see in this and the following chapters, the students in this ED school culture experienced all forms of Power-Over.

Societal Power

Societal power, which refers to the context of power within a culture or larger society, manifested itself in several ways for the girls in this study including socioeconomic status, disability, age, and gender. However, one of these arenas of power seemed to have had a greater impact on these girls within the bounded context of the ED culture, which is the focus of this

study. While poverty, age, and disability may have contributed to the oppression of these young women in their daily lives, gender seemed to be the form of societal power which weighed heaviest upon the shoulders of these young women every day within the ED school culture.

Disability. While I had fully expected gender to play a major role in the subjugation of these girls, the preponderance of gender as the primary source of societal Power-Over surprised me somewhat. I had initially expected that disability labeling would also have had a dominant negative impact on their school lives. In truth, disability did play a primary role in the oppression and subsequent subjugated status of these girls as students. However, the greatest impact disability had on these girls occurred prior to their officially entering the ED environment. The term *emotional disturbance,* as a school-related disability, is socially constructed by schools as a means for sorting and classifying students. The very process of making an eligibility determination for special education services under this category is a form of societal oppression because it demands that school personnel validate the presence of *abnormal* behavior. What is considered either normal or abnormal is determined by those with power both in society and in schools. Not only is the construction and identification of a set of characteristics for ED related to societal Power-Over, but once labeled as having a disability, the social stereotypes and expectations that exist about students with ED further contribute to their oppression. Just as Mahoney (1994) explained about battered women, these stereotypes actually mask the acts of resistance and accommodation the girls demonstrate, reducing their resistance to the lowest denominator, viewing them simply as unacceptable aberrations of behavior that need to be controlled.

Yet, even as societal conceptions of what is acceptable and unacceptable contributed to the initial placement of these girls in the ED culture, the influence disability had on these girls *once immersed* within the ED environment was somewhat nullified. This nullification occurred since all of the students within the ED culture had also experienced societal Power-Over through the special education identification process. They too had been relegated to a subordinate position among students in general and experienced segregation. So when students enter the ED environment, they are indoctrinated into a culture where all the students are equal in relation to their disability and behavior. Within this bounded context, there did not appear to be a hierarchy among students related to the severity of their behavior, giving some students more status in the ED classroom over others. The segregated ED classroom is one place where all of the students were

considered equal in relation to their behavior, albeit on a lower status to their non-disabled peers.

Perhaps this phenomenon explains why many of the students in the ED program preferred the segregated school environment. Since they had all experienced subordination in their neighborhood schools, these students possibly recognized the ED classroom as a sanctuary from ridicule and a safe haven in which they could be themselves. Air told us that she liked this school better than her old school *"because there is a lot more communication here—more chances to talk with my friends and teachers."* Isis expressed a similar sentiment, recognizing that the ED school program had helped her to control her behavior. She was apprehensive about being sent back to her neighborhood school for fear of being *"set up"* again because of her swearing. Even Mandy claimed that she preferred this ED program over the others she had attended. While disability certainly was a form of societal Power-Over impinging upon these girls, they appeared to accept it and even almost welcome it as a means for explaining their existence.

Another reason why disability did not seem to be a primary factor in these girls' oppression is because they were considered to have a school-related disability that did not have a broader influence on these students outside of the school environment. As Isis explained, ED *"has something to do with my behavior keeping me from learning."* Since learning is the primary function of schools, the disability is directly related to something that interferes with learning academic skills. These students were not considered disabled outside of the school walls and were free to participate in activities in which most adolescents engage, such as football games, parties, and family events. It was only within the bounded confines of the school environment that these students were perceived as being disabled. One contradiction to this theory might have been in Isis's report that she was stereotyped by a police officer when she and her friend were pulled over for a traffic violation.

> *As the cop was looking over her driver's license, he asked her where she was coming from and she told him she had just picked me up from school. So the cop stuck his head in the window and asked me where I go to school and I told him. As soon as he heard the name of the school, his attitude towards us changed and he started giving us a real hard time.*

However, the stereotype was perhaps in reference to the school Isis attended and the reputation many of the students had as delinquents, and not through recognition of a specific disability.

Gender. Although disability did not appear to be the primary cause of societal oppression once the girls were placed in the ED environment, gender did, influencing these girls' sense of identity as they negotiated the mixed messages they received from society and from the ED culture. Due to their attention-seeking or aggressive behaviors, many of the girls involved in this ED program were less valued strictly because their actions were exhibited by females. While the behaviors demonstrated by these young women may in fact have been a form of individual power, their actions contributed to a stereotype that was demeaned by both peers and teachers in the ED culture. For example, during one class discussion about the study I was conducting, one male student expressed his opinion that *"Most of the girls at this school are sluts. I know they are sluts because I've heard stories about them sleeping with lots of people and giving blow jobs."* When I asked him what he would call the boys these girls were sleeping with, he responded, *"I guess they are sluts too, but it's more acceptable for boys. Its just society. That's the way it is."* The ED culture was no different than society as a whole in this instance because the students bought into the belief that differences exist between the genders about what is acceptable and unacceptable sexual behavior. For boys, sex appeared to be a mark of a hegemonic masculinity and power (Connell, 1996), while for girls it appeared that sex was an exhibition of objectionable behavior and weakness. While the girls who were promiscuous may have been attempting to gain back power over their lives, such attempts were regarded as disgusting, resulting in derogatory opinions about the girls in general.

During a subsequent conversation I had with several of the boys when the girls were not present, the *"sluttiness"* of some of the girls recurred as a theme. When asked why the boys thought most of the girls in this program acted slutty, one male student, Clyde, hypothesized that it was because of poor self-esteem. It appeared to be common knowledge among the male adolescents in this class that many of the girls acted this way in order to gain attention from boys. Amber, the female student who was sent to a drug rehabilitation facility early in the school year, was offered as an example. Clyde recounted a time when Amber announced to him that she acted the way she did in order to get attention. Our dialogue then evolved into a discussion about what boys in general do to reinforce that type of behavior from the girls, but the boys did not really know, saying they personally did not do anything to promote this attention-seeking behavior. *"I don't even talk to them"* was Arty's response. Clyde stated that he would not have anything to do with them either. There was no acknowledgment of any external contributing factors, relinquishing the choice of how the girls behaved to an internal mechanism inherent to some of the young women.

These stereotypes about girls were not lost on the teachers in this program either. While one might think that being a minority gender as a student would not be an issue in this ED program since most of the staff were female, I had felt differently at the onset of this study, especially for girls who use their sexuality to make friends. From my experience as a female, as someone with two sisters, and as a mother of two daughters, girls in general are not tolerant of other girls who dress in a provocative manner or who are considered "sluts." Air touched on this as well. *"I've been beaten up my entire life. Not just like that, but with girls saying stuff, you know, that immature stuff that girls do."* Due to this generalized oppressive practice within one gender, I suspected the teachers, who were primarily female, would probably have less tolerance for Air and other females in the program because of the way they dressed and talked. My suspicions were confirmed during a conversation with the principal of this program, who is a woman. She confided that while she relates really well with Isis because of her direct way of speaking, she is uncomfortable around Air. *"It's that whole sexuality thing."* In Air's case, having female teachers and mental health workers may not have been to her advantage.

Even though girls who gain attention through their dress and actions are often less valued in some settings such as school or in the realm of the larger society, girls receive mixed messages about what is acceptable and unacceptable through contradictions in the popular culture. In the midst of breast implants and beauty pageants, motorcycle and beer ads with scantily clad females, and actresses and pop artists wearing revealing clothing when receiving awards, the girls struggle to find their place. An example comes to mind when I learned that one of the girls in the study had been invited to appear on *The Jenny Jones Show*, a television talk show that often sensationalizes the lives of people who do not live by the rules of the mainstream culture. Air's story about her experience on that show exemplifies this tension between acceptable and unacceptable sexual behavior. As Alison Jones (1993) explained, girls actually position themselves within gender roles, depending on their culture, class, race, experiences, and what roles and subjectivities are either offered to them or made unavailable to them. In essence, what it means to be a girl—the way one walks, dresses, talks, and acts—varies significantly in different settings. As a result, girls and women may even adopt contradictory roles, simultaneously acting out different identities to satisfy the requirements of various *feminine roles* of multiple settings.

Aside from shunning girls who both the boys and the educators deemed were being *overly female* such as Air, the boys in this ED program also expressed little tolerance for girls who acted more traditionally masculine,

such as Isis, and even Mandy when she was mad. Clyde explained, *"I don't think it's very attractive for a girl to cuss and have a bad mouth on her either."* When I asked him if he felt the same way about boys who swear, Clyde said that he did not. *"I don't know. It's just more acceptable for a boy to cuss than for a girl to do it."* Arty added that *"Sometimes, the girls here try to act like the guys, punching and hitting guys and stuff. I don't like that."* However narrowly defined gender roles are in society (Jordan, 1995), these roles are even more narrowly defined within the bounded context of this ED school culture. Although students could tolerate disruptive, aggressive, or attention-seeking behaviors exhibited by their peers in relation to their disability, they had more difficulty accepting these behaviors in relation to a student's gender. Therefore, some students, simply because they were female, were looked upon in an unfavorable manner.

The scope of gender inequities in the ED culture extended beyond the attitudes peers and teachers had toward the girls in this ED program, and was perpetuated in a variety of subtle ways. One way in which the double standard was demonstrated is through the enforcement (or lack of enforcement) of school rules around dress codes. Early in the study, Air made the observation that although there was a new school rule that students could not wear tank tops, one male student was wearing one that very day and had not gotten into trouble. *"They said we could not wear tank tops this year, and Mark wears one everyday. God forbid if a chick were to wear one—they'd be expelled!"* Notations made in my field notes during classroom observations support Air's perception around this issue. Each time Air's shirt slid up enough to expose a fraction of her midriff, teachers and teaching assistants quietly directed Air to pull her shirt down. However, regardless of how low a boy's pants rested on his hips, exposing his waist, no comments were ever heard requesting the student to pull his pants up or to wear a belt or a longer shirt.

While there may not be a hierarchy established among the students in relation to the severity of their disability, a hierarchy was apparent in relation to gender, with males often oppressing females, keeping them in a position of inferiority. The boys continually tried to maintain a disequilibrium of power across genders, preserving their positions of dominance, verbalizing their concern when their power status was threatened. The following is an example of the males making sure that the scales did not tip too far in the girls' favor.

Isis:	*I have this full body mirror at home. Could I bring it in and hang it on the wall in here so I can check my outfit out and stuff, so I don't have to go upstairs and use that mirror all the time?*
Ms. Fields:	*We'll see. I'll have to ask Ms. Smith.*
Arty:	*Then can I bring in an easy chair and just sit around all day?*

Ms. Fields:	*No, you may not.*
Arty:	*If she can bring in a mirror, then I should be able to bring in an easy chair.*
Ms. Fields:	*It's not the same thing.*

When attempts were made by the school staff to equalize the playing field a bit, the boys quickly picked up on the attempt and responded as if an injustice were occurring. One example occurred during an altercation between a male and female student. As a teacher tried to calm the male student down he retorted, *"Why do you always take the girls' side?"*

In addition to the hierarchical structure across genders, the boys also preferred their majority status, as revealed in the following observation note.

> *Once back in the class, the students continued to mill around a bit. Isaiah, Evan, and Maury left the room and Clyde said, "Hey man. I'm in this room with all women." Then Isaiah walked back in and Clyde made an exaggerated sigh of relief.*

The simple fact that the girls were outnumbered in their classes is an issue around gender that warrants consideration. Overall, the ratio of males to females in this school environment was five or six to one, but in elective classes the numbers often grew. For example, when Mandy went to art class, there were 10 boys, most of them high school age. Mandy was the only girl. During a conversation with the boys in one of the ED classes, I asked the group why they thought there were so few girls in this ED program. Arty felt that in general, schools were more tolerant of girls and were more willing to work with them, but with boys schools tended to give up and just throw the boys out. While Arty had the perception that girls received more help in schools, according to a report conducted by the American Association of University Women (1992), the opposite is true. In summary of their research findings, the report, in essence, suggested that as a group, girls actually receive less attention from classroom teachers than do boys.

With this research in mind, I told Arty that the girls in this school program would probably say that they too were just kicked out of their home school. I asked him why he thought these girls would be the exception, receiving less help than their female counterparts, and he said perhaps because they had more problems than other girls. Again, just as with boys, if a female student becomes unruly and noncompliant, attention is given to the student by way of punishment, and intolerance prevails as students are suspended, expelled, or placed in segregated school programs such as alternative schools or self-contained special education classrooms.

Before our conversation ended, I reminded Arty of a comment I had overhead him say while explaining to another student my presence there. He had said, *"She's here to study the traumatizing effects of being a girl in a school with all boys."* I asked him why he had chosen to use the word *"traumatizing"* and he said because he thought it probably *was* traumatizing. *"Girls here get harassed and don't have anyone here to talk to."* Even the boys recognized the deleterious effects being a minority gender had on the girls in this school program because of their knowledge of social hierarchies related to gender.

The Reality of Being Caught in the Crossfire. Aside from the perceptions male students and teachers had about the female students enrolled in this ED program, gender as a form of societal Power-Over also reared its ugly head through the interpersonal relations observed across classmates. As noted previously, oftentimes the girls in this study found themselves "caught in the crossfire" (Jordan, 1995, p. 79) between boys as they strove to create a masculine *self*, doing so through opposition of traditional notions of femininity as suggested in the examples below.

> One male student said to another male student in disgust, "You're such a girl!" A third student added, "Well, if he's a girl, then I'm sexist!"

> In art, two boys arguing with each other: "I bet the girls in this school could beat you up!"

> "You hit like a bitch."

Even the female teachers and students contributed to the demotion of girls in the gender hierarchy.

> Isaiah was walking around the room with a girl's barrette in his hair (he has long hair, which he wears in several tiny braids). Ms. Smith commented, "Oh, look at Isaiah. Pretty little girl Isaiah."

> Later, Isis taunted Isaiah, saying "Oh Isaiah. You got held down by a girl!"

Such comments actively worked to place girls in an inferior position in the power hierarchy. As Goodenough explained (as cited in Jordan, 1995), girls who are exposed to this type of verbal aggression typical of boy-girl interactions often become more inclined to be antagonistic toward other girls. Jordan's (1995) conjecture about the negative influence this crossfire often caused was realized in this school environment through the difficulty the female students had with their female peers, with all three of the young

women involved in this study expressing dislike for other females. Air simply explained *"I don't get along very well with girls."* Isis reiterated. *"I don't act like the other girls here at this school anyway."*

Mandy almost quoted Air when she said *"I don't get along with girls very well,"* but then went on to describe her violent response to some girls. *"There are actually a couple of girls I would like to beat up. I don't know why. One girl is prettier than me and is a prep and bugs me. Other girls just bug me."* Violence against girls was also expressed by Air as she described hitting the head of her ex-boyfriend's sister into the concrete. *"I had to beat her up three times to get her to leave me alone. I remember hitting this girl's head into the concrete, but man, she just kept coming back for more."* Air also shared with us that she had punched Amber in the jaw at the mall at one time.

Although Isis did not report beating up other girls, she did express extreme aversion to the antics of typical female adolescents. *"All of our ... other friends always dick their friends for guys. That really pisses me off when people do that and I don't really like to hang out with them after they dick me or Kara."* As these girls tried to make sense out of what they heard and saw around them, they either resisted the stereotypes portrayed of or by girls, or embraced them. There appeared to be a constant struggle displayed by these girls in response to perceptions others had of them, infiltrating their senses of self.

Sexual Harassment. Sexual harassment was yet another way gender played a role in societal oppression within the bounded context of the ED culture. Although I was pleasantly surprised to see a lower number of actual incidents of sexual harassment of females by males than anticipated, this environment was certainly not immune to sexual harassment. Just as Air had said, *"you gotta expect it—it happens everywhere."* The following are several examples.

> *A male peer said "Mandy wears the same pants every day." Another male peer responded "How do you know? You must be looking at her butt every day." Laughter among the boys ensued.*

> *As Air was leaving for the day, Jake said to Air "Hate to see you leave, but love to watch you go."*

> *As we continued down the hall, Mark said to Isis, "Hey sexy."*

> *Ms. Smith was being playful with the students. She actually wrestled Isaiah to the floor, trying to take pop tarts away from him that he had stolen from another*

student. Isaiah called out to Isis, "Isis, you're used to this! Help me!" Isis was offended and said "Screw you Isaiah!"

When Ms. Smith came into the room, she redirected the students to their seats. Arty jumped down off the table he was sitting on and told the teacher not to touch him. "I think you do that just so you can fondle me." The teacher joked it off.

Although I did not witness many overt demonstrations of sexual harassment, there were several occasions when I was able to hear a female student's response to some advance made by a male peer, such as when I heard Air say in the lunchroom, *"Get your hands off me."* During another observation, I recorded Air saying, *"All I want to give you is a split lip."* During these times, I was unable to see what had happened to cause Air to give those responses, but it is probable someone had overstepped their bounds with her.

Many of the sexual comments recorded during my observations were not directed at a particular female student, but rather were embedded within a conversation. The intent was often not to make suggestive comments to a girl, but rather was simply part of the performance male students played to create an image of masculinity. This was similar to the students' use of swear words. Comments such as *"He don't get no pussy,"* *"I'm not using no condoms!"* and *"It's colder than a witches tit in here!"* were all said more for effect. The constant barrage of sexual references seemed to be more of a statement about the male students themselves than about the girls sitting nearby.

As the male students negotiated their identities, the female students were doing the same, displaying various forms of accommodation and resistance to the expectations presented to them by the media, by the teachers, by each other, and by their male peers (Anyon, 1984). As Jordan (1995) explained, for girls, gender development is actually a series of attempts to cope with and resolve the contradictory social messages regarding what they should do and be. Gender identity is not imposed from without, but rather constructed within by individuals as they interact with one another. Therefore, it could be hypothesized that Air's promiscuity could have been a form of accommodation, as she actualized the expectations she perceived men and boys had of her as a female. Isis and Mandy, on the other hand, resisted these stereotypes, defining themselves in opposition to traditional conceptions of gender.

Organizational Power and a Curriculum of Control

There were doors all round the hall, but they were all locked;
and where Alice had been all the way down one side and up
the other, trying every door, she walked sadly down the
middle, wondering how she was ever to get out again.

Lewis Carroll
Alice's Adventures in Wonderland

Expectations of Conformity

The reality of Power-Over extends beyond the examples of societal power explored in the last chapter. In fact, organizational power reared its head as the most obvious form of Power-Over demonstrated in this school setting, just as it is in most schools. When looking for signs of organizational power in schools, one must investigate the ways in which schools are structured to control student access to rewards and knowledge. Critical research conducted within schools could also investigate the hierarchical structures of power among school staff members as well. However, only structures created to regulate the power of students will be explored here since the focus of this study was on student perceptions of and reaction to power.

As I began looking at the data gathered during my observations in this school culture, I noticed that the organizational power represented in this school fell into categories involving institutionalized *systems*, including a system of rules, point systems, level systems, both formal and informal systems of rewards and privileges, and the Juvenile Justice system. Each of these systems was utilized to establish and monitor expectations of conformity. Each is a system of control integrated into the school culture with a primary focus on punishment.

Following The Rules. One of the ways in which organizational Power-Over was evident in this high school, special education program was in the overabundance of school rules that existed. Each classroom had a set of specified rules created to help learners understand what behaviors were expected of them. While some classrooms had a lengthy list of rules, others

were more generic, such as the rules noted in Mandy's classroom. These simple rules were *1) Take care of yourself; 2) Take care of others; and 3) Take care of your environment.* During the first week of school, Mandy's teacher spent time each day reviewing these rules with her students. The class discussed what each rule meant and came up with both examples and non-examples for each rule. In doing so, the teacher created a tool she could use for redirection when a student made choices that demonstrated nonconformity, as illustrated in the following examples from Mandy's classroom.

> *A student was talking while others were completing their assignments. The teacher asked that student if he was taking care of others, and asked him to state what he could do instead to show that he knew how to take care of others.*

> *A male student forgot to push his chair in. The teacher called the student's name. "Chris, are you taking care of the environment?" Chris returned to his seat and pushed his chair in.*

These formal classroom rules were used to effectively prompt the students toward demonstrating a desired behavior, similar to many school cultures. And just as in most schools, each environment in the school had its own unique set of rules. There were unwritten rules for walking in the hallway, eating in the cafeteria, and getting on and off of the buses. There were even separate rules established for group therapy time that was conducted by mental health workers, as Mandy described.

Each year this school program had been in existence, new rules had been added. As the teachers became more aware of the extreme challenges many of these students presented, they responded by becoming more strict. New rules were layered upon old ones in an attempt to better control student behavior. Having attended this school from its inception, this increase in school structure did not go unnoticed by the young women participating in this study. *"This year there are too many stupid rules!"* *"Although I like this school, it was better here last year because there weren't so many rules..."* Privileges were directly related to the number of rules that were adhered to, but if the rules were broken, consequences befell the students. Although the rules provided structure for students, outlining expectations and limitations for student performance, they were only the first line of defense used by the teachers and staff in this ED program.

Rewards and Consequences. As a motivation for cooperating with the school and classroom rules, teachers doled out rewards and consequences for the performance of various student behaviors. Rewards for desirable student

behavior included participation in Friday Clubs, the privilege of ordering out lunch or buying chocolate milk instead of whole milk, extra gym time, the opportunity to have free time on the computer, or even a class movie. Friday Clubs was the only reward offered consistently throughout the school in the form of a schoolwide behavior incentive plan. The other privileges were idiosyncratic to particular teachers and varied from classroom to classroom. Consequences also varied, but more often than not they were extolled in the form of a restriction of the aforementioned privileges. Beyond that, students were subject to the schoolwide level system for punishment.

Points and Levels of Punishment. The extolling of either rewards or consequences was often determined by the number of points each student earned through an elaborate point system used to monitor student progress throughout the ED school environment. Every staff member in the school had the authority to either give or take away points. Students earned and lost points based on the demonstration of certain key behaviors, such as attendance, remaining on task, staying in one's seat, keeping hands and feet to selves, and talking *appropriately*. While many students complied with the rules and earned points, more often than not students lost points for some infraction of some rule. Notations of such were plentiful in my field notes.

> *Mandy lost points for fiddling with her hair for so long earlier in the day... Isis lost points for swearing... Since Air has been absent, she could not earn points... The teacher told her 'If you are not going to do the work, then you will not earn points..''... She stopped to talk with Maury. As a result she lost points. ... "Well, so far you are not participating at all today, so you are not earning points."*

The students often relied on the tally of the points they had earned in order to judge what kind of day they were having. On multiple occasions, students could be heard asking a teacher how many points they had earned and occasionally remarked that they were working toward some privilege.

> *At one point during the morning work, Isis came over to Ms.Fields's desk and asked whether or not she had earned clubs this afternoon.*

> *Mandy asked her teacher if she earned gym today.*

Having the point system seemed to provide students with a visual indicator of their personal progress and students seemed to benefit from a periodic review of their points to help them monitor their own behavior. However, there were times when this system backfired because students did not necessarily understand why they had not earned the desired number of points.

When Mandy received her point sheet, she became angry. "Didn't I have a good day?"

When she didn't hear her name, Air realized she had not earned clubs. As she stood in the doorway, she said "And I guess I didn't earn clubs again? This is shit."

Ms. Fields began doing Brady's point sheet and reminded him that she had to take a point off because he swore at her. "No I didn't!"

After lunch, the teacher began discussing points with Maury. He thought he had made clubs this week, but Ms. Smith told him he hadn't since he had been sent to a Level III earlier in the week.

Even though students were well aware of what needed to be demonstrated in order to earn points, they seemed to have a difficult time reflecting on their own behavior throughout the day to determine just how *good* they had been. However, I can not be sure whether this was the students' inability to self monitor their own behavior, or whether it was due to inconsistencies in the rewarding of points by teachers, which contributed to the students being unaware of their progress. Perhaps Brady was on target when he made this suggestion about the point sheets: *"We'd all be more responsible if you let us do this ourselves."*

When the point system was not enough to curb student behavior, teachers relied on the schoolwide level system to prompt compliance and conformity. As we learned from the students' personal life presentations, there were three different levels of control imposed by the school staff. In Level I, students were asked to take a time-out from their work and remain in their classroom. During my entire time conducting this study in this school program, this lower level punishment was never observed being administered by any staff member, unless having a student stand for 10 minutes next to his desk because he could not stay on task would be considered a Level I intervention. However, it was never referred to as such. Usually, when noncompliance occurred, after initially taking away points, staff members resorted to immediately sending a student to a Level II, which was a time-out in another teacher's classroom. The scenarios depicted below are examples of how this strategy was used and various student responses to Level II.

Over the walkie-talkies a teacher called for assistance with a Level II. Ms. Stacks called back "Stacks can help out." The student was escorted into Ms. Stacks class to sit in a corner in a time-out chair to complete his work. Ms. Stacks told the student to read the red card in front of him, letting him know the rules of how a Level II worked in her room. There was another all-call for assistance with a Level II for a different student. A conversation ensued across

walkie-talkies about where the student could be taken and who would monitor him.

Two students were brought in for a Level II, both of whom caused some disruption to the class because they were angry. One student immediately tore up his paper but eventually agreed to do some work for Ms. Stacks.

"You have to either do the work here or do it in a Level II."

Another student from Ms. Casper's room was in a Level II in this room.

Jimmy came into the room for a Level II. "Man, I'm tired of this damn school! I'm gonna quit! Ms. Smith, give me a god damn pencil!" Ms. Smith told him that she would not give him anything when he asked like that. He adjusted his request. "Ms. Smith, may I please have a pencil." As she was handing one to him, he said, "This is fucking stupid!"

Throughout the course of any school day, there was a constant buzz over the walkie-talkies that each staff member had, with teachers calling for assistance with a Level II intervention. As noted in the scenarios shared, the frequent use of this intervention often caused a disruption to the students in whose class the Level II was assigned.

Level III was also used quite frequently to control learner behavior, as demonstrated by the plethora of examples recorded in my field notes.

Ms. Stacks said that Mandy was in a Level III and was having a rough day.

With the help of Sheila, a mental health worker, Mandy was quietly escorted to a Level III time-out.

Mandy was in a Level III time-out.

Ms. Casper had been heard over the walkie-talkie requesting a Level II, but after the sound of a crash coming from her room, she changed it to a Level III.

He had spent two days in Level III because he refused to work.

Isaiah was in a Level III.

It was the refusal that eventually landed him in a Level II and then a Level III.

Of the three girls involved in this study, Mandy seemed to be the one with the most number of Level III interventions accredited to her. Given the frustration the school staff had with trying to control Mandy's behavior, it appeared that Level III was actually most often used not when the situation had been assessed and it had been determined that it would be the best

intervention, but rather when the educators simply did not know what else to do. The use of a Level III intervention by teachers was reinforced because at times it had proven to be an effective strategy for coercing students to eventually do their work.

In addition to seclusion, physical restraint, and threatening to involve the police and Juvenile Justice system were also common strategies used by teachers in an attempt to control seemingly uncontrollable students. The multiple field notations below demonstrate this fact.

> *Apparently, last Friday Mandy became very difficult to handle in school, requiring three people to restrain her.*
>
> *He had several violent episodes, needing to be restrained in a Level III by Ms. Stacks because he repeatedly attempted to choke himself.*
>
> *A police officer and teacher came to intervene and the male student was escorted to the office.*
>
> *Charges were filed against Mark and he was put in jail.*
>
> *The person in charge of Juvenile Detention agreed to take Mandy if she continued to not work in school.*
>
> *Ms. Casper told her that she could file charges on her too...*
>
> *Isis was not in school because she was in court for throwing a chalk eraser at her teacher.*
>
> *The bus driver wanted the incidents reported to Air's probation officer.*
>
> *"You either go to Level III or get arrested!"*

The use of restraint and Juvenile Detention were perhaps the most severe forms of organizational power demonstrated by the staff in this ED environment, totally stripping students of all choices because the adults were at a loss of what else to do. As in Mandy's case, when teachers and mental health workers had their personal control threatened, Mandy was put in Juvenile Detention for an indeterminate amount of time. In addition to being overpowered as a student, Mandy was then further marginalized through her inmate status at the detention center. As a result, additional forms of societal Power-Over may also eventually have taken its toll on Mandy, as society then labeled her as a juvenile delinquent—a title that has its own negative ramifications.

For children with behavioral problems, schools are often the first port of entry into the penal system. Given the number of times the staff of this school

program resorted to the threat or follow-through of filing charges, it could be suggested that the ED program may simply be a transition for some of these students, acculturating them for life in prison. When local juvenile detention facilities were not enough to deter aberrant behavior of these students, then even more restrictive intervention systems were sought, such as the state juvenile prison system or hospitalization for psychiatric treatment.

Mandy is up for a review soon and it is possible that she might be sent to the Department of Youth Services in Columbus.

Ms. Oneida said that actually Air is setting herself up for being sent to either the Department of Youth Services or a treatment facility.

Mandy has been hospitalized.

As a past supervisor of ED programs, I had participated in these very acts of organizational Power-Over. We used to condone these strategies as a means for "widening the umbrella of support" over these students, creating a broader environment of control beyond the walls of the school program. As I have come to view it now through the lens of these students, however, I would have to call it more of a "cage of restraint" rather than an "umbrella of support."

Detentions and Suspensions. Beyond this individual school's unique use of organizational Power-Over, the students were also subjected to the more commonly found structures in school, in general, such as bus write-ups, detentions, and suspensions.

"We also get lunch detentions if our behavior is bad."

I found out from Isis's teacher that she was suspended yesterday for some incident in her classroom.

When I signed in this morning, Ms. Oneida pulled me aside and showed me the bus write-ups Air had been getting.

Attending a program for learners who have been identified as having an emotional disturbance manifested by behavioral problems did not inoculate these students against the traditional forms of Power-Over demonstrated in other public schools as well.

Curriculum and Instruction as a Means of Taking Power

Another way that organizational structure was deployed in this school program was through the school curriculum and instructional strategies utilized by many of the teachers. As Isis complained, *"We do the same things every day... You work all morning on one packet of papers, and then when you get done with that set of worksheets, she just gives you another one!"* Mandy shared a similar scenario, except in her class, the worksheets were used as a form of punishment. *"One day, everyone was acting up so she gave us tons of paperwork to do. That's all we did all day! There were papers laid out all over the floor and we had to just keep picking new ones up when we got done with the old ones."* But even on days when the class was being good, the school day was structured around class assignments, used as a form of classroom management. *"Every morning when we come in, my teacher has assignments waiting for us."*

Similar to Isis, Air also expressed her dislike of the use of worksheets. *"It's hard to stay focused all day long on these worksheets..."* Later, she reiterated, *"I really hate all the worksheets they give us."* In my field notes, I too noted the overreliance of worksheets as the primary instructional strategy.

For most of the morning, Isis worked independently at her desk, completing a packet of worksheets her teacher had given her.

When I returned to Isis's classroom, she was once again working independently on the packet of worksheets.

When I went into Mandy's class, she was working very hard, completing her worksheets and other seatwork.

When Air finished her packet of papers, she turned it in. Ms. Smith brought more over to Air to complete. Air said to her teacher, "Why do you keep giving me more work?"

Isis had been working very hard for half an hour on various worksheets that had been assigned. When she finished, she turned them in and returned to her seat. Her teacher, Ms. Smith, put another packet of worksheets on Isis's desk for her to do next.

When I entered the room, Air was working on some geography papers... When she finished her geography, Air turned the page and saw that the next assignment was math.

As students finished work, they would turn it in and then Ms. Stacks would hand them the next assignment.

By keeping the students busy, teachers were better able to control learner behavior. For the greater part of every school day, in most every classroom I went in with the exception of one, worksheets and copying notes off the board were the extent of the instruction given. Only on a few occasions did I observe a teacher actually *teaching* a subject or providing hands-on activities to explore material. Group work or pair work was permitted on occasion, but always for the purpose of completing a worksheet. Although one teacher did attempt to read to her students every afternoon, again the students were not often asked to actively engage in learning during those times.

Several students complained about how boring or unchallenging the work was, such as when Arty argued, *"You don't understand how boring this work is to me. It is sooo boring."* Isis shared the same sentiment in her Personal Life Presentation when she told her teacher that she did not even have to use her brain to complete the work that was assigned. Although one teacher in particular did attempt to create a classroom environment that was a learning environment, for the most part, teachers used the materials to keep students quiet and engaged, and not to promote critical thinking skills.

In addition to using seatwork as a method for exerting power over students, the school grading system was also a source of organizational Power-Over of which the teachers had total control.

Ms. Casper came into the room and the two teachers briefly discussed how Air wasn't going to pass because she had missed way over 20 days of school the first quarter.

Isis commented that since she never participates in gym she had gotten an "F" on her report card in gym.

Arty said that he had gotten all "Fs." He began to blame his teacher since she was the one who had given them to him. However, she had a different perspective. Ms. Smith told Arty that she did not give him grades, but rather he had earned them.

Clyde started complaining that he was failing every subject. Ms. Fields reminded him that the only reason he is failing is because he doesn't do his work.

Since the teachers put the onus of responsibility for failing on the students, as do most schools, the use of grades as a form of punishment actually became a way to continually oppress these students, reminding them of their inadequacies as members of a school culture. Albeit unintentional for

the most part, the practice of failing a student for not participating was nonetheless a powerful tool for subordinating students.

When the Structure Breaks Down

The ED program itself was like an intricate latticework of organizational Power-Over, with one form of structure or procedure supporting another in such a tight weave that theoretically no student would slip through the cracks and become unruly. If the structured lessons and inflexible grading system were not adequate to deter or de-escalate challenging student behaviors, then the rules, points and level systems would. If, however, these systems failed, there was always the jail system to pick up the pieces. Theoretically, holding the latticework together was the mental health services component incorporated into this particular school environment.

However, while the intent was to provide students with a level of care not found in their neighborhood schools, sometimes the latticework weakened when mental health services were not provided as planned. For example, at one point during this study, I became concerned about Air. She had missed a lot of school after the threatening situation she had experienced with Jimmy and Jake. I spoke with Sharon, Air's mental health worker, to ask her if anyone was intervening on Air's behalf since she was missing so much school. Sharon said that since Air had been moved to Ms. Smith's class she was no longer the case manager for Air, so she was unaware that Air had been absent from school. Sharon explained that mental health case managers were assigned to each teacher, working with all the students in one particular class. This way the teachers would not have to talk to a variety of mental health workers and it would facilitate collaboration across staff members. Sharon then shared that Sheila would now be Air's case manager, however, Sheila had recently broken her collarbone and arm and would be out for awhile. I asked her if there was a backup for Air while Sheila was recuperating and Sharon said no, but that she would be happy to fill in until Sheila returned.

Although the organizational system was created to better support learners, in this instance, the system had broken down, and Air was the casualty, squeezing through the gaping hole left in the latticework. What the creators of this system had actually done was to design a support system for the convenience of educators, not students. Since case managers were assigned to classroom teachers and not students, it would be probable that students who attended this ED program for several years would have a different case manager each year, losing consistency in their therapy, having

to reestablish relationships with their mental health workers over and over again. In addition, if a student were to return to her or his neighborhood public school and still require mental health services, she or he would be assigned to someone else entirely—someone who did not work in this ED program—and again, consistency and perhaps a sense of safety would be lost.

Interpersonal Power and Social Hierarchies

"I never was so ordered about before, in all my life, never!"
Lewis Carroll
Alice's Adventures in Wonderland

Personal Rules

As in most school environments, organizational power was probably the most obvious form of Power-Over exerted by the staff in this ED environment. One might assume this to be the case given the nature and purpose of ED programs in general. However, the teachers also resorted to using various forms of interpersonal power to maintain authority over the students they were charged to teach. Beyond the various school and classroom rules, the teachers in this program were not different from any other teacher, as they generated their own set of impromptu personal *rules*—rules about relationships and rules about authority. These were oftentimes the unposted rules, communicated to the students through a teacher's use of rewards or consequences, or choice of language. Although these were informal rules idiosyncratic to each of the educators who worked in this school program, an infraction of these rules was just as punishable as any infraction of the more formalized sets of rules imposed. The students in this ED environment were also victims of interpersonal power imposed by peers and family members as well. Interpersonal power in this context is about how people treated one another in an effort to have control over how another person thought or felt or acted. The final goal of interpersonal power in any context, whether done consciously or not, is the subjugation of another person.

Teachers as Power Brokers

Within the bounded context of the ED culture, teachers were a major source of interpersonal Power-Over for the students. When the schoolwide or classroom rules themselves were not enough to control learners and their behaviors, then teachers often resorted to this less formal, albeit probably

more powerful form of Power-Over, further marginalizing these students. Oftentimes, interpersonal power was displayed by the manner in which the adults in the program spoke to the students, communicating authority through their word choices or topics for interaction. For example, in her Personal Life Presentation Air explained how her principal, Ms. Oneida, had power over her because of what she chose to communicate to Air. *"Ms. Oneida can say some very hurtful things, things that get right into your stomach and tear it out."* She made Air feel so badly that Air admitted to obeying Ms. Oneida in order to avoid hearing such criticisms. Air also reported being treated in a similar fashion by her bus driver. She told us that when she went to the front of the bus to look in the bus driver's mirror, the driver said to her, *"Air, I don't want you near me."* Transcripts from a videotape of this incident further illustrate this point.

> Bus Driver: Air, nobody can talk to you. My supervisor told me to give you one more chance before kicking you off the bus.
> Air: I haven't done anything!
> Bus Driver: I can't trust you. I let the other kids put their heads down because they don't do the things you do.
> Air: I haven't done nothing! This is bull shit!
> Bus Driver: That's it. I'm not going to take this anymore!

In this instance, the bus driver attempted to control Air by *guilting* her into compliance (Chelsom-Gossen, 1992), telling Air that she could not trust her, and putting the blame for their relationship difficulties entirely on Air. Although Air tried to veil her hurt feelings by being smug with the other students on the bus, she expressed her sense of persecution as a result of the incident, stating that the bus driver *"makes me feel real bad."*

Interpersonal Power-Over played a major role in how Isis perceived her school environment. Her relationships with her teachers seemed to be the most important aspect of her school experience, even though Isis challenged those relationships frequently. Although Isis claimed to not care what her teacher thought, she was hurt when Ms. Smith shot down her dream of living independently after high school, blurring her vision with sobering talk of bills and expenses. Air had a similar experience when she shared her plans to get married and leave school. Once again, her teacher squelched Air's dreams when she suggested that Air's fiancé could get charged with statutory rape, corruption of a minor, and educational neglect for allowing Air to quit school. In essence, in both of those instances, Ms. Smith had used her interpersonal power to strip these girls of their hopes and dreams. As a result, both of these students chose to avoid conversations with their teacher about their hopes for the future.

Mandy was also victimized by interpersonal power. As she shared in her Personal Life Presentation, Mandy's teacher exerted a form of interpersonal Power-Over when she required Mandy to write a letter to her class, asking their forgiveness of her behavior. The teacher also put Mandy's classmates in a position to exert interpersonal Power-Over by requiring them to make the final decision as to whether or not Mandy could return and become a member of the class again.

Oftentimes, however, the interpersonal Power-Over exerted by teachers was not as subtle, as in this next example from Mandy's story. In this scenario, Mandy's teacher demonstrated a posture of control through the choices she gave Mandy.

> *"She said I could either do my work in Level III or I could do it in the Juvenile Detention Center. Ms. Stacks said that I wasn't going to get out of doing any work, and that I had to make the choice of where I was going to do it. I chose Level III."*

Although in this example interpersonal Power-Over is camouflaged by the *choice* Mandy was given, there actually was no real choice to be made. In the end, Mandy was to do her work, no matter which environment she chose.

Beyond the discreet forms of interpersonal power communicated by teachers, some of the more overt examples were displayed through the creation of new rules, rules beyond the scope of the already established rules for the classroom. These rules were often created on the spur of the moment as a means for dealing with circumstances that had not, nor could not have been predicted. Beyond the rule itself, often embedded in these newly formulated policies were threats of punishment for noncompliance, such as when a teacher said *"I will separate you two if you don't stop touching each other,"* or *"If you're not going to participate, sit down."* Additional examples follow.

> *Brady:* *Ms. Smith. Can I go to the restroom?*
> *Ms. Smith:* *Straight there. Straight back.*

> *The class was so engrossed in their worksheets that they completely missed their gym time. When Evan realized this, he became very upset. The teacher said they would try to find a time to make it up this week, but since Evan had not given the teachers a chance to work through their mistake before becoming upset, he would not be allowed to go.*

> *Mandy continued scraping her pencil across the table. Her teacher came over and took her book bag and pencil away from her without saying a word.*

In each of these examples, the teacher created a rule to fit the situation, using it in a purposeful manner to remind students of their marginalized status. Even when humor was incorporated into the interaction between teacher and student, the message remained clear to the students, as demonstrated in this example.

> *Brady returned to the room with a bottle of Mountain Dew. Ms. Fields*
> *immediately said, "Brady, give that to me."*
>
> Brady: No.
> Ms. Fields: *Either give it to me and get it back for lunch, or I'll take it away*
> *and you won't have it for lunch.*
> Brady: *Is it your nature to jump on me as soon as I walk into the room?*
> Ms. Fields: *Yes, because I love you.*

Although the teacher communicated a sense of caring for this student through her final statement, the result was indicative of some of the other teacher-student interactions recorded. Through her command to the student, the student was reminded of his unequal status in the ED environment, to which he responded by relinquishing his drink to his teacher.

Beyond the verbal imposition of additional rules, there were also various written rules created for specific situations which, when read by students, signified a form of interpersonal power of teachers over students. For example, the rules for student placement in a Level II were posted in front of the time-out seat in several classrooms. These posted rules were established to let the visiting students know what expectations this teacher had for the students while in a Level II in her or his classroom. In one particular class, the following set of rules were written on red cards and placed in front of each student who came in for a Level II intervention.

> *Welcome to time-out! My name is Ms. Stacks and I do not answer to any other*
> *names! There will be no talking, use of foul language, sleeping, or temper*
> *tantrums! I do not make deals! You are to do your job and leave. If you choose*
> *not to work, you will stand. If your head is down, you will stand. You will not*
> *have privileges such as hats, coats, drinks, or restroom! You will be searched, if*
> *needed. I am not your buddy and you are not a part of my class. You will not be*
> *acknowledged without raising your hand! Your job is to calm down, sit quietly,*
> *and raise your hand when you are ready to work!*
> * * I do hold after school detention! Ms. Stacks*

The posted rules effectively communicated to students their status in a Level II intervention, outlining how they were not expected to be a member of that particular classroom community while in a Level II, concretizing their disenfranchisement in the ED school culture.

Another teacher did something similar to threaten students into behaving acceptably during her brief absence from the room. The following was written on the chalkboard in the front of the room as a message to her class.

> *If there are ANY problems today while I am gone, with ANYONE the ENTIRE class loses all free time / activities for the whole week. This is Not a threat but a PROMISE! Ms. Casper*

These types of discreet forms of interpersonal power can be seen in any school environment. As in this example, in the context of interpersonal power there is no difference between a promise or a threat. In either case, the teacher used her authority to remind students of where they are positioned in the power hierarchy, remaining relatively powerless within the ED school culture.

Beyond the impromptu rules generated by teachers when deemed necessary, the way in which teachers chose to enforce previously established rules was also often a display of interpersonal power. Even when students attempted to comply with the appropriate rules and procedures for accessing what they wanted or needed, sometimes the teachers themselves, through their interactions, imposed additional restrictions, as exemplified in the vignette that follows.

> *After lunch, the teacher began discussing points with Maury. He thought he had made clubs this week, but Ms. Smith told him he hadn't... Maury was upset and requested to speak with Ms. Oneida... He said, "I'm trying to be nice here Ms. Smith. I'm telling you I need to go talk to somebody, and you really need to let me go... You tell us when we're in Level III that if we need to talk with someone, just ask. If we had asked, you say that we wouldn't have to end up in Level III. But when we ask, you don't let us go. You're a hypocrite sometimes." Ms. Smith gave Maury a sheet to fill out so that he could go talk with Ms. Oneida. She told him that was the process he had to follow if he wanted to go to the office. Maury began to fill out the form, but then let it drop to the floor, saying he could not do this and once again begged Ms. Smith to let him just go talk with Ms. Oneida. The teacher continued to discuss the issue with Maury in a calm voice, marking on his point sheet every time he used profanity. Maury remained fairly calm but agitated, and continued to hound his teacher about going to the office. He told her to call Candy, his mental health worker since he couldn't go to the office, but she refused. "You're stubborn," he said. When she redirected him, he said "The truth hurts, don't it Ms. Smith?"*

> *After some quiet negotiations, the teacher stepped out of the room and called Candy to come down and talk with Maury. Fifteen minutes went by, and Candy did not show up at the room. Maury's agitation was growing... Ms. Smith tried to return to reading... Maury interrupted. "Ms. Smith, I'm tired. I've been nice about*

it. I'm not going to be nice to you no more." Maury was visibly trying to maintain
control of his behavior. He attempted to leave the room twice, but Ms. Smith stood
in his way. He told her not to touch him, but she replied "Then don't charge me."
Maury responded, "I'm not trying to charge you. I'm trying to get around you."

Candy came to the door, but Ms. Smith would not let Maury leave. She told him
he could talk with Candy over by his seat. Maury said with growing frustration,
"You don't understand. You are the problem. If I don't get out of this room and
away from you I'm going to go crazy. Now let me leave!" Eventually she allowed
him to leave the room, but he blew up in the hallway, banging the wall and
saying, "This school is messed up!"

In the above sample, the student, while demonstrating his agitation
through the use of profanity and argument, was in actuality attempting to
approximate compliance with established procedures. Maury's disability
manifested itself through his extremely impulsive and active nature,
responding to incidents and stimuli in his environment in a spontaneous
manner without much forethought. Yet, on this particular occasion, Maury
was attempting to attain the support he needed instead of losing control over
his behavior. However, his teacher did not respond to his attempts and
instead chose to enforce a strict adherence to the established procedures. Her
decision to force Maury to stay in the classroom was perhaps a display of her
need to control the situation, as Isis had so adeptly pointed out to this teacher
on numerous occasions. A power struggle ensued, with the educator asserting
her authority as an adult and teacher over this student.

Later that day, this teacher asked to speak with me about this incident.
She wanted to know my perceptions about what had occurred in her
classroom that afternoon. She relayed to me that the reason Candy had taken
so long to come to the room was because she had asked her to wait 15
minutes before coming. The teacher said that she wanted to teach Maury how
to wait for help. Since his IEP team had been considering sending him back
to his home school next year, she wanted him to practice the skill of waiting.
By being unwilling to relinquish some control to the student, however, this
teacher had perhaps undermined the progress that had been made over the
past several years to teach this student how to independently take actions to
help himself. This teacher perceived her role as an authority figure to teach
these students compliance to authority and nothing more, unwittingly
(perhaps) subordinating this student to his marginalized status not just as a
student, but as a powerless, dependent human being.

As the teacher and I continued to discuss this issue, I attempted to relay
my concerns about the misuse of power to her, using Isis as another example.
We talked about Isis's request to work in the office during lunch. I suggested
that perhaps Isis, because of her disability, could only hold it together during

the morning and may have needed a break at lunch from the structure and expectations for attention to task. Ms. Smith, after stating that she felt that Isis was *"just so ... hateful"* conceded, *"What she needs is a break from me."* I asked her if that was so bad. Would it be wrong to give her a break by allowing her to go to the office during lunch? Ms. Smith said no, but explained they had tried it last year and Isis had always returned *"hateful and gloating"* to the other students about how she was *"special."* We discussed the possibility of Isis earning the privilege of spending lunch in the office if she earned a certain amount of points in the afternoon of one day and the morning of the next. She said she would think about it, and in fact occasionally allowed Isis to do just that, although inconsistently. Throughout the school year, she continued to exert extensive power over Isis and her other students, remaining reluctant to relinquish any control to the learners in her classroom.

Establishing a Pecking Order

Along with the teacher-imposed rules used as a form of interpersonal power over all of the students, the young women in this study were also subjected to various forms of interpersonal power by their peers in the form of sexual harassment, verbal threats, and aggression, some of which have been previously discussed. These issues, often related to gender identity, were all forms of interpersonal power exhibited by students, mimicking societal pressures as they were played out in this school environment. A similar phenomenon occurred related to race.

While there were no students of color attending this ED program, it was apparent through several conversations with the students that it would be a threatening environment for students of color because of the pervasive racist attitudes among the white students who attended this program. I acknowledge racism as a form of societal Power-Over since the attitudes these students had were most probably formulated as a result of the students' family cultures and the environments in which they lived. Yet, as I reread the field notes, I noted that one of the primary ways racism manifested itself in this particular school culture was through various forms of interpersonal Power-Over, as students resented being positioned at the bottom of the social totem pole, resisting that status by perpetuating an established racial pecking order. The following passage from my field notes is presented in its entirety in order to provide a more accurate illustration of this complicated issue.

When I walked into the room, the class was engaged in a conversation about racism. Jake was saying that he didn't think it was right that African Americans can call each other "niggers," but that white people couldn't. He said that since they don't consider it bad, then the teachers should quit correcting students when they used the word "nigger". The discussion became quite heated, with Ms. Smith being the only person in the room actively supporting an anti-racist attitude. The rest of the students were adamantly racist. Isis brought out the same arguments against blacks that she had shared with me on a previous occasion. She didn't think it was fair that blacks had an organization like the NAACP, when whites didn't have such an organization. Ms. Smith turned to me and asked for my help. I asked the group why they thought African Americans needed to have an organization like the NAACP. The students were able to recite early American history about slavery, but they thought that was ancient history and said that it didn't pertain to whites and blacks anymore. Jake reiterated several times that "blacks were brought over here to do a job." Now that their job was done, they were no longer needed and should just "go home." I discussed the need for understanding various perspectives, and reminded the group that we were all whites discussing this issue. If they really wanted to understand why blacks felt it was okay to call each other "nigger," then they might want to ask someone who is African American to get their perspective. I reminded Isis that it was just like the study I was doing with her. Because I did not previously understand her perspective, I was talking with her and hoping to share her thoughts with other people so that they too could better understand her.

Air came back into class about that time and joined in on the conversation. "I don't understand why a black person would hate me just because I am white. I didn't put them into slavery. I know that my ancestors did, but I didn't. That was all in the past. We're all equal now, but blacks are always shouting racism. Every time a white guy beats up a black guy, they say that it was racially motivated. They don't say that when a black guy beats up a white guy, but every time a white guy does it they cry racism... I don't think that it's right that whites chase people out of neighborhoods and stuff. People can't help what color skin they were born into, just like someone can't help if they're fat, or skinny, or a blond or a redhead. So I don't have any problem with black people. They have their own ways about them, like they all have greasy fingers and wild hair and shit, and they're all self-centered, but they should be able to live where they want. But I would never have sex with a black man. That's sick."

Ms. Smith reiterated that the students needed to talk with people who are African American in order to better understand them, which prompted several stories from Air about negative experiences she had with African Americans, including rape. She stated that because she had been raped by a carload of African American men, she did not like "black people."

MJ: *If you had been raped by a car full of white men, would you hate all whites?*

Air: *No, because that is my race. If I hated every race that had done something to me, I wouldn't like anybody. There wouldn't be anyone left and I'd be a mean person. I don't want to be a mean person. But*

> *you can't tell me that if a bunch of black guys raped your daughter, you wouldn't hate an entire race!"*

Ms. Smith: *I would hate the men who raped her, and I would want them punished. But I wouldn't condemn an entire race because of it.*

Air: *Yeah, right. That's a bunch of bull! I hate that when people say that, because they wouldn't. You try to sound all high and mighty, but if it happened to you, you wouldn't feel that way. You would want to kill those guys!*

Evan: *I don't even know why we are having this conversation. You're not going to change anybody's mind. It's useless!*

Jake: *Well, I just think that blacks and whites should not have sex together. We shouldn't mix the races. I wouldn't let my kids date a black person.*

Isis: *Yeah. It says that in the Bible!*

Ms. Smith *There are a lot of interpretations of what it says in the Bible.*

Air: *I don't even think there is a black man or a black woman that is attractive.*

MJ: *But that's because you are responding to a white person's perspective on beauty. How do you think a black girl feels when she thinks that she could never be beautiful in anyone's eyes because she is black?*

Air: *She'd be beautiful to black men.*

Jake: *See, they should stick with their own kind.*

By promoting the segregation of races, these students were perhaps able to feel somehow superior over African Americans and other people of color, a position not often realized by these students in their daily lives. As noted in Air's comments about hating an entire race because of an experience she had, she kept herself on a different level than people of color, situating herself in a position of power. She used the rape as an excuse to hate African Americans, and yet admitted that she would not hate Caucasians if she had been raped by a white man. Motives for racism have long been connected to the competitive aspects of group relations such as those demonstrated by this class of students. As groups compete for scarce resources, such as power, the contest ultimately ends in the injury of an *Other* (Katz & Taylor, 1988). It is as if the students in this class had gone into a survival mode, perpetuating a dominance-subordination relationship to assure their position on the power hierarchy.

Aside from the competitive aspect of racism, perhaps for the students in this ED program racism served an ideologic purpose as well (Katz & Taylor, 1988), with the students perceiving membership to a hegemonic group of which they were actually not a part. These students may have made the mistake that since they were of the same pale skin color as those who are in power, that they too had some authority in society. For these students, or anyone else who perceives herself or himself as having power, there must

naturally be a group who is subjugated. In the eyes of these students, a convenient scapegoat would be people of color.

This *Pecking Order* theory goes beyond racism, and was also evidenced by the way in which male students in this ED environment responded to homosexuality. In the following example, a male student who had a history of sexual abuse by another man, was often accused by his male peers of being homosexual. The following is an example of how he was treated by his peers.

> *While walking down the hall to go to group therapy, Jonathan accidentally ran into Jarrod. Jarrod yelled at Jonathan, saying "You mother fucker! Get the fuck away from me! Don't be giving me no queer disease!" When the teacher redirected him, he explained that the peer had stepped on his heel and that he was trying to give him "queer disease." Then Jarrod pushed Jonathan when the teacher wasn't looking.*

As noted in this scenario, it seemed important to Jarrod to put Jonathan in his place, establishing a hierarchy in relation to an assumed sexual preference. Establishing and maintaining hierarchies among groups of people these students deemed different from themselves was possibly one way in which they were able to exert a form of interpersonal power over others. This also relates back to the students embracing traditional notions of masculinity as part of their identities, remaining intolerant of others who threatened their current understanding of what it means to be male, perpetuating a monolithic view of identity.

Power in Aggression. Aggression was another way in which students demonstrated interpersonal power over others, whether it be verbal aggression or physical aggression. The act of being aggressive demonstrates an attempt to dominate someone, epitomizing the definition of interpersonal Power-Over. Aggression appeared to be a common element in the life histories of many of these students. They had either witnessed aggression or personally been victimized by aggressive acts. As one student described, *"I seen someone break someone's bones for real. I seen him grab her hand and shake her wrist so hard that it just snapped, and her shoulder was pulled right out of its socket!"* As a result, many of these students had possibly learned firsthand how effective this strategy was for gaining and losing power within their family and school cultures, and therefore freely demonstrated aggression toward others in an effort to equalize the playing field, as illustrated in the examples that follow.

During art, one male peer threatened to hit Mandy with a ruler.

Jimmy became very upset and started threatening Air. "I'm gonna fucking hit you! If you keep it up, I'm gonna fucking hit you! I'll knock your head off!" Air seemed scared and began to cry.

The students were lining up for lunch, with Isaiah walking very slowly to find his place in line. He had an ice pack taped to his hand. He had told me that he hurt it when he hit a locker this morning.

Sometimes the aggression demonstrated by students was not as obvious as a threat of physical violence, yet just as potent.

The class went to lunch. While waiting in the lunch line, Air asked Clyde to share his milk with her.
Air: *Clyde, give me one of those please.*
Clyde: *Why should I give you one of my milks. I don't even like you, Air.*
 Air walked away without saying a word.

Maury: *Isis is in her "I'm a bitch" mode.*

While no actual threat of violence was made in either example, what is described above could still be considered a form of aggression. Clyde effectively overpowered Air by stating that he did not like her, and Isis was kept in her place by Maury as he, in essence, called her a derogatory name.

Each time a student was aggressive, they were aggressive toward someone else, thus victimizing another individual. This individual in turn might have felt the need to respond in a domineering manner toward another person, such as the case in the following field note excerpt.

Mandy: *Can I go back to class?*
Sheila: *Why?*
Mandy: *Cause I'm about to hit somebody.*
Sheila: *Why do you want to hit someone?*
Mandy: *Cause he's trying to mark on me with a yellow marker.*

This cycle of interpersonal domination and subjugation seemed never ending within this school culture and often snowballed from a seemingly minor incident into a major one. The continuous cycle of interpersonal Power-Over appeared to be a powerful dynamic between teachers and students as well as between students themselves within this school environment.

Families as Power Sources

Outside of the school environment, the shared histories of each of these girls unveiled long track records of interpersonal Power-Over imposed upon them by their family members as well. For example, Air's accounts of sexual abuse, rape, neglect, and abandonment convey a gloomy picture fraught with interpersonal Power-Over. Her relationship with her parents remained strained, and as Air explained, they did not even talk to her anymore. *"I hardly ever see them because I'm usually in bed by the time they get home from doing drugs downtown."* Air appeared to be particularly upset by the relationship she had (or did not have) with her mother. *"Over Thanksgiving, me and my mom fought and had shitty attitudes all weekend long."* She constantly remarked on her disappointment with her mother, describing deplorable living conditions and her mother's failure to be there in the home because of her arrests and convictions for drug possession and use.

Yet, through it all, Air continued to want to have a close relationship with her mother. When her journals were stolen, her mom was the first person she called. She expressed frustration when her mother did not recognize her accomplishments, such as when Air made an effort to clean the house but did not receive accolades from her mother for having done so. Instead, Air's mother had simply commented, *"So, you don't clean up anymore?"* This infuriated Air, as it would anyone. One can see in the example above how comments such as these are forms of interpersonal power that many parents typically use to try to curb the actions of their children. I cringe when I think of all the harmful things I said to my daughters in my bumbling attempts to raise two teenagers. Only in Air's case, the constant barrage of criticisms had a deleterious effect on Air and on her relationship with her mother, whom she implied through her actions that she loved very much.

Air's difficulties with her family extended beyond just her parents. Even what Air shared about her relationship with her older brother demonstrated how interpersonal power was manifested in Air's family life.

> One time, though, when I was 12, I went on a trip with my brother to Florida. Well, at least that was the plan. At first it was fun because he actually let me drive part of the way. When we got to Georgia, however, things didn't end up going so good. We had gotten out of the car to switch drivers, and as I was stepping into the passenger seat, my brother said something stupid to me (I don't remember what) and I told him to shut up. He got so angry that he stepped on the gas and left me stranded in Georgia.

This passage reminds us that interpersonal power is about the messages we send to one another not just in words, but also in our actions. Air's brother sent the message that he devalued Air by leaving her stranded in Georgia, never returning to pick her up.

As far as their families were concerned, a theme of abandonment as a crucial form of interpersonal power was revealed as the stories these girls shared about their families unfolded. Air's biological father had little interaction with her, and both Isis and Mandy were in essence abandoned by their fathers. Their experiences with abandonment had a lasting effect on each of these students. In Isis's case, her father had continued to refuse to speak with her, letting her know that he still had power over her even though he was no longer her legal guardian. His message was heard loud and clear by Isis, who continued to be subjugated by her father's avoidance of her, as noted in the following conversation I had with her.

> *I asked Isis how school had been going for her, and she said, "Not good." She hadn't been feeling well, and last week was really rough. I asked her if she had gone to Level III last week and she said yes.*
>
> MJ: *What was going on?*
> Isis: *I don't know. It was just everything.*
> MJ: *Was it stuff here at school, what was going on in the classroom? Or was it something from home that upset you so much.*
> Isis: *Everything, but mostly home. That stuff with my dad.*
> MJ: *Have you spoken with him yet?*
> Isis: *No. My sister did, and he said some stuff.*
> MJ: *About you?*
> Isis: *Yes.*
> MJ: *Does he want to talk to you or see you?*
> Isis: *No.*
> MJ: *If it upsets you so much, why won't you talk to him? Just give him a call. [Isis shook her head no.]*
> Isis: *It's not that I'm afraid. It's that... well, I don't know.*

Even though Isis had not personally spoken with her father, just hearing that he was still upset with her was more than Isis could handle. This seemingly strong individual was like porcelain when it came to her relationship with her father, and it would appear that he was using that to his advantage. As noted in her Personal Life Presentation, Isis later told me that her father had called her a liar, maintaining that her black eye had been caused by her falling and hitting her head on the edge of a table and not by him striking her. As Isis relayed this to me, she was very subdued and almost resigned to the fact that her relationship with her father would never be the same, because he would not let it be. In these instances, abandonment and neglect was perhaps the worst form of child abuse these young women

experienced, as their parents demonstrated a lack of care for their children, time and time again.

While Isis and Air shared stories about how interpersonal power exerted by family members contributed to their reactions to life, Mandy had not disclosed information about an abusive situation. Yet, she continued to act in a way that demonstrated a need to defy some form of interpersonal power possibly exerted upon her at one point in her life. Although Mandy did not disclose any such incidence of abuse, her avoidance of all conversations that could have led her to discuss that possibility hinted that something may have occurred nonetheless. She alluded to this in her Personal Life Presentation.

> *I used to see my real dad, but I haven't seen him in over a year. Whenever I saw him, he always left me with his girlfriend anyway. He always had something else he had to do. That isn't why I don't see him no more, but I don't want to talk about it. I don't like to talk about stuff that's happened to me. I'd rather forget about it. That's what helps me deal with things. I just forget about it. Even though some bad stuff has gone on, I really like my family because I think they are cool in a lot of ways. I can't tell you how they're cool because it's inappropriate to talk about.*

Although Mandy remained adamant that she would not discuss family issues, her silence spoke loudly about how interpersonal power may have been an extreme influence on her life.

No Exceptions

Although I was an outsider to this culture, as time went on I realized that I was not immune to the interpersonal power displayed by students. There were no exceptions made for me even though I never participated in their punishment or rewards, nor did I respond when I witnessed an infraction of the rules. Possibly because of my adult status, to some of the students I was still perceived as someone who was threatening. As a result, I was also a victim of interpersonal power on several occasions, one of which is described below.

> *As I was writing, Jimmy came in to the office to get something. He reached out to pretend to grab my notebook and asked, "What's this?" Although I always tried to keep my reactions in check, I have to admit that I jumped back. Jimmy is over six feet tall and weighs close to 300 lbs. I had heard him threaten Air and others and I had a growing uneasiness about him. In actuality, it was probably more than an uneasiness, but rather a fear. Jimmy walked out of the room with a smile on his face. He returned a few minutes later and did the exact same thing. This time I did not flinch and just kept writing.*

As I reflect back on this incident, I can see that Jimmy was demonstrating a silent power over me, one that was quite threatening and detrimental. While he did not say anything directly to me that would illicit fear, his presence and then subsequent return to repeat his actions once he observed my discomfort, was an act of covert interpersonal power. I learned first hand that causing someone to have fear certainly influences how that person behaves in the future.

It seems that some of what Power-Over truly is comes from what one allows it to be for her or him as an individual. As others exert interpersonal Power-Over a person, one actually *chooses* how much power that experience will be allotted, deciding what influence it will have. An individual can either *take it* and allow herself or himself to be identified in relation to how other forms of Power-Over are accepted, such as with Air's identity as a victim, or one can fight back against it. This is where individual power comes into play.

Individual Power: Taking Back Control

"I wish I hadn't cried so much!" said Alice, as she swam about, trying to find her way out. "I shall be punished for it now, I suppose, by being drowned in my own tears!"

Lewis Carroll
Alice's Adventures in Wonderland

Striking Back

The school staff made efforts to control student behavior through a rigid and unimaginative curriculum and approach to instruction, the use of multiple classroom management strategies such as point systems and lunch detentions, and the imposition of formal and informal rules. These strategies were all a form of either organizational or interpersonal Power-Over in which the rewards and punishments were controlled by the teachers and administrator of the program. While these strategies seemed to help initially in some cases, providing students with a structure many of them needed to succeed in school, they also provided a legitimate reason for students to demonstrate acts of individual Power-Over, defying the control attempts.

Individual power is exhibited when a person strikes back against societal, organizational, and interpersonal forms of Power-Over, actively resisting oppression. Individual power is perhaps the most devastating form of Power-Over because often times it leads to even further oppression and marginalization. Willis (1977) noted this phenomenon in his renowned research on the *lads*, as the boys he studied, through their responses to oppressive environments and circumstances, actually contributed to their being tracked into the common labor pool. Similarly, through various forms of individual power, the students in this ED environment also contributed to the low status to which they were relegated. Of all the forms of Power-Over, individual Power-Over is the one that is most directly related to the way these three adolescent women defined themselves in relation to their environment. bell hooks (1984) reminds us that people who are oppressed cannot afford to feel powerless. Similarly, the girls in this study possibly felt a need to exercise some measure of control in their lives because they could not afford

to remain powerless, establishing an oppositional identity. Unfortunately, the resistance they enacted was diluted as they perhaps demonstrated both a true and a false consciousness (Mahoney, 1994), contradictory consciousness (Gramsci, 1971), or rather dysconsciousness (Leistyna, Woodrum, & Sherblom, 1996), acting both in response to the recognition of oppression and in denial of how that oppression had an impact on their lives, simultaneously resisting oppressive influences while perpetuating their own oppression. These students' actions were more than simply acts of resistance, however. In actuality, they were oftentimes acts of survival. Individual Power-Over is different than agency because agency implies freedom from victimization and these young women continued to be shackled through ongoing victimization in response to their actions. Some may argue that resistance and agency for the purpose of survival are inherently the same thing. Many adolescents, however, are inhibited from fully realizing liberation from oppressive practices due to the constraints within a school environment. Recognizing individual Power-Over as separate from agency provides an opportunity to better understand the barriers hindering student empowerment.

The Power of Avoidance

One of the ways in which Air demonstrated individual power was through her drug use. As Air explained, drugs were a way for her to escape the pain she felt in her daily life. She recognized her use of drugs as an artificial high, rationalizing her drug use as a survival tool. Self-mutilation, sex, and suicidal ideations were used in a similar fashion by Air to occupy her thoughts and to provide a distraction from her pain. All of these actions, as well as her absenteeism, running away from home and school, and her dropping out of school to get married were ways in which Air resisted other forms of Power-Over through avoidance, attempting to escape oppression by ignoring it.

Perhaps since Air felt disenfranchised from her home and school environment, avoidance or running away was an easy tactic for her to use. Since Air did not feel a part of either culture, neither adequately welcomed nor nurtured, she had nothing to lose when she left, while gaining a sense of safety by avoiding what was discomforting. Air demonstrated this time and time again, as her first defense was always to run away.

Air was not the only student to use avoidance as a strategy for individual power. In fact, all three girls utilized this strategy quite frequently. Similar to Air, Isis used her poor attendance as a way to take control over her life, refusing to come to school more than three or four days a week, avoiding

the hassles she received when she did come. She also avoided difficult work, masking her avoidance through overt noncompliance.

Mandy also masterfully utilized avoidance as a coping strategy in a variety of ways. For example, although Mandy claimed to talk with her therapist and the other adults in the school, in actuality she did not talk with anyone about her life or about things that were troubling her. In fact, it had been a major frustration to her team of educators, probation officer, mental health workers, and family members because they had suspected for quite some time that Mandy had been sexually abused. She had frequent mood swings, oscillating back and forth between total compliance to noncompliance and aggression, lashing out at everyone around her no matter what type of relationship she had with them. Yet, whenever asked why Mandy behaved this way, she simply said, *"I don't want to talk about it."*

Aside from her refusal to talk about her personal life, Mandy also frequently avoided participation in challenging or uncomfortable activities. For example, oftentimes when Mandy did not want to participate in an activity, she claimed that she was either injured or sick as a way to avoid that activity. Her teacher, however, recognized this about Mandy and required her to participate anyway, providing minimal acknowledgment of Mandy's aches and pains and redirecting her back to the activity. This instructional method of planned ignoring by the teachers seemed to be somewhat effective because Mandy did eventually participate in most activities. However, for some reason her avoidance behavior seemed to be reinforced since she continued to use the strategy of feigning illness or injury in an attempt to avoid participation in certain activities, both academic and physical. *"Ms. Schlesinger, my stomach hurts."* Other times, Mandy would simply refuse to participate at all, regardless of the consequences. *"I told Ms. Stacks I didn't care if I lost all my points."*

Other students exhibited the use of avoidance as well. A popular form of avoidance among the boys in this program was to simply have their parents sign them out of school as soon as they turned 16, although some of the students waited until they were 18 and then signed themselves out.

> *"My mom said she thought I was going to graduate this year. I told her that in January, she was going to sign me out. She said that she wasn't so I told her 'Then we'll both go to jail for truancy.' She said, 'Then I guess I'll have to sign you out."*

> *While the class was working, Michael came into class, looking for Ms. Casper, who had been out for a meeting on Michael. He said he wanted the sign-out papers because he wanted to get out of this school for good. Ms. Stacks asked him if he was sure he wanted to do that and he said yes—he needed to get away from this school.*

Two students were brought in for a Level II... One student immediately tore up his paper but eventually agreed to do some work for Ms. Stacks. He explained that he did not get along with his teacher and in two weeks he would be old enough to sign himself out of school.

Throughout the school year, students were heard proposing *signing out* of school as a means for avoiding further subjugation. Sometimes the process of signing out was a formal one, but more often than not students simply vanished from the classrooms, remaining as only faint whispers among the staff and students.

Planned Ignoring as a Form of Individual Power-Over

Another way in which the students in general demonstrated individual Power-Over was by disengaging themselves from friction and oppression being actualized around them. I was continually amazed at how adept many of the students in this ED culture were at ignoring the violence and aggression that permeated this school environment, continually working through chaos as noted in the following field note excerpts.

Suddenly there was a loud crash heard along with a lot of yelling. The disruption was coming from the classroom next door... Initially, the students ignored the chaos, but after the crash sound, Arty stood up to see what was going on. Isis said "Sit down Arty. It's none of your business." Ms. Fields got up and closed the door to the classroom. The rest of the class continued working without responding to the commotion going on outside their door.

A loud slam was heard down the hall. Jarrod murmured "Now he's mad." Over the walkie-talkie a call came to announce that a student was leaving the building. A call was then heard for Jeremy, the police officer, who went running past the door. Ms. Stacks got up to close the door... The class continued to work.

There was a loud commotion going on out in the hall. Yelling and loud banging noises could be heard. Over the walkie-talkie a Code Red was issued, asking teachers to close their doors. The students continued to work.

All three of the girls in this study described their use of planned ignoring as an approach to coping with the ED environment and life in general. As noted earlier, Air said that she tried not to worry about things because it did her no good. Isis often shared how she felt she had no control over what others did, and Mandy simply said she did not care what was going on with others. Although compassion and empathy for peers was demonstrated periodically throughout the school year by each of these girls,

they had accepted their powerlessness in some instances and chose to not become involved. Perhaps they recognized that if they had become involved, they might not have continued to be witnesses, but rather victims again.

Acts of Defiance

When the learners in this school environment could not avoid a difficult situation, the only other strategy they seemed to have in their repertoire was to address the problem head on, confronting the challenge presented before them and putting up a fight. Using back talk, profanity, defiance, and noncompliance, these young women, as well as the other students in this program, exercised individual Power-Over against the rules and their teachers. Isis offered us several prime examples of someone who chose to aggressively retaliate against other forms of Power-Over, possibly attempting to take power back, which she felt had been taken from her. It was as if Isis came to school prepared for battle, just waiting for the opportunity to strike out against authority. Even her own mother noticed the difference in Isis when she came to school. She expressed concern over this, telling Isis that she saw her demeanor change even as they drove into the school parking lot. *Telling it like it is* was one way individual Power-Over was used by Isis, subjugating others through her comments and commands. The following are several examples in which Isis directed individual Power-Over toward her peers.

> *"Why do you keep asking that! You know that if you swear you lose points. It's been that way since you got here. It's not going to change. Why do you keep bugging her about it!"*

> *"Isaiah, stop tapping your feet... please!"* He stopped.

> *"Would you stop chewing your gum so loud please!"*

> *"What's it to you anyway? She wasn't talking to you."*

In each of these circumstances, the peer receiving the reprimand, which was a different peer in each scenario, stopped doing whatever it was he was doing to aggravate Isis, ceasing with little or no hesitancy.

When Mandy got upset, she often resorted to some fairly intense strategies in an effort to impose individual power over her teachers in response to organizational or interpersonal Power-Over she was experiencing.

*"Sometimes my behavior gets so bad that I hit people and stuff. I broke a
teacher's nose last year." "One day I hit Ms. Stacks and had to go to Juvenile
Detention." "Another day I went off and I guess I was banging my elbows on a
table or something because now they are really bruised up."*

For Mandy, physical aggression to herself or others had become an
effective form of retaliation. Although other students also utilized aggression
or the threat of violence as a means for demonstrating individual power,
some of the more commonly used forms of individual Power-Over, however,
were profanity and noncompliance.

The Power of Profanity

The uninhibited use of profanity by students revealed the power this speech
act wielded, the display of profanity being a material entity or sign to
investigate. Within the educational community, profanity is a powerful tool
as it readily receives the attention of teachers and administrators (Jay, 1992;
Kaufman & Center, 1992; White & Koorland, 1996). The use of profanity by
students is possibly considered a personal affront to educators, perceiving the
use of profanity as a threat to their authority. Therefore, profanity had
perhaps become one of the easiest ways for these students to demonstrate
resistance against the authoritative school culture, as noted in the smattering
of examples that follow.

*The bus driver opens the door and gets off the bus, directing Air to do the same.
As Air leaves the bus, she can be heard yelling, "You can kiss my fucking ass!"*

*Isis complained, "You're telling him the answers and you tell me to look it up.
Bull shit!"*

*Brady came into the room and told Ms. Smith that he couldn't wait for her to read
the note his mom had written her. He said it was a doosey. She asked him in a
joking manner, "Why? Did you go home and complain to your mommy?" Brady
replied, "Yes. I told her I hate this fucking place." His teacher reminded him to
watch his language. He said "No."*

*Isis said, "No, I'm not doing that. You're fucking stupid. I was doing okay and
then you had to come in and fucking piss me off."*

Arty: Fuck you (under his breath).
Ms. Smith: Arty!
Arty: What? I didn't say nothing.
Ms. Fields: I think everyone in here heard it.
Isaiah: I heard it.

Arty: *That's bull shit. There, you can hear that one.*

As Air sat back down to complete her work, she discovered that she had some additional questions to complete on the back page of one worksheet. "Shit." Ms. Smith asked, "Air, what did you say?" Air replied, "I said 'shit'."

While Air had stated that the swearing by students *"don't mean nothing,"* that it was just a release, in fact profanity may very well have meant a very significant *something* in the students' constant battle against cultural reproduction. While the use of profanity could be considered a form of noncompliance as students overtly broke school rules around *appropriate* language, as a tactic for individual power it may also have had a communicative function (Jones, 1998). Many examples captured in my field notes exhibited the use of a swear word in direct response to some personal injustice imposed by teachers on students. The use of profanity in isolation of other rebellious actions may have been a quick and efficient reminder to the teachers that they did not have total control, keeping teachers aware that while students may have had no formal authority, they often had command of the situation. Profanity was typically a powerful enough strategy by itself to communicate this message to teachers and to other adults, as noted when frequently after swearing, the students reinitiated working on their assignments without further complaint.

Noncompliance. While profanity may have been an effective communication tool for the students and not simply an act of defiance, there were other actions students in the ED environment displayed which had no other purpose other than sheer defiance of rules. For example, as noted in the story Air shared in her Personal Life Presentation about Mark being arrested for resisting the school police officer, the incident actually began with unadorned noncompliance. When the teaching assistant told him to stop, he had continued to walk down the hall, and when his teacher and the police officer tried to get him to go to a Level II, Mark had refused to get up. Following are several more examples of noncompliance being used by the students in the ED environment.

Mandy adamantly proclaimed, "I don't care. I don't want to go to electives...I am not going to electives at all...It's stupid. It's retarded. It's for little babies. I don't care if I'm not participating. I'm not going to do no work today... I'm not going to gay art with those stupid gay teachers."

When I walked into art, Mandy was sitting at a table by herself with her head in her hands, covering her face. The art teacher, Ms. Smith, tried to coax Mandy to do work, kneeling beside her and talking with her quietly. Mandy replied, "I ain't

doing nuttin'... I ain't doing nuttin', period!.. I'm not gonna do any more work here the rest of the year."

The day began with journal writing. The writing prompt was "Tell me about your favorite childhood toy." Isis refused. "I'm not going to write in my journal. I always get in trouble when I write in my journal." Even after being quietly prodded by her teacher, Isis said "Noooooo."

Isis:	*Why are you looking at my journal?*
Ms. Smith:	*You need eight sentences Isis.*
Isis:	*No I don't. You never told us we needed eight sentences. No! No! No! No! No! No! I'm not going to do it. It doesn't say that. No.*
Ms. Smith:	*Come on Isis. Write eight sentences. It could be like 'I like Isis because sometimes she helps Isaiah with his work.' See, that's one sentence. That's all it has to be – complete sentences.*
Isis:	*No, nooooo, no, no, no! I hate this school. I'm quitting.*

A lot of effort was often put into a student's demonstration of noncompliance, as students refused to work for extended periods of time, or engaged in extensive arguments over school rules or policies. On occasion, even elaborate schemes were devised to exert individual Power-Over in the form of noncompliance, as in the following lengthy scenario.

Isis said, "I have to find somewhere to put this." She was referring to a packet of papers all folded up into a small square.

MJ:	*What is it?*
Isis:	*My work from Wednesday.*
MJ:	*I thought you were finished with your work.*
Isis:	*I finished today's, but I'm not doing Wednesday's.*

After lunch, the teacher directed students to complete their work left over from the morning. Isis said she had finished all of her work, so the teacher checked to see what Isis had turned in.

Ms. Smith:	*Where's your packet from Wednesday?*
Isis:	*I turned it in.*

Ms. Smith searched the pile of papers and still could not find the packet. She asked Isis for it again.

Isis:	*"I don't know where it is. I left it on my desk before lunch and now it's gone!"*

Ms. Smith began looking around Isis's desk and then began to search Isis's book bag for the missing papers.

Isis:	*It's not in my fucking book bag!*
Ms. Smith:	*I just want to know where it went.*
Isis:	*I bet you wish you knew.*
Ms. Smith:	*I'm trying to help you out hon.*
Isis:	*I told you I don't have it!*

Giving up on the search for the packet of Wednesday papers, Ms. Smith went back to her desk to check the work for today that Isis had turned in. She found a part that Isis needed to complete, and then asked Isis where the paper was that showed her math work. Isis said that she had thrown it away. Ms. Smith asked her to get it out of the trash. Isis refused. "I'm not going through the trash can!" Ms. Smith checked the can herself. There wasn't much in there so she could easily see that the paper was not there. Isis yelled, "Not that trash can! I threw it away in the cafeteria trash!"

Ms. Smith explained that since Isis could not find the paper on which she had recorded her work, Isis would not get credit for that assignment. She told her that she would have to do it again to show that she had not used a calculator or copied the answers from someone else. "Why Ms. Smith? That's fucking stupid! I didn't use a fucking calculator. I told you, I threw it away... Find it your fucking self!"

As Ms. Smith continued to encourage Isis to redo the work, Isis continued to argue.
Isis: Check the answers. They're probably all fucking right!
*Ms. Smith: I'm sure they are, Isis. But I need to see your work in order to give
 you credit for it.*
Isis: You didn't tell us we had to show our fucking work!

Isis began to whistle. "Isaiah, how does that one whistling song go, from that show? You know." Isaiah answered, "Andy Griffith?" Isis responded, "Yeah, how does that go?" Isaiah started to demonstrate and Isis picked up the tune. Ms. Smith asked her to stop whistling. Then Isis began to loudly tap her foot on the floor, resulting in her teacher asking her to stop that as well. Isis replied, "Actually, I'm not trying to be annoying. I'm just trying not to be bored." Ms. Smith countered, "Then do your math." Isis refused once again. "No. I already did that once. I'm not doing it again..."

Back in the classroom, Isis worked quietly and independently. Ms. Smith went over to her and tried to show her what she still needed to do. "No, I'm not doing that one. No. I've made my decision. I'm not doing it." When she was done with her packet, she stapled it and turned it in.

This episode had occurred during the course of an entire school day, with neither Isis nor her teacher giving up the fight for control in this situation. The battle had become almost absurd as neither individual would relinquish power.

Sometimes these power struggles were fruitless for the students, as in the following example.

While most of the students were working well, Arty was having a difficult time. He had been lying on the floor and his teacher asked him to return to his seat. Once he did, Ms. Smith knelt beside his chair and quietly prodded him to do his work. Arty responded, "I'm not doing no fucking work. It ain't even related to English!" Ms.

Smith continued to talk with him and must have tried to get Arty to take his coat off.
"You're not getting my coat off me. Don't even try!" Eventually, Arty was escorted
to Level III. When the teacher came back, she had his coat in her hand.

In the scenario above, Arty's defiance did not result in his having power over the situation since in the end he lost the right to keep his coat. Although he avoided participation in his work for the time being, he did end up having to complete it in a Level III.

While Arty lost the battle for control in the above scenario, other times the noncompliance of students worked well to get a student's needs met.

Ms. Johnson came in to the room to ask if Isaiah had any shoes. He was in Level III
with only his socks on. Ms. Smith replied that Isaiah had torn them up this morning,
however, that was not entirely true. In actuality, he had been wearing a pair of army
boots that were worn through. Isaiah had them taped with duct tape. When he came
into class that morning, he had taken the tape off and was going to fix them, but Ms.
Smith told him he had to do his work first. That's what started Isaiah's refusals to
work. He said he was not going to do any work until after he fixed his boots. It was
this refusal that eventually landed him in a Level II and then a Level III. He was now
walking around the school with only socks on. Jeremy, the police officer, came in to
get Isaiah's shoes and said he would look for some duct tape. Eventually, Isaiah
returned to the room with his shoes on and repaired. He sat at his desk and worked
diligently throughout the remainder of the school day. He had gotten what he
wanted.

Not all of the forms of individual power that existed in this school culture were quite as obvious, however, as the tactics of swearing, outright refusals, or noncompliance. These students exerted individual power in a variety of rather creative ways as well, such as through organized solidarity.

Solidarity

Aside from the theory that racism offered students a leg up on the social ladder since the students attending this particular ED program were of European descent, there is also the possibility that schoolwide racism afforded these students an opportunity for solidarity. Even though each of the students appeared to understand that it was politically incorrect to be racist and that their teacher did not want them to be racist, they continued to openly proclaim racist beliefs. Their adamant position was possibly an act of open defiance against social norms of *acceptable behavior.* As members of an artificially constructed culture, they may have realized more power in numbers and used that power against teachers in perhaps one of the few ways they could. This is not to suggest that their expression of racist beliefs was a

premeditated strategy organized for the sole purpose of presenting a united front against their teachers and society in general. However, these students may have actually discovered something to which they all had a common allegiance, and then perhaps conveniently used their common support for racism as a means for rebelling against the mainstream culture which they perceived to have a different set of beliefs. This manifested itself in a variety of ways. For example, in the following passage, Isis attempted to use Ms. Smith's dislike for racism as a way to demonstrate resistance. Picking up on her cue, another student chimed in with his own racist comments.

> *Ms. Smith eventually left Isis alone, giving her the direction once again to redo her math. Isis sat quietly, but did not do any work. As she often did, she leaned her chair back on two legs. Ms. Smith told Isis to please put her chair down, and Isis responded, "Yes massir" as she complied with the request. Isaiah passively refused to work as well by not attending to his assignment, periodically making comments such as "Nigger" and "Fucking Negro people."*

In this example, a sense of solidarity was apparent between Isis and Isaiah as the two students actively joined forces through a common theme to demonstrate a cohesive union of resistance.

Another example of solidarity comes to mind as one student attempted to rally other students to defy school rules.

> *Ms. Johnson came in to the room to tell the teacher that she had to remove Arty from the time-out room because he was trying to incite a riot with the other students in time-out. She said he was saying "We don't have to take this! Come on! Let's just walk out! There's power in numbers!"*

When I spoke with this student about this and other similar incidents, he expressed his belief in civil disobedience, but not as a strategy for creating change. Rather, this student saw civil disobedience as a way to wage battle against oppressive forces. He was not looking for long-term effects such as changing the rules or to force the education establishment to provide more freedom to students in the ED environment. Instead, this student was focused on the immediacy of the win-lose situation. He had simply wanted to "win."

Further Subjugation

The students in this ED program, both male and female alike, used a variety of methods to exert their individual power over others. For the most part, the strategies they used were the very ones that contributed to them being identified as having a disability because these strategies were not considered

acceptable ways of "earning" power. The techniques and strategies these students used, including student protest of rules, refusal to complete assignments, absenteeism, swearing, aggression, unique dress, drug use, attempted suicide, self-mutilation, promiscuity, "signing out," and even getting married, were all utilized to rebel against other Power-Over conditions. Yet, each of these acts subverted the students' original goal, because instead of resulting in freedom from oppression, the use of these strategies often resulted in punishment, retribution, and further subjugation.

Air's overt use of drugs and sex as a form of escape contributed to further societal oppression because of the low social status drug abusers and "sluts" are relegated. Even her dire need for attention got her into trouble as peers misinterpreted the messages she sent and became offended, retaliating through verbal and emotional abuse. When Air ran away from home, her case worker put her in foster care. By missing school, she missed instruction, thereby causing her to struggle in school that eventually led to her being retained due to poor school performance. While in this ED program, absenteeism had a negative impact on the number of points Air could earn, often resulting in her missing clubs. She also received detention time for truancy as well. When Air lashed out at her mother she again received time in a detention center. By dropping out of school, Air had further limited her options for accessing power through employment. Poverty may, in turn, take its toll as societal oppression continues to have an impact on her outside of the school walls.

Isis's absences also worked against her as she too missed an extensive amount of schoolwork and instruction. In addition, she was expected to complete the work she had missed, giving her less freedom the day she returned to school. Although Isis continued to fight against the rules and oppressive practices in school, she did so in a way that only subordinated her more as she lost privileges and spent an increasing amount of time in a Level II or Level III intervention.

Mandy was similarly affected by the choices she made. Her subjugation increased as the school year went on, initially losing points, then privileges, then the right to participate in certain classes, escalating to isolation and restraint. Eventually, Mandy was extremely oppressed in response to her actions by being court ordered to a juvenile detention facility. No longer in school, Mandy was possibly being acculturated into prison life with little or no freedom at all. Each of these students' acts of individual power actually became the foundation for further subjugation by the other forms of Power-Over existing within this school culture.

The Interconnectedness of Power

It is not my intention to present Power-Over in a reductionist manner, sorting the various forms of power observed into tidy categories of constraint. The issues of Power-Over in this school culture are in fact quite complex, with each source of power interconnected with the others. The students themselves recognized the complicity of Power-Over, sharing their perceptions of how one form of power was intertwined with another. For example, Air appeared to view organizational power and interpersonal power as the same thing. She suggested that authority figures imposed organizational structures as a means for exerting interpersonal power, as in this example when she said, *"She is such a mean teacher. She probably doesn't even like me. The point sheets are a way for her to show it."* She viewed the bus driver write-ups as a way for the bus driver to get back at Air for something she had done at the beginning of the year, and the mental health worker's reporting of disclosed abuse as a way of diminishing the rapport between school faculty and students, keeping their status unequal.

Isis echoed this sentiment as she too, recognized the connection between organizational and interpersonal Power-Over. In her rendition of the lunchroom episode when her teacher tried to redirect Isis to put her chair down on all four legs, Isis explained that the issue was more about the teacher's need for control over the situation, which is an interpersonal form of power. Yet, her teacher used the loss of points, an organizational source of power, as a way of taking control since Isis would not comply with her direction. Isis described a similar scenario when she detailed the additional rules her teacher had created around Isis sleeping once her work was completed. As Isis put it, *"It's just a way for her to make more rules! Ms. Smith is such a control freak."* Even though there was an organizational structure for Isis to earn the reward of going to the office during lunch through the implementation of a behavior plan, the teacher exerted her interpersonal power to let Isis know that she could only go if the teacher felt she had earned it.

Behavior plans are often used in this manner. Although the purpose of behavior intervention plans is to be a teaching tool for students, they oftentimes become a source of manipulation and further control on the part of the educators who create them because of the multiple ways Power-Over is applied as part of the plan. Behavior intervention plans are a typical form of organizational Power-Over commonly used for students, particularly those who receive special education services. It is actually a requirement for any student in special education whose behavior is a significant concern, including those involved in this study, to have an individualized behavior

intervention plan, outlining the unique and specific strategies which are to be implemented to help the student control her or his behavior. Mandy had such a plan, which I assisted in writing.

Upon review of the behavior plan designed for Mandy, one can see that creating forms of organizational Power-Over as well as interpersonal Power-Over were the primary foci of this plan. Although the team recognized Mandy's need for control over some situations by providing her choices of free time activities and opportunities to demonstrate leadership and gain attention, the bulk of the plan scripted out how the school staff was to demonstrate Power-Over with Mandy. While the behavior plan itself was a form of organizational power, the implementation of the plan was actually related to interpersonal power, outlining how the school staff was to interact with Mandy in a way to communicate authority over her. Just as with Mandy's behavior intervention plan, the categories of Power-Over are all interconnected and cannot be genuinely realized in isolation of one another.

Another Fantasy?
Personal Empowerment
and Power-To

"Hold your tongue!" said the Queen, turning purple. "I wo'n't!" said Alice. "Off with her head!" the Queen shouted at the top of her voice. Nobody moved. "Who cares for you?" said Alice... "You're nothing but a pack of cards!"

Lewis Carroll
Alice's Adventures in Wonderland

Agency Requires Visual Acuity

In contrast to Power-Over, through which power is exerted over another, Power-To can be defined as personal empowerment or agency, as individuals acknowledge the catalysts of oppression that have had an influence on them. Power-To is different than individual Power-Over because when one enacts Power-To, one does so in a way that does not contribute to further victimization. Besides the ability to identify oppressive forces, another integral facet of Power-To includes the ability to control one's own thoughts and actions, presenting a thoughtful and critical response to attempts at marginalization, leading to personal empowerment.

As Alison Jones (1993) requests of researchers, it was not really the intent of this research to depict a segment of the female school aged population as oppressed. Rather, it was to discern how this particular group might position themselves within a school climate that was oppressive. Forced to survive in an environment that is structured predominately for the perceived needs of their male counterparts and within particular class and cultural expectations, these young women most likely demonstrated resilience through their ability to navigate the stormy waters of the ED class environment. It was not assumed that these girls were passive recipients of harassment and oppression, but rather active agents against oppressive realities. Recognizing alternative means for acting out against oppression might have been a possible outcome of their participation in this research project.

By searching for evidence of Power-To in this ED environment, I was looking for signs that the young women engaged in this study recognized Power-Over as it was demonstrated in the school culture and in the broader context of society. Recognition is the first step to action, and I hypothesized that if these adolescents were able to recognize these power structures, they would be on their way toward personal empowerment. However, what I found was that these girls currently did not have in their repertoire of skills the tools needed to act in a manner to effect change toward emancipation. Instead, they continued to revert to demonstrations of individual Power-Over that contributed to further subjugation within this school culture, creating a perilous tension between Power-Over, or victimization, and Power-To, or agency. Plus, the deck was stacked against them through the structural organization of the school culture, inhibiting the realization of liberation. Yet, even though liberation from oppression may not have been realized, the young women engaged in this study were still able to identify some of the social and political structures that subordinated them, albeit in a superficial manner.

Air's Nearsightedness

The girls in this study demonstrated an understanding of Power-Over issues in several ways, including the recognition of global oppressive practices, oppressive practices specific to the ED culture, and oppression each had personally experienced. Air was a prime example of a student who grasped each of these concepts. First, she seemed to be cognizant of many social injustices. For example, in her conversation about racism, Air demonstrated a cursory understanding of the historical oppression experienced by African Americans. *"I don't understand why a black person would hate me just because I am white. I didn't put them into slavery. I know that my ancestors did, but I didn't..."* She also noted current practices of racial prejudice. *"I don't think that it's right that whites chase people out of neighborhoods and stuff..."* Aside from racial discrimination, Air also acknowledged the social incongruities between genders, complaining that when girls drop out of school, everyone assumes they are pregnant, but if a boy drops out, *"it's no big deal."* At times she even questioned why her boyfriend, a 24-year-old man, would want to date a 15-year-old girl. She verged on the brink of self-discovery concerning this issue, but then quickly shoved any burgeoning thoughts of subjugation out of her mind.

As well as the social inequalities Air recognized, she also could identify events specific to her personal life that were oppressive. For example, during

one of our conversations, I had shared with Air my understanding that many girls who make the same life choices that Air had, such as repeatedly running away, being promiscuous, drug abuse, and prostitution, often did so in response to an experience with sexual abuse. I asked her if she had ever disclosed an abusive situation such as this and she quickly confirmed my suspicions. At that point, Air shared with me her history of sexual abuse by her father, the early abandonment by her mother, and even a hypothesis that her mother abused drugs as an escape mechanism just as Air had. Her mother had also been sexually abused by a male relative. Without reservation, Air easily made tenuous connections between her actions and the actions of her mother, with their similar experiences of victimization.

In the ED environment, Air demonstrated Power-To by recognizing ways she and others had been marginalized. As Air stated so eloquently, *"No one's behavior is naturally bad—other people make it that way."* She did not believe teachers should give disapproving looks to students because she felt they had no right to judge how others behaved. Air even recognized how many of the teaching strategies teachers used may have been contributing factors to students' behavior. *"Sometimes I think teachers make things worse with kids by riding them when they are upset and having a bad day. They should just leave us alone when we're like that."* Air also recognized how the lack of confidentiality for what students disclosed, paired with action taken by the local Children's Services agency, added to student disenfranchisement and marginalization. *"You want kids to talk to you but as soon as they open up you go and tell someone and it just makes it all worse. It makes them not want to talk with anyone anymore."* Each of these incidents demonstrates Air's intuitiveness about Power-Over in the ED culture.

While Air had begun to distinguish the life events, both in school and out of school, that acted to oppress her, her observations fell short of Power-To because they were merely surface observations, with Air giving those incidents only a polite nod of recognition. She failed to take a more microscopic examination of the connection between these incidents and her subsequent actions. It was as if Air had given in to the powerful influences in her life, surrendering herself to them when she was too weak to fight back. And since Air could not fathom an alternative Power-To response (*"I don't know how else to behave"*), her attempts to retaliate only landed her in more trouble. In the end, Air resorted to acting out various forms of accommodation such as promiscuity, and then chose to simply avoid oppression whenever possible. Perhaps because the sources of Power-Over had been so pervasive in her life, Air had been unable to realize a sense of self-consciousness beyond the oppression, only seeing herself through her

revelations about her dominating world. In 1903, Du Bois (1989) referred to this as a double-consciousness in which one looks "at one's self through the eyes of others, of measuring one's soul by the tape of a world that looks on in amused contempt and pity" (p. 3). Air's view of herself and her place in the world perhaps related to the way she felt others viewed her, becoming a self-fulfilling prophesy at work.

Isis's Farsightedness

Isis came closer than Air in being able to demonstrate Power-To. Like Air, she too comprehended that certain events and practices to which she had been subjected had acted to oppress her. Yet, there were times when Isis was able to take it a step further than Air, and actually attempted to manage her own actions so that she would not be subjected to further oppression. One way in which Isis exhibited Power-To was in her identification of certain organizational power structures. For example, she was able to identify specific times of the day that had a negative influence on her within the school environment. She told me that she had compared her point sheets and said that the trouble she had in school usually began during the lunch period.

Isis:	*It's Ms. Smith. She changes over lunch. Everyone sees it."*
MJ:	*Are you sure it's her and not you?*
Isis:	*No, it's her. Everyone knows it.*
MJ:	*So, you think it starts at lunch. Is it because she doesn't let you go to the office?*
Isis:	*Yeah, probably.*
MJ:	*If she let you go to the office, would that help?*
Isis:	*Yeah. Because I feel too closed up in there. It feels like a prison. I can't stand that.*

In this example, Isis initially blamed her teacher for the difficulties she experienced during that particular time of the day. However, she eventually identified the oppressive atmosphere of the school environment as a primary contributor to her misbehavior.

Although Isis did recognize various aspects of power, she was most adept at identifying the numerous ways in which interpersonal Power-Over was actualized in her school environment. Just as Air had commented on the teachers' role in intensifying a student's behavioral issue, Isis also recognized how the actions of teachers escalated certain situations. She explained this principle using her teacher as an example, *"the way I handle things sometimes, like yelling and cussing, can be prevented by the way she reacts to things."* Isis also recognized when she was *"being manipulated into being*

respectful" by school staff instead of teachers earning respect from their students, and that sometimes teachers responded in certain ways for the simple purpose of communicating to students that they have dominion over them. The following is an example.

> *At lunch time, Ms. Smith came looking for us and told Isis that she had to come join them for lunch. As we walked down the hall, Isis said, "See, that's how she's a bitch. When she does stuff like that. She knows I never eat lunch. Why couldn't I have stayed in here with you? Why did I have to go to lunch?"*

Having to eat in the lunchroom was one way in which Isis's teacher exerted authority over her, and it remained an issue of contention throughout the school year because Isis was aware of the teacher's intent to control her.

Isis's ability to discern specific acts of domination and Power-Over was actually quite astute as she demonstrated her understanding of Power-Over in rather complex ways. One such example was when Isis relayed the story of the school mascot. Explaining why she did not want to put the school mascot choices to a vote, Isis said that she knew the students would choose the mascot that the staff did not want, and since there were more students in the school than staff members, the student mascot choice would most likely win by majority vote. Except, because of her comprehension of the power hierarchy that existed in the ED environment, Isis prophesied that the majority vote would not count because it would not be for the mascot the staff would prefer. Not wanting to see the teachers' power realized in this situation, Isis had been reluctant to pursue a schoolwide vote. Even her preference for a school mascot demonstrated some knowledge about the components of power that influenced her life. In an explanation about the demeanor of pit bulls, Isis suggested that *"It depends on how they're raised. Just like us. We're the way we are because of the way we were raised."*

In addition to the ways in which Power-Over were manifested in this school environment, Isis also recognized the power of her disability, understanding that some of the reason she acted the way she did was due to her disability. She readily named her handicapping condition and even said that she would like to learn more about it. Her specific questions posed to me were *"Why do I have this?"* and *"Was I born with it or did I get it later and why?"* In my attempt to contribute to Isis's sense of empowerment, I explained to her that those questions could be answered differently for each student assigned to that special education program. We discussed how some students may have been born with a neurology or some other biological predisposition which contributed to conditions such as Attention Deficit Hyperactivity Disorder (ADHD), which Isis said she had. Other students had perhaps never learned to cope with a traumatic event in their lives, while still

others may have suffered ongoing abuse or had grown up in environments where everyone dealt with their problems by fighting. I told her that I would be happy to bring her information about her disability for her to read and offered to get her information on the disorders she had been diagnosed with so that she could read about them and decide for herself which she felt best fit her. Isis responded, *"Cool."*

As a result of this interaction as well as others on the topic of Isis's disability, she began to actually demonstrate a flickering of agency in association to better understanding her disability. An excerpt from my field notes illustrates this possibility.

> *Late in the afternoon, the class took a walk to the public library, which is across the street from the school. Students were encouraged to find a book to take out. Isis accessed the computer and typed in "severe behavior handicap" but did not come up with anything. Once I noticed what she was doing, I helped her use other key words, but it was embarrassing to have to tell her to try things like "deviant behavior" and "juvenile delinquent." Right when Ms. Smith told the students they had to go, Isis found one book, but it was geared more toward parenting skills, so Isis left without a book.*

Although Isis tried to independently seek information on her disability, the attempt was futile given the limited amount of time allowed for her research and the scant amount of information accessible to her through the public library. As far as I know, she did not try to research her disability again, although I did supply Isis with articles on the subject of her disability, several of which we discussed together.

Despite my undertaking to empower Isis, her view of Power-To remained somewhat myopic. This limited vision was not only in relation to her disability, using it as an excuse for not controlling her own behavior, but also in relation to the ED school environment in general. In order to achieve agency, aside from recognizing oppressive practices, one must also be able to recognize the resources available to support one's liberatory actions. For the most part, however, Isis only had visual acuity for the oppressive forces presented to her. The following is an example of how Isis maintained this limited view.

MJ:	*What is it about Mrs. Smith that you don't like.*
Isis:	*She can be a bitch.*
MJ:	*When I am in the classroom, I'm having a hard time seeing what she does that would classify her as a bitch. Like today, when she was working with Arty, she was kneeling quietly with Arty and trying to get him to work. Did she do something then?*
Isis:	*No. I don't know what she does. She just is.*

MJ: *It's weird to think that someone who calls all of you guys "babe"*
 and "hon" would be considered a bitch.
Isis: *She does?*
MJ: *Yeah. Haven't you ever heard her?*
Isis: *No, not really.*
MJ: *Well, listen to her sometime.*

This conversation exemplifies my attempts to encourage Isis to see her teachers as resources in some aspect toward her emancipation. My efforts were to no avail. She also had a difficult time recognizing how her own acts of individual Power-Over contributed to her continued oppression in school. On one occasion, after Isis had admitted to me that she purposefully tilted her chair back to annoy her teacher, I asked her if she thought that perhaps some of the problems she and her teacher experienced were because she too had an issue with control. Isis disagreed and continued to place the blame on her teacher. On another occasion, Isis again refused to accept any responsibility for the difficulties she had in school. As noted previously, she had initially suggested that her teacher was the cause for Isis having trouble around lunchtime. *"It's Ms. Smith. She changes over lunch. Everyone sees it."* In response, I asked her *"Are you sure it's her and not you?"* and Isis simply replied without hesitation, *"No, it's her. Everyone knows it."* This farsighted perspective actively contributed to Isis's continued oppression because without acknowledgment of her personal contribution to oppression, she could not begin to realize Power-To.

With the exception of her disability, Isis also did not acknowledge the oppression she experienced outside of school and in the broader context of her life. As she shared in her pit bull explanation, while Isis demonstrated an understanding of how her family may have had an influence on her current behavior, she was unable to pinpoint any specific life events that may have contributed to her current sense of self. *"I guess my behavior got worse when my parents split up. They say sometimes something can happen that you don't remember, but can mess you up for a long time."* Although she willingly shared with me her experiences with both her father and mother hitting her, she remained unable to make a direct connection between those experiences and her current actions in school. While Isis may have exhibited Power-To, she did so as a neophyte, lacking the sophistication to move beyond the limited context of her family and her school environment. In addition, she was reticent to acknowledge societal factors that may have had an impact on her life, possibly further subordinating her in asymmetrical power relations.

Mandy's Visual Impairment

Mandy appeared to be the exception to the rule when it came to the female students involved in this study acknowledging Power-To. On only one occasion did Mandy hint at understanding how she had been the subject of oppression. *"See, I'm bad because of the people I hang around with and my cousins do stuff around me that they shouldn't—they're teaching me bad stuff."* However, Mandy refused to go into detail about what specifically her cousins had taught her. Similarly, Mandy shared in her Personal Life Presentation that there were things her family did that were inappropriate to talk about. Somewhere in Mandy's short educational history she had learned that it was not safe to share certain aspects of her life, alienating her from the rest of the school culture because of a perception that there was something wrong about the way Mandy lived. She had been successfully indoctrinated into the artificial dichotomy of right and wrong of family life as delineated by the *values* shared in schools and in society. Although Mandy often described a fairly typical family life, she occasionally hinted of a lifestyle that may have been at odds with prevailing paradigms, leaving her feeling disenfranchised from the school culture.

Other than the one instance when Mandy acknowledged that her cousins taught her to be bad, overall Mandy failed to recognize how she was influenced by oppressive practices and how she contributed to her own oppression. For example, during one of our many conversations, I told Mandy that I had noticed that when I was in her classroom, she often asked for help or said that she did not know how to do something. She said, *"I do that?"* She genuinely seemed to be unaware of her own responses to the environment. On another occasion, Mandy shared with me that she had gotten mad at her art teacher, Ms. Smith, because she *"always wants us to draw leaves!"* I reminded her that Ms. Smith usually gave her options. Mandy countered by maintaining that on a previous occasion, she had wanted to draw a plastic lizard, but Ms. Smith would not let her. Once again, I reminded Mandy what I had observed, that Mandy had asked Ms. Smith to draw the outline of the lizard for her and Ms. Smith responded by saying that she would draw a few lines to help Mandy get started, but not the whole thing. It was Mandy who had chosen not to draw the lizard at that point. Once again, Mandy seemed stunned and did not appear to remember the incident in the same way I had it recorded in my field notes. While Air exhibited a double-consciousness, perhaps Mandy was living an anesthetized conscious, either numb or perhaps ambivalent to the causes of pain and oppression that existed in her life, including her own self-imposed oppression.

Even though Mandy seemed incapable of recognizing the various forms of Power-Over which contributed to her sense of self, I remained relentless in my quest to help Mandy become aware of at least the individual Power-Over she exerted to gain some control over her environment. However, when I asked Mandy why she asked for so much help when she already knew how to do the work, she simply said, *"I'm lazy,"* and when I asked her why her stomach hurt so much, she explained it was because of her medication. While this may have been true in some instances, I continued to suspect that some of Mandy's illnesses had been feigned in order to avoid participation in certain tasks such as group therapy and art.

Recognizing the Power Hierarchy

The students observed in this ED environment presented multiple dimensions of understanding about Power-Over, and most appeared to have some notion that they were subjugated in this asymmetrical power hierarchy. One student communicated this knowledge of their low status quite well, as demonstrated in the following example.

> *Ms. Fields began doing Brady's point sheet and reminded him that she had to take a point off because he swore at her. "No I didn't." ... Evan spoke up and said that Brady did not swear and that it was his teacher's word against his and Brady's, but then joked "But then again, who's going to believe us?"*

Evan had initially joined Brady in solidarity against his teacher's accusation. However, he quickly acquiesced, acknowledging the futility of rebellion without power. While he may have felt a sense of agency, it was short lived, perhaps because he had witnessed the suppression of similar attempts by other students in the past. Evan's comment represents more than just a flicker of recognition of student oppression, demonstrating promise in these students' abilities to realize Power-To if given support to do so. Perhaps continuing efforts to access students as participants in future studies could make Power-To within grasp of students instead of being restricted to the periphery of student vision and access.

Questions and Possibilities

"Would you tell me, please, which way I ought to go from here?"
"That depends a good deal on where you want to get to," said the Cat.

Lewis Carroll
Alice's Adventures in Wonderland

Walking the Tightrope in Research

There exists a voyeuristic nature to this research since the stories shared herein occur in an environment that is not familiar to most people (Lather & Smithies, 1997). Through the creation of segregated special education programs, schools have successfully shielded the general population from witnessing the overt acts of defiance and rebellion exhibited by some students, or from becoming aware of the traumatic histories many of these students share. Fearing contamination, students labeled as ED are often colonized and isolated out of the general public's view and awareness. Walking the tightrope between relaying these students' messages and sensationalizing their traumatic histories remained a constant struggle throughout the course of this research project.

Casualties of Oppression

The original purpose of this study was to gain a better understanding of the perspectives of three female adolescents educated in a segregated school program for students with an emotional disturbance. Through this research it has become apparent that many of the students involved in this ED program are casualties of oppressive practices. It has also become apparent that the female students in this program are even further victimized through their minority status as a gender. Issues of power and subjugation are prevalent in this school culture, and the girls respond through a variety of forms of accommodation and resistance. Understanding their acts of nonconformity as accommodation and resistance was a focus of this study.

In a sense, the researcher's role during this inquiry was to facilitate these students in taking stands against oppression, promoting the students' involvement in social and political action, hopefully helping to expand the range of possible social identities these young women might adopt and choose to perform. As stated previously, my intent throughout this research project was not for me to empower these young women, for empowerment implies *giving power to*. The very act of giving denotes a power relation. Instead, my focus was on facilitating their acknowledgment of the "Power-To" they already had and their dispositions and abilities to exercise their power.

Aside from considering the forces of power in which these students and teachers are enmeshed, priority was also given to discovering a way for these students to share their stories so that others could learn from these students. Through ongoing dialogue and interactions between the students and myself, these young women have been offered an opportunity to share their experiences in order for others to gain a better understanding of their lives, both in school and out of school. The development of Personal Life Presentations as a qualitative research methodology provided the outlet needed through which these students could find their voice.

Unlegitimated Voices

While I feel confident that the praxiology of this study provided the young women who participated a voice, I am disappointed that my aspirations for an emancipatory ends had not been realized. Although the girls expressed an understanding of the influences some of the power sources had on their behaviors, this understanding was not necessarily a new revelation as a result of this study. Who was I to think that I could have an influence within one school year when these young women were bombarded with oppressive practices every day (and had been for years) and perpetuated oppression of themselves?

Although I feel I had a critical empathy for these young women, I could not enable them to find their own way, as Greene (1986) suggests. Not only did they not have political clarity to recognize all of the linkages between their lives and oppressive practices, but they did not receive the ongoing support they needed to become emancipated. Although their acts of resistance were in response to domination, their resistance was not part of a larger political project advocating change.

Girls who have ED have been truly silenced. Discussions of girls with ED are almost completely absent from the literature, particularly special

education literature, and the voices of any students with ED have been virtually ignored. As Fine (1991) remarked, this silencing of student voice "signifies a terror of words, a fear of talk" (p. 32). As educators, perhaps this silencing occurs because we fear what these students are trying to say. We are either unable or unwilling to take the restructuring challenges that would be needed in order to address these students' concerns. Instead, we continue to censor these learners through isolation, removing many students with ED from the social milieu of public schools because what they have to say, or how they choose to say it, is considered both offensive and possibly contagious.

What may be particularly offensive to educators is what the girls with ED have to say, because through their *talk*, they are challenging not only the rules, but also the social conformities related to their gender. In order to get their immediate needs met, many of these young women use either their sexuality, which is frowned upon by other females, or aggression, which is frowned upon by males. In response to the oppositional identities exhibited by many of the students with ED, perhaps school personnel feel the need to keep these students away from others so as to not pollute the minds of other students. Although what these students have to say is potent, their talk is considered *inappropriate* because of the language they use. Their word choices mask the messages sent by these young students, even though the students are speaking both loudly and clearly, practically shouting from the roof tops their need for someone to listen.

For example, many of the students in this special education program had not been successful with academics and exhibited frustration with their lack of success. As one student plainly said, *"I'm not gonna bother doing this. If I do the work I get it wrong anyway so why bother."* While many teachers might interpret this statement as noncompliance, in fact this student was communicating a need to feel successful with his work, requiring support in order to achieve that success. The same was true for Isis when she demanded the use of a calculator, Air when she constantly requested help with her work, and Mandy who consistently wanted to receive positive feedback about the work she had done.

Sometimes the students clearly communicated what strategy they needed the teacher to use to help them control their behavior, but oftentimes their requests went unheeded as in the following example.

Arty:	Why don't you just leave me alone.
Ms. Smith:	That's not an option, honey. You have to either do the work here or in a Level II. What can I do to help you?
Arty:	I told you what you could do. Just leave me alone.
Ms. Smith:	Do you want me to call Kyle so you can talk with her?

Arty: *I just want to be left alone. Everything is agitating me today. Just
 leave me alone.*

In this instance, the teacher felt that it was important for this student to
complete his work. She appeared not to realize how she may have been
"feeding the flame" of this student by not leaving him alone after he had
made that request. By not valuing his request, she had effectively
communicated to this student, and to the others listening, that he had no
choices. Even if he was frustrated, the expectations did not change for him.
This is not to suggest that the teacher should allow the students to never
complete work, but it would be helpful for her to begin to listen to the clues
provided by students before immediately assuming the authoritative role of
taskmaster.

Many of the students simply cried out for attention, as illustrated by this
tale told by one of the students to his teacher.

> *Isaiah was off task, so Ms. Smith went over to him and started to scratch his back
> in order to wake him up. Isaiah said, "I use a knife to scratch my back at home
> because that's all I can reach it with. Then I end up cutting my back and when it
> heals, it itches." Ms. Smith did not comment.*

Air had communicated a need for attention in a similar manner. At one
point during the school year, a student who had been out with a serious
illness came back to school, requiring an intravenous drip so that he could
receive continuous medication for a severe internal infection. He had been
sharing his scars from surgery with another student when Air yelled out to
them, *"Stitches aren't nothing."* She said this as she rubbed the scar on her
arm where she had received metal staples to close a self-inflicted wound.
However, no one responded to her. These students are quite vocal in their
requests. And yet, as educators, we continue to squelch their cries, muffling
their sobs, and renaming their resistance as something inherent to the
students themselves, failing to recognize our complicity in their rebellion.
The voices of these students remain unlegitimated by the general school
culture.

Reflecting on Educational Practices

The teachers in this school program were good people, showing up to school
day after day, week after week, enduring abuse themselves, and living in fear
of the day when they would not be able to *control* a learner's behavior. The
principal of the program was a continuous learner, applying progressive

principles of classroom management that focused on peaceful resolutions to conflict. The therapists and police officer as well as the rest of the school staff showed a genuine like for most of the students who were assigned to this school program and made attempts to establish positive relationships with the students. They worked long hours preparing assignments and often spent their own money on materials, just as many teachers do, and participated in countless meetings to support individual students through collaboration and planning. They attended court hearings and hospital staffings, and engaged in countless discussions with case workers, probation officers, and mental health therapists in an effort to better understand the complex lives of these students.

Yet, even with their best intentions and heroic efforts, the educators and staff of this school program continued to struggle to find how to best teach these students with ED. Their vision for these students may have been clouded by the stress and fear these educators voluntarily lived with on a daily basis. Although I offer few alternatives to these teachers, perhaps as a result of this research they will be better able to listen to their students and discover alternatives in collaboration with them. For example, perhaps they could take a closer look at the level of freedom and choices provided to students, encouraging autonomy whenever possible. Or perhaps they might consider creating meaningful curricular experiences for these students to challenge and motivate them to learn. Reflecting on how they, as teachers, contributed to Power-Over might also be helpful to this staff, becoming aware of even the incidental interactions they have with students and the power plays inherent in those interactions. In general, maybe this research suggests that we need to move toward a humanization of students in schools. As a mini-society, schools are possibly overly preoccupied with control, regimenting education and putting too much value on acquiescence and silence. This is particularly evident in middle school and high school settings where the focus on control by educators is in direct opposition to adolescents' focus on autonomy.

Fine (1991) suggests that silencing is more predominant in low-income public schools. However, maybe it is more accurate to say that systemic silencing of students occurs most frequently in any school arena in which students speak without conventions, creating controversy that, if attended to, might end up in a critique of current school policies. This, in turn, challenges established power hierarchies. Possibly, similar to the way the students in this ED program established a social pecking order, students with ED are kept in their place through the control and distribution of resources among the area public schools and this special education program.

Access versus Outcomes. While the school provided educational access to these students, this program did not necessarily provide positive educational outcomes equal to that of their non-disabled peers (Fine, 1991). Students who were assigned to this program continued to fail classes, skip school, receive multiple punishments for "bad behavior," and were sent to juvenile detention. I often wondered what had changed for these students as a result of their participation in this school program in which educators collaborated with mental health therapists, case workers, and probation officers? What were the payoffs for being involved in such a program? Was it simply that an environment was provided in which the professional staff were available to listen to the students more than educators would have been in the public school setting? Was it that students were not removed from school due to profanity? Was a positive outcome that there were less out-of-school suspensions imposed, replaced by in-school time-outs through Level II and Level III interventions? How was this environment beneficial to these students? Did the students learn more by completing reams of worksheet packets? Did they benefit from witnessing and participating in the collective aggression and noncompliance indicative of this artificial school culture? Did the young women assigned to this program benefit from their disproportionate numbers? What positive outcomes could be measured as a result of these students being in this segregated environment?

There were nine public school districts participating in the consortium to financially support the existence of this school program. Perhaps the administrators of these districts identified success by the fact that they had effectively removed these challenging students from view, ignoring their communication so they could go about the business of a perverted *democratic education*. The segregated school environment may have been an effective mechanism for silencing these students, exporting their dissent to the hinterlands of the school community.

Searching for Answers

Although these students were conscious of some of the oppressive forces enveloping them, they lacked the knowledge, or ability, or desire to actually achieve freedom from their oppression. Perhaps in some way they were unable to overcome an internalized oppression (Greene, 1986), actually believing what others said about them. As students labeled with an emotional disturbance, they were set apart not only as different but inferior to other students. These students seemed to be well aware of this fact as they crossed the threshold of this ED program. They were not valued by their home school

community. Instead, they were ostracized, becoming outcasts to the rest of the school culture. Even as students attempted to reenter the general education arena, often their insecurities showed in increased behavior problems within the ED program. Perhaps by banishing these students to segregated islands, schools were able to remain blind to their existence, allowing educators to believe that they had created a democratic learning environment for children. The visibility of these students with a behavioral disability would be a disclaimer to the existence of such a community, and this could not be tolerated.

If schools are truly sources of cultural reproduction, whereby the structures, interactions, and curricula are means of ideological control (Leistyna, Woodrum, & Sherblom, 1996), then what can we be manufacturing through our current hierarchical educational practices? This hegemonic practice of producing institutional structures to maintain positions of privilege and the binary of such positions would need to be imploded before any substantial change in education could occur, including the realization of a true democratic community. Educators are fooling themselves if they think they can actualize both democracy and segregated environments simultaneously.

Broader Implications

While the focus of this inquiry may have been narrow, the scope and impact of this research extends to all schools as well as to other adolescents beyond those directly involved in this study. The strategies used by the school administrator and teachers were somewhat similar to the strategies deployed by most school systems and educators. For example, punishment is widely considered an acceptable technique for managing large groups of students. For most students, the threat of a detention, suspension, or expulsion is enough to promote conformity. For many, even the threat of a note home is enough to deter noncompliance. However, there are also many students who do not respond well to this form of behavior management. We know this simply by reviewing discipline referrals. Ask any principal or assistant principal and they will be able to name, without looking at any list, individual students who have been repeatedly suspended. What this data suggests is that for those students, just as with the students involved in this study, suspension and other traditional forms of punishment are not effective strategies (Gartin & Murdick, 2001).

While similarities abound between the way this particular school program handled discipline problems and how other schools handle

behavioral issues, there are also similarities between the reactions of these students and the reactions of other adolescents. The responses these students had to the various forms of power they were subjected to were not far removed from the responses of *typical* adolescents. Noncompliance to rules, use of profanity, backtalk, aggression, avoidance through absenteeism, drug and alcohol use, and even the contemplation of suicide are ways in which many adolescents cope with the stressors in their lives. While the examples shared by the students enrolled in the ED program may have appeared sensational with situations drastically escalating, in actuality, the students' initial responses were not all that different from their adolescent peers who are not considered disabled.

If we truly engage in listening, and we actually hear what these students have been saying to us, then we can begin the process of developing educational programs that are better suited to middle school and high school students, recognizing the unique needs of teenage girls in the process. What I heard through the conversations and stories recorded in this book was that students in general want three things—to be successful, to be respected, and to have choices. Glasser (1986) made a similar discovery quite some time ago, suggesting that students strive for power (to have choices), freedom (to be respected and trusted enough to make those choices), and fun (which is often tied to success). On the surface, these do not sound like difficult requests to fulfill. What it would take is for schools to begin embracing a philosophy of support for student strengths, abandoning the deficit-driven models of intervention that have permeated our school cultures. It is not about discovering what is wrong with a student and classifying it, but rather about gaining an understanding of what the students' interests and skills are and building on that.

Borrowing from research on successful school programs created to support children at risk due to poverty, there are several integral components educators might want to consider when restructuring schools to better meet the needs of their students. Maeroff (1998) suggests that schools focus on becoming places where students can feel *connected*, have a sense of *well-being*, realize a sense of *academic initiative*, and develop a *sense of knowing*.

To feel *connected*, students would need to feel as if they were a part of something important and meaningful. Creating a sense of community within each school might be done through schoolwide or classwide philanthropic projects; older students tutoring and mentoring younger students; fostering involvement in student activities; expanding the school day to include after-school programs; connecting the community and the school through collaborative projects; or creating clubs or groups based on student interests and skills. Involvement in any of these activities would not be something a

student would earn, but would be encouraged no matter what type of day or week the student was having. The important things in life, those things that sustain our sense of self, should not be privileges earned or lost, but rather requirements for all students' participation.

Developing a sense of *well-being* or feeling safe would take an important paradigm shift in the mind of many educators if it is to be realized in our current school systems. It is not enough to install metal detectors, entrance call buttons, or armed security to ensure a sense of well-being among students. In actuality, it might be argued that many students feel less safe by the presence of such formidable deterrents. What the students in this study described as a sense of well-being included being liked by their teachers as shown through respectful interactions. To know that they are valued as individuals, no matter from what circumstances they come. To have decisions explained to them, and to even be involved in the decision-making process. To have their successes celebrated and to not focus on their struggles or deficits. To know that when they ask for help, someone will be there to listen to them and respond. Teachers would need to become more reflective and evaluate their communicative acts when dialoguing with students. Educators would not only need to reflect on what they say to students, but how and when they say it, and to even analyze for what purpose something was said.

Changing our focus away from punishment and more toward discipline is another way that a sense of well-being might be nurtured in our students. Punishment is a reactive stance taken by many schools and people in authority as a quick fix to ending problem behaviors. However, the get-tough zero-tolerance attitudes many schools have adopted in recent years, using punishment as a primary means for managing student behavior, tend to actually generate school environments that are negative, adversarial, and even hostile (Sugai & Horner, 2001). Discipline, on the other hand, focuses on understanding the function of a person's behavior, and taking the time to teach students a better or more conventional way of dealing with the problem situation. Discipline is done over time and has a significant teaching component. While there can be consequences for one's actions within a discipline paradigm, those consequences are related to the problem issue and are not as arbitrary as time-out, detention, suspension, or expulsion.

Restitution (Chelsom-Gossen, 1992) is one method that can be used within a disciplinary model to promote student learning within the context of the issue of concern. With restitution, the student works with the teacher to understand the deleterious effects of the problem behavior, and together they come up with ways to address the situation. Restitution is not retribution. Instead, it involves having the student somehow giving back to the

community or the person that was wronged, making things right again, helping the student to save face and to actually foster a sense of altruism. Restitution could become a part of the discipline referral process of any school, with trained personnel to work through each issue with the students who have committed the offenses.

Academic initiative is most often fostered through experiences with success. When teachers describe a student as lazy and unmotivated, usually, if one digs a bit deeper and peels back the layers of facade the student has built up, one will find a child who has a history of academic failure. Once this cycle of failure begins, students lose hope in their abilities and eventually their futures. Without hope, there is no motivation to keep trying. To attend to the need of students to feel successful, teachers would need to begin by identifying the times when students demonstrated the desired skills, either social or academic, and then build upon those moments of success. Instead of spending time collecting mountains of data documenting the learner's deficits, teachers could begin collecting data demonstrating student strengths and successes, and sharing that data with both students and their families. Lessons could be created to build upon those successes, adopting a constructivist approach to learning.

Teachers would need to be willing to change their lesson plans from year to year, tailoring the way instruction was implemented based on the needs of the students. Creating academic initiative would also mean that educators become knowledgeable about the students' home and community culture and experiences, using those experiences as a basis for instruction. Facilitating learning that is both challenging and meaningful to students would guide learners to understand connections beyond the printed facts and subject content that is often the focus of our instruction, supporting students to think critically about the broader constructs and implications of the information learned.

Many students who we struggle to reach disengage from the school culture because they simply do not have a *sense of knowing*. Having been restricted to their community, with few opportunities to explore the world outside the radius of their neighborhoods, many students have only a limited view of what is available to them in the larger community of our society. To put it simply, they do not know what they do not know.

As Maeroff (1998) explained, students who come from affluent communities have had multiple educational experiences that extend beyond the school walls. They have been on vacations to other parts of the country (or even other countries), they have viewed terrain—such as deserts, mountains, and oceans—that is different from their neighborhoods, they have met diverse people and have been introduced to diverse ways of life. Many

middle-class, suburban students have had opportunities to see plays, view art, or listen to music that they do not encounter on a daily basis. They have had opportunities to play sports, go camping or hiking, water ski, and hang glide. These students have been given the gift of sight—to see beyond their world and to understand the unlimited possibilities there are for them.

In contrast, many students who come from poverty or restrictive lifestyles may not know about such things. Their imaginations have not been sparked, and any sense of hope is limited to survival. They cannot see beyond the neighborhood, or as in the case of the students involved in this study, cannot see beyond the trauma they have encountered. Their vision of what could be is blurred and even limited. In order for schools to address this issue, programs would need to be created and supported that provide opportunities for students to see beyond their world, not just through books, but through actual lived experiences. Raising money for class or group trips, engaging students in conversations about diversity, and using inquiry-based instruction to have students investigate a different culture, philosophy, or values would all be ways to stimulate a student's sense of knowing. Schools could create mentoring opportunities for students, pairing them up with adults from diverse communities. While field trips to museums and other cultural programs to help expand the horizons of students is a widely used strategy for helping students to develop a sense of knowing, perhaps these programs need to be broadened to include a wider array of sites to visit.

Another great way to support student awareness would be to facilitate students to investigate the forms of oppression they have experienced, and lead them to ways to address those issues such as contacting legislators or publishing articles, poetry, or a book on the topic or issue they are addressing, or to create personal life histories through pictures. Creative instructional strategies such as these have proven to open doors to the minds of learners living in conflict, such as with the Freedom Writers (Gruwell,1999).

If we truly want to realize schools that can reach all students, then gone are the days of rote learning and skill drills. If students do not come to school open to learning, or if schools do not begin to reinforce students for attempting to learn and create atmospheres conducive to inquiry and creativity, then many students will continue to be unmotivated and hence, will continue to fail. Students who are disenfranchised from the learning environment do not stay in school, or resist learning as a means of gaining some semblance of control over their lives.

Providing Volume to Student Voice

While some suggestions have been made to improve the quality of our education programs to better meet the unique needs of adolescents, this investigation was actually about posing questions, not providing answers, and generating possibilities, not solutions. The questions and possibilities generated could guide further investigation, bringing issues of ableism, sexism, and a curriculum of control out of the private sphere of special education into the public milieu of general education. Aside from exposing possibilities and questions, this research was engaged in with a focus on students finding voice. What is presented by this project is a possible methodology for researchers attempting to uncover similar threads in the disheveled tapestry of student voice, particularly of the voices of young women with ED. In addition, the questions this research proposed could be used by educators to assess their own educational programs, having implications for special education and general education alike.

The young women in this study, due to various demonstrations of resistance, have been relegated to classrooms for learners with an emotional disturbance. Although, while in these classrooms they received support to deal with the multiple stressors that continually invaded their lives, I believe these girls continued to find themselves in situations that perpetuated their need to protest. It was my hope that these young women would be able to demonstrate ways in which schools could offer these students alternative strategies for resistance, as I attempted to uncover how and why they resisted and how they defined themselves as a result. While the strategies in which these participants engaged did not help them to break free from the subjugation in which they were imprisoned as I had hoped, perhaps through continued attempts at liberatory research, refusing to be silent could be viewed as an emancipatory response to be listened to instead of a rebellious act needing to be diffused and controlled. Writing in the margins could be encouraged, and reading what is written in the margins mandatory as a way to inform school restructuring practices and school reform.

It is my contention that many of the female adolescents in ED classrooms have overtly refused to be silent, speaking their opposition to hegemony or the greater society through their dress, actions, and speech in an attempt at agency. I can only hope that their messages have now been heard. I acknowledge that these three students are only a minute sampling of adolescent girls with ED. Although not representative of all female adolescents in such programs, their voices do have validity because they are veritably theirs. While only a whisper in the possible cacophony of voice which would genuinely represent young women with ED, because of this

work perhaps their whispers will increase in volume, encouraging others to seek out similar echoes in school hallways and classrooms elsewhere.

"I almost wish I hadn't gone down *that* rabbit-hole—and yet—it's rather curious, you know, this sort of life! I do wonder what can have happened to me! When I used to read fairy tales, I fancied that kind of thing never happened, and now here I am in the middle of one! There ought to be a book written about me, that there ought! · And when I grow up, I'll write one..."

Lewis Carroll
Alice's Adventures in Wonderland

✠ Epilogue

While the narratives in this book capture a snapshot of several students' lives, the reality is that it is only a snapshot—one moment frozen in time that represents only a fraction of these students' lives. As this researcher disengaged from the school in which this study was conducted, the three young students who had been involved in this study resumed their lives.

Air, who had dropped out of school to get married when she turned 16, returned to the school for one day the following school year, separated from her husband and seven months pregnant. She spent the day visiting with old friends and then, as quickly as she had reentered this school culture, she once again vanished. Rumored reports suggest that she has since gotten divorced from her husband and has lost custody of her baby. No one is quite sure where she is living or how she is supporting herself, although prostitution has been mentioned as a possibility. It seems that Air continues to avoid difficult situations, remaining an apparition, floating from one reality to the next.

Isis, who during this study had adamantly refused to choose a boyfriend over her best friend, started coming to school with enormous *hickies* on her neck, which she displayed proudly. The creator of the marks was reportedly another student in the program. This student was a notorious juvenile offender and frequent guest of the Juvenile Justice system. Isis has since graduated from this segregated school program, gotten married to this same young man, and is now also a parent.

Mandy, who continued to struggle with behavioral issues in school, was eventually remanded by the Juvenile Justice system to a *Boy's Ranch* (ironic, isn't it?) somewhere else in the state. While it has been suggested that Mandy is "doing well" in this therapeutic but highly restrictive environment, the reports are inconsistent. Some say she may have even been released. However, she has not enrolled in any local school district in the area, nor has she returned to the special education school program she was in prior to being sent upstate. Mandy continues to keep her secrets and remains an enigma to her former teachers and this researcher.

✠

❧ Bibliography

American Association of University Women Educational Foundation Survey. (1993). *Hostile hallways: The AAUW survey on sexual harassment in America's schools.* Washington, DC: Author.

American Association of University Women Report. (1992). *How schools shortchange girls: Executive summary.* Washington, DC: Author.

American Psychiatric Association. (1994). *Diagnostic and statistical manual of mental disorders* (4th ed.). Washington, DC: Author.

Anyon, J. (1984). Intersections of gender and class: Accommodation and resistance by working-class and affluent females to contradictory sex role ideologies. *Journal of Education, 166* (1), 25–48.

Ayers, W. C., & Miller, J. L. (eds.). (1998). *A light in dark times: Maxine Greene and the unfinished conversation.* New York: Teachers College Press.

Brendtro, L. K., Brokenleg, M., & Van Bockern, S. (1992). *Reclaiming youth at risk: Our hope for the future.* Bloomington, IN: National Educational Service.

Brunner, D. D. (1994). *Inquiry and reflection: Framing narrative practice in education.* Albany: State University of New York Press.

Carlson, D. (1987). Teachers as political actors: From reproductive theory to the crisis of schooling. *Harvard Educational Review, 57* (3), 283–307.

Carroll, L. (1865/1992). *Alice's adventures in wonderland.* New York: Bantam Doubleday Dell for Young Readers.

Center, D. B., & Kaufman, M. E. (1993). Present and future needs for personnel to prepare teachers of the behaviorally disordered. *Behavioral Disorders, 18* (2), 87–91.

Charlton, J. I. (1998). *Nothing about us without us: Disability oppression and empowerment.* Berkeley: University of California Press.

Chelsom-Gossen, D. (1992). *Restitution: Restructuring school discipline.* Chapel Hill, NC: New View Publications.

Chodorow, N. J. (1978). *The reproduction of mothering: Psychoanalysis and the sociology of gender.* Berkeley: University of California Press.

Clandinin, D. J., & Connelly, F. M. (1991). Narrative and story in practice and research. In Schon, D. A., *The reflective turn: Case studies in and on educational practice.* New York: Teachers College Press.

Connell, R. W. (1996). Teaching the boys: New research on masculinity, and gender strategies for schools. *Teachers College Record, 98* (2), 206–235.

Conquergood, D. (1991). Rethinking ethnography: Towards a critical cultural politics. *Communication Monographs, 58,* 179–194.

Cullinan, D., Epstein, M. H., & Sabornie, E. J. (1992). Selected characteristics of a national sample of seriously emotionally disturbed adolescents. *Behavior Disorders, 7* (4), 273–280.

Du Bois, W. E. B. (1903/1989). *The souls of black folk.* New York: Bantam Books.

Eder, D., Evans, C. C., & Parker, S. (1995). *School talk: Gender and adolescent culture.* New Brunswick, NJ: Rutgers University Press.

The educational needs of children living with violence. (1995). *News Link, 9* (1), 1–2.

Ellsworth, E. (1989). Why doesn't this feel empowering? Working through the repressive myths of critical pedagogy. In Linda Stone (ed.). (1994), *The Education Feminism Reader* (pp. 300–327). New York: Routledge.

Fine, M. (1991). *Framing dropouts: Notes on the politics of an urban high school.* Albany: State University of New York Press.

Fine, M. (1992). *Disruptive voices: The possibilities of feminist research.* Ann Arbor: The University of Michigan Press.

Freire, P. (1971). *Pedagogy of the oppressed.* New York: Herder & Herder.

Freire, P., & Shor, I. (1987). *A pedagogy for liberation.* London: MacMillan.

Gartin, B. C., & Murdick, N. L. (2001). A new IDEA mandate. *Remedial and Special Education, 22,* 344–359.

Glasser, W. (1986). *Control theory in the classroom.* New York: Harper & Row.

Goffman, I. (1959). *The presentation of self in everyday life.* New York: Doubleday.

Gramsci, A. (1971). *Selections from prison notebooks.* New York: International Press.

Greene, M. (1986). In search of a critical pedagogy. *Harvard Educational Review, 56* (4), 427–441.

Grumet, M. (1980). Autobiography and reconceptualization. In William F. Pinar (ed.). (1999), *Contemporary curriculum discourses: Twenty years of JCT* (pp. 24–30). New York: Peter Lang Publishing, Inc.

Gruwell, E. (1999). The freedom writers diary: How a group of extraordinary teens used writing to change themselves and the world around them. Garden City, NY: Doubleday & Company, Inc.

Herman, J. L. (1992). *Trauma and recovery: The aftermath of violence—from domestic abuse to political terror.* New York: Basic Books.

hooks, b. (1984). *Feminist theory from margin to center.* Boston: South End Press.

Individuals with Disabilities Education Act Amendment of 1997, Pub. L. No.105-17 Fed. Reg. 34 CFR 300.7(c)(4).

Jackson, D., & Salisbury, J. (1996). Why should secondary schools take working with boys seriously? *Gender and Education, 8* (1), 103–115.

Jay, T. (1992). *Cursing in America.* Philadelphia: Johns Benjamin.

Jones, A. (1993). Becoming a "Girl": Post-structuralist suggestions for educational research. *Gender and education, 5* (2), 157–166.

Jones, M. M. (1998). *Within our reach: Behavior prevention and intervention strategies for learners with mental retardation and autism.* Reston, VA: The Council for Exceptional Children, MRDD Division.

Jordan, E. (1995). Fighting boys and fantasy play: The construction of masculinity in the early years of school. *Gender and Education, 7* (1), 69–86.

Kaufman, M. E., & Center, D. D. (1992). Administrators rank discipline problems—common and serious. *National Association of Secondary School Principals (NASSP) Bulletin, 76* (542), 116–119.

Katz, P. A., & Taylor, D. A. (1988). *Eliminating racism: Profiles in controversy.* New York: Plenum Press.

Kehily, M. J. (1995). Self-narration, autobiography and identity construction. *Gender and Education, 7* (1), 23–31.

Kenway, J. A., & Fitzclarence, L. (1997). Masculinity, violence and schooling: Challenging "poisonous pedagogies." *Gender and Education, 9* (1), 117–133.

Kurz, D. (1998). Old problems and new direction in the study of violence against women. In R. K. Bergen (ed.)., *Issues in intimate violence.* (pp. 197–208). Thousand Oaks, CA: Sage Publications.

Lather, P., & Smithies, C. (1997). *Troubling the angels: Women living with HIV/AIDS.* Boulder, CO: Westview Press.

LeCompte, M. D. (1993). A framework for hearing silence: What does telling stories mean when we are supposed to be doing science? In D. McLaughlin & W. Tierney (eds.), *Naming silenced lives: Personal narratives and the process of educational change* (pp. 9-27). New York: Routledge.

Leistyna, P., Woodrum, A., & Sherblom, S. A. (eds.). (1996). *Breaking free: The transformative power of critical pedagogy.* Cambridge, MA: Harvard Educational Review.

Lincoln, Y. S. (1993). I and thou: Method, voice and roles in research with the silenced. In D. McLaughlin & W. Tierney (eds.), *Naming silenced lives: Personal narratives and the process of educational change* (pp. 29-47). New York: Routledge.

Maeroff, G. I. (1998). Altered destinies: Making life better for schoolchildren in need. *Phi Delta Kappan, February,* 425–432.

Mahoney, M. R. (1994). Victimization or oppression? Women's lives, violence, and agency. In M. A. Fineman & R. Mykitiuk (eds.), *The public nature of private violence: The discovery of domestic abuse* (pp. 59-92). New York: Routledge

McRobbie, A. (1978). Working class girls and the culture of femininity. In *Women's Studies Group, Women Take Issue.* Birmingham, AL: Birmingham Centre for Contemporary Cultural Studies, University of Birmingham.

Mead, G. H. (1934). *Mind, self and society.* Chicago: University of Chicago Press.

Miller, D. (1993). Sexual and physical abuse among adolescents with behavioral disorders: Profiles and implications. *Behavioral Disorders, 18* (2), 129–138.

Morris, J. (1993). Prejudice. In J. Swain, V. Finkelstein, S. French, & M. Oliver (eds.), *Disabling barriers—Enabling environments.* Newbury Park, CA: Sage Publications Inc.

Oliver, M. (1996). *Understanding disability: From theory to practice.* New York: St. Martin's Press.

Pinar, W. F. (1988). *Contemporary curriculum discourses.* Scottsdale, AZ: Gorsuch Scarisbrick Publishers.

Pinar, W. F. (1994). *Autobiography, politics and sexuality: Essays in curriculum theory 1972-1992.* New York: Peter Lang Publishing, Inc.

Pipher, M. (1994). *Reviving Ophelia: Saving the selves of adolescent girls.* New York: Ballantine Books.

Proweller, A. (1998). *Constructing female identities: Meaning making in an upper middle class youth culture.* Albany: State University of New York Press.

Roman, L. G. (1992). The political significance of other ways of narrating ethnography: A feminist materialist approach. In M. D. LeCompte, W. Millroy, & J. Preissle (eds.), *The handbook of qualitative research in education* (pp. 555–594). San Diego, CA: Academic Press, Inc.

Sadker, M., & Sadker, D. (1994). *Failing at fairness: How America's schools cheat girls.* New York: Charles Scribner's Sons.

Shandler, S. (1999). *Ophelia speaks: Adolescent girls write about their search for self.* New York: HarperCollins Publishers, Inc.

Shores, R. E., Gunter, P. L., & Jack, S. L. (1993). Classroom management strategies: Are they setting events for coercion? *Behavioral Disorders, 18* (2), 92–102.

Smith, S. E. (1997). Deepening participatory action-research. In S. E. Smith & D. G. Willms (eds.), *Nurtured by knowledge: Learning to do participatory action research* (pp. 173–191). New York: The Apex Press.

Stein, N. (1998). Sexual harassment in schools: The public performance of gendered violence. In C. A. Woysher & H. S. Gelfond, *Minding women: Reshaping the education realm* (pp. 227–246). Cambridge, MA: Harvard Educational Review.

Sugai, G., & Horner, R. H. (2001). School climate and discipline: Going to scale. Paper presented at the National Summit on the shared implementation of IDEA, www.pbis.org.

United States Department of Education Office of Special Education and Rehabilitative Services Office of Special Education Programs. (1996). *National agenda for achieving better results for children and youth with serious emotional disturbance,* web site: www.air.org/cecp/resources.

Valdes, K. A., Williamson, C. L., & Wagner, M. M. (1990). *The national longitudinal transition study of special education students. Vol 3: Youth categorized as emotionally disturbed.* Menlo Park, CA: SRI International.

Weis, L. (1990). *Issues of disproportionality and social justice in tomorrow's schools: A symposium presented at the annual meeting of the AERA.* Buffalo, NY: Graduate School of Education Publications.

Wexler, P. (1988). Symbolic economy of identity an denial of labor: Studies in high school number 1. In L. Weis (ed.)., *Class, race, & gender in American education.* Albany: State University of New York Press.

White, R. B., & Koorland, M. A. (1996). Curses! What can we do about cursing? *Teaching Exceptional Children, 28* (4), 48–52.

Willis, P. E. (1977). *Learning to labour: How working class kids get working class jobs.* Westmead, Farnborough, Hants, England: Saxon House.

Wright, J. (1995). A feminist poststructuralist methodology for the study of gender construction in physical education: Description of a study. *Journal of Teaching Physical Education, 15,* 1–24.

Yoder, J. D., & Kahn, A. S. (1992). Toward a feminist understanding of women and power. *Psychology of Women Quarterly, 16, 381-388.*